Making Early Histories in Museums

Making Histories in Museums
Series Editor: Gaynor Kavanagh

Also in the series:
Making Histories in Museums. Edited by Gaynor Kavanagh
Making City Histories in Museums. Edited by Gaynor Kavanagh
and Elizabeth Frostick

Making Early Histories in Museums

Edited by Nick Merriman

Leicester University Press
London and New York

Leicester University Press
A Cassell imprint
Wellington House, 125 Strand, London WC2R 0BB
370 Lexington Avenue, New York, NY 10017–6550

First published 1999

British Library Cataloguing-in-Publication Data

A catalogue record for this book is available from the British Library.

ISBN 0-7185-0110-1

Typeset by BookEns Ltd., Royston, Herts.
Printed and bound in Great Britain by Cromwell Press Ltd, Trowbridge, Wiltshire

Contents

Contents

Illustrations

Contributors

Mary Beard teaches Classics at Cambridge and is a Fellow of Newnham College. Her next book will be *Classical Myths and Myth-making: The Invention of Jane Ellen Harrison*.

Jonathan Cotton is Curator (Prehistory) within the Department of Early London History and Collections at the Museum of London.

John Henderson teaches Classics at Cambridge and is a Fellow of King's College. He is co-author (with Mary Beard) of *Classics: A Very Short Introduction*.

Clare Herring is a postgraduate student in the Department of Archaeology, Cambridge University.

Simon James is Leverhulme Special Research Fellow at the Department of Archaeology, Durham University, on attachment from the British Museum Education Service.

Sam Lucy is a lecturer in Early Medieval Archaeology at Durham University.

Nick Merriman is a senior lecturer at the Institute of Archaeology, University College London, and co-ordinator of Museum Studies programmes.

Stephanie Moser is a lecturer in the Representation of the Past in the Department of Archaeology, Southampton University.

Janet Owen is a lecturer in the Department of Museum Studies, Leicester University.

Susan M. Pearce is Professor of Museum Studies and Dean of the Faculty of Arts at Leicester University.

Angela Piccini is Publications Officer for Cadw: Welsh Historic Monuments, an Executive Agency of the Welsh Office. Her paper is derived from PhD research undertaken at the Department of Archaeology, Sheffield University.

Alan Saville is a curator in the Department of Archaeology, National Museums of Scotland, Edinburgh.

Marie Louise Stig Sørensen is a lecturer in the Department of Archaeology, Cambridge University, and co-ordinator of the MPhil in Archaeological Heritage and Museums.

Barbara Wood was formerly an assistant curator in the Department of Early London History and Collections at the Museum of London.

Preface

Museums are an engaging, challenging, memorable means of discovering episodes of past human experience. Their appeal to all the senses, their location within free time and leisure choices, their increased sophistication in terms of collection care and communication – all have a part to play in this. Museums can produce histories that are compelling and vivid, evocative and affecting, argumentative and enriching. They can help cross cultural and generational divides, open forms of learning otherwise denied, and accommodate personal as well as social encounters. They can be insightful commentators, great teachers, debaters of the best and the worst of human history. They can provoke the imagination, move people to tears, raise expectations. And by the same token, they can be none of these things and only confuse, appropriate and deny.

Somewhere between the exhilaration and the disappointment lies the field of museum studies which seeks to gain understanding of the educational, social and cultural roles of museums and their assumed and actual functions within modern life. The task bridges the professional and the academic, the theoretical and the practical: both why and how questions need to be asked. The facility to deconstruct brings with it the responsibility to reconstruct, in order to find more successful and effective ways forward.

The *Making Histories* series was devised to explore both product and process, the ways histories are made in museums and the nature of popular and individual engagement with them. In this the premiss is that museums operate dynamically on many different levels, providing opportunities which are seldom uniform and often beyond direct comparison. Broad trends may be discerned and certain generalizations made; ideology and culture saturate museums and shape the visit. Yet the neat theoretical patterns are disrupted by alternative readings, or none at all, and the powerful figure in this is often the visitor. As a result, the fascination in museum practice shifts from the general to the specific and often lies in the anomaly, the variant and the development which shifts the boundaries forward.

In this volume, devoted to the making of early histories, the authors discuss one of the most tantalizing aspects of museums: the meaning that

is made from that material evidence of human experience which is classified as archaeology. Understood in terms of its context and associations, such material is frequently without benefit of the contemporary accounts, verbal and written, that historians working on later periods take for granted. There is a great mystery in much of what can be known. Thus, whether it is within the academic approach of the archaeologist or the personal approach of the visitor, a certain present-dayness is unavoidable, and it is often in this that our concerns lie. Struggling to grasp the meaning of the barest fragments, we draw from what we know, yet in so doing we may be pushing the past even further away from us.

The objects and pieces we have in museums, the evidence of the past lives they represent are very small pieces in huge puzzles and we fill the gaps as best we can. As a historian I am left wondering about the sound of Lucy's voice and I speculate on how different our understanding would be if the Glen Parva woman had left us a note. I also wonder how different our view of the remote past would be if flint rather than leather were perishable and the dominant evidence we had of these periods were not axe heads but the slings in which babies were carried. In such speculations I act as a museum visitor, taking the evidence out of the hands of the authoritative archaeologist and into the realms of my imagination. Exploring what we know allows us to explore what we don't know. Therein lies the excitement and the intellectual challenge of early histories in museums.

This volume explores these and other episodes in museum provision and makes a significant contribution to the ways of thinking about and working with the evidence of early lives that museums hold.

Gaynor Kavanagh
July 1998

Acknowledgements

Above all I would like to thank the contributors to the volume for the time and effort they have put into preparing their articles, and for taking my comments and suggestions into consideration. The resulting volume is a stimulating contribution to the representation of the past in museums.

Just as importantly, thanks are due to Gaynor Kavanagh for inviting me to edit the volume in the first place, and for her encouragement, advice and comments during the editorial process. Roz Sherris deserves my gratitude in assisting with word-processing, letter-writing and fielding phone calls.

Most of the chapters in this volume were presented in earlier versions at the conference 'Representing Archaeology in Museums', held at the Museum of London from 9 to 11 November 1995, organized by the Society of Museum Archaeologists. The conference papers, including abbreviated versions of some of the articles here, were published as 'Representing Archaeology in Museums', *The Museum Archaeologist*, vol. 22, 1997, edited by G.T. Denford. I would like to thank my colleagues at the Museum of London for helping to organize the conference, and fellow committee members of the Society of Museum Archaeologists for their generosity in allowing me to encourage contributors to publish expanded versions of their papers.

The following institutions kindly gave permission for their photographs to be published: Field Museum, Chicago; American Museum of Natural History, New York; Australian Museum, Sydney. Peter Connolly also kindly gave permission for one of his paintings to be reproduced, and Simon James for one of his cartoons.

Nick Merriman

Introduction

Nick Merriman

Museum representations of the distant past have for centuries been an important medium of communication, yet they have been relatively little discussed or researched. 'Early' histories (defined here as those covering the prehistoric to early medieval periods), where the bulk of evidence is artefactual rather than documentary, represent a particular interpretive challenge in academic terms, where theory must (or ought to) play a significant part in articulating the patterns of evidence revealed by archaeology. The museum representation of such early histories has its own distinctive part to play in this enterprise. Here the aim is not to communicate to an academic peer group, but to a hugely diverse non-specialist audience. The ideas expressed in museum exhibitions consequently receive a much greater degree of public scrutiny than those put forward in academic publications, with attendant political ramifications. 'Public archaeology', of which museum representation is just one part, can therefore justifiably claim to be a distinct aspect of the practice of archaeology, separate from, though closely linked to, academic archaeology.

This volume attempts to lay out some of the contributions that museum archaeology can make to the public representation of the past. The book itself was stimulated by a conference organized by the Society of Museum Archaeologists and held at the Museum of London in November 1995 entitled 'Representing Archaeology in Museums' (Denford, 1997). The level of interest generated by that conference, and the importance of some of the issues discussed, led to the decision to invite some of the conference contributors to expand their presentations, and to commission others to contribute new chapters covering particular issues not covered in the conference. The aim was not to be comprehensive in coverage, but to provide a series of papers covering some of the 'early' periods (prehistory, Roman, early Anglo-Saxon), some of the common issues (archaeological knowledge, gender, approaches to material culture) and some specific 'technologies' (dioramas, reconstruction paintings, hands-on activities, and open-air reconstructions). The volume is primarily concerned with the UK and Europe, but some of its implications may be applicable more widely.

1

The critique of museums and archaeology

In recent years a large body of literature has grown up around the representation of the past in museums, work that identifies the historical contingency, bias and ideology which structures much museum practice (e.g. Karp and Lavine, 1991; Lumley, 1988; Macdonald and Fyfe, 1996; Vergo, 1989). At the same time, archaeology as a discipline has gone through a parallel exercise in self-reflection, attempting to grapple with issues concerning the partiality and subjectivity of archaeological inter-pretations (e.g. Gathercole and Lowenthal, 1990; Hodder, 1991; Shanks and Tilley, 1987).

Some, though relatively little, of this literature has bridged the two areas and examined critically the representation of the early past in museums. Shanks and Tilley (1987), in their fundamental critique of archaeology, recognized museum display as an important component of the discipline, but argued that museum representations served con-temporary interests. The museum was seen as 'the death mask of the present' in which contemporary capitalist values were given the im-primatur of timeless legitimacy by being projected back into the past through museum displays. Their critique was acknowledged by Pearce (1990), who examined different approaches to exhibiting archaeology using formal semiotic analysis and a general critical approach in order to analyse different displays from the point of view of whether they were didactic, emotive, static or dynamic, and to examine their political mes-sages. She also made the important point (1990: 168–9) that exhibitions can usefully be conceived as works of art rather than in any sense true depictions of the past.

Such analyses have represented a considerable challenge to the repre-sentation of the early past in museums. Yet this challenge has only been partly recognized by many museum archaeologists, let alone taken up. With a few North American exceptions (e.g. Leone *et al.*, 1987) and the feminist critique (e.g. Jones and Pay, 1990; Moore and Scott, 1997) there is still very little written about archaeological presentations from a critically informed perspective. This is all the more surprising given the influence of archaeological theory in the development of critical writings about museums (e.g. Pearce, 1986, 1987).

One of the reasons why critical perspectives in archaeology and museology have found relatively little resonance in contemporary archaeological museum practice may be because the priorities of many practising museum archaeologists seem to lie elsewhere, apparently in the more pressing practical concerns – of funding, maintaining staffing levels, managing collections (particularly the ever-growing archive of excavated material), providing services to schools and enquirers, and recording metal detector finds – than in theoretical discussions about the

representation of early history (particularly when for financial reasons display work may occur relatively infrequently). Another reason may be that much of the critical friction generated in recent writings has been concerned with archaeology and museums outside the UK, particularly in those countries where there is a strong living indigenous tradition claiming rights over the archaeological heritage (Simpson, 1996; Stone and MacKenzie, 1990; Stone and Molyneaux, 1994). Such issues can seem superficially irrelevant to UK curators, particularly if cultural restitution demands do not impinge on their museums. A third, related, reason may be that museum archaeologists discern few links between what they see as their concerns and the issues which are foremost in much of the literature, such as cultural diversity, gender, and the past of disenfranchised groups (see also Saville, Chapter 10, this volume, for a critique of current priorities).

However, such debates *are* highly relevant for museum archaeologists, and impinge directly on apparently more pressing matters such as curating archaeological archives and recording treasure hunters' finds. The reason for this is that at the core of such debates lies a transformation of the relationship between museums and the public. No one working practically in museums can afford to ignore this transformation because it has profound implications for museum practice, particularly at a time when museums are urged to make themselves more accessible to a wider range of visitors in order to demonstrate to local taxpayers accountability and value for money (e.g. Audit Commission, 1991). This is particularly germane for museum archaeology, because it has been evident for some time that, while the potential public interest in the early past as a subject is large (as witnessed by high viewing figures for television programmes such as *Time Team*, and widespread participation in metal detecting), traditional museum displays of archaeology are generally not particularly attractive to the public (Merriman, 1991: 121). Museum archaeologists can experience difficulties in achieving a high public profile for their subject and collections. Possibly because of this, recent years have seen a gradual erosion of archaeological posts in museum services across the country as other areas take precedence. The aim of the contributors to this volume is, at least in part, to 'reconnect' the representation of early archaeological histories in museums with some of the wider issues in representation debated in archaeology and museology, to their mutual benefit. The argument is that a greater level of critical awareness of what museum archaeologists are doing, or trying to do, and a willingness to imagine new ways of doing things, will stimulate a greater level of public service and involvement, in ways that are also intellectually acceptable. I outline below some of the main issues pertinent to the argument, beginning with the implications of the theoretical challenges to museum histories.

The multi-faceted past

Analysis of museum cultures has tended to show that museums have historically produced authoritative versions of the past that have — intentionally or not — served to educate the public in the ways of the dominant culture. The critique of this consensual view of the past has challenged it with alternative, often competing, perspectives, such as those provided by socialist, feminist, or anti-colonialist readings. There is general agreement amongst the contributors to this book that space needs to be made for these other viewpoints in recognition of the partiality of previous accounts. This is an issue that can generate some disquiet (e.g. Saville, Chapter 10, this volume; Yoffee and Sherratt, 1993): it could imply a descent into relativism whereby any competing version of the past has equal rights with any other. The old curatorial certainties could be in danger of being replaced by a pusillanimous, politically correct present where interpretive anarchy reigns.

However, one of the refreshing conclusions to emerge from this book is that this descent into relativism is not a necessary consequence of the recognition that there is more than one 'past' that can be portrayed (see also Buckley, 1996; Thomas, 1995). It is noteworthy that the word 'honest' appears in three separate contributions to this volume as a way of describing some of the new interpretive approaches. This suggests that we are becoming a little more confident in admitting that contingency, bias and gaps in our knowledge are inherent in the construction of early pasts, and that these pasts are always constructed in the service of the present. An acceptance of these circumstances need not, however, mean that anything goes. Whereas previously self-reflexiveness and critique seemed to be aimed at constructing a fairer, more accurate, truthful or error-free version of the past, it is now gradually becoming recognized (Sørensen, Chapter 7) that 'history is not fair' and that the aim of a 'truthful' picture of the past is unattainable. Just as it is not possible to gain a 'true' picture of current issues (your viewpoint will depend on your own perspective which may be coloured by your ethnicity, nationality, gender, age, education, class and so on), neither is it possible to claim total accuracy for any interpretation of the past. Exclusion of certain perspectives, for example, on grounds of limitations on display space makes this inevitable. Instead, it is now suggested that the past has a partial objectivity in that we can agree on certain core facts, but that these can be interpreted from a number of different perspectives, a position which Thomas (1995: 353) describes as 'perspectivism'. The rules of normal academic discourse (such as coherence of argument and correspondence with the evidence) can still be invoked to winnow out arguments that are entirely spurious, or if they are incorporated, it can be made clear that they have to be evaluated against different, non-scientific belief systems. Thus, it is quite possible to

make early museum histories that emphasize, for example, cultural diversity or gender, if they can be shown to have a reasonable basis in evidence (or if their absence tells us something about the partiality of the archaeological record; see Sørensen, Chapter 7), while at the same time rejecting, or placing in a different category, others which do not meet these criteria.

For some (such as Beard and Henderson, Chapter 3), the recognition that we can tell different stories is essentially an exercise in self-reflexiveness, with the well-informed curator taking on a variety of viewpoints to widen the interpretive scope. In some cases, this can mean examining whole periods in new ways, such as seeing Roman Britain from a colonialist perspective, or one that acknowledges the cultural diversity of the population, including the presence of Africans (Agyeman, 1993). Lucy and Herring (Chapter 4) show, in relation to the use of the Anglo-Saxon past, that there is a need for critical analyses of the ways in which museum displays have been used to support certain political views about the ethnic composition of Great Britain. The long shelf-life of museum displays (usually twenty years or more) can lead them to preserve long-discarded academic views in a highly public arena. While much critical analysis has been undertaken of the origins of museums in general (Bennett, 1995; Hooper-Greenhill, 1992), relatively little analysis has been undertaken of specific displays relating to early periods, either historically or in their contemporary context. Analysis of this relatively unexplored field might, for example, reveal the political uses to which the displays of certain periods have been put, or why certain periods are excluded or underplayed in the National Curriculum.

Similarly, very little work of a critical and analytical nature has been undertaken on the mechanisms and technologies of museum display beyond the formal evaluation of the effectiveness of (primarily) science exhibits. Critics have tended to analyse museums as if they were texts, with great emphasis placed on the words written on the panels and labels, and relatively little attention given to other display technologies (particularly those of a visual nature), and to the fact that a visit consists of physical movement in a space, quite unlike reading the chapters of a book.

Moser, in her historical analysis of the development of dioramas (Chapter 5), makes the point that despite claims of scientific accuracy, these important means of museum representation remain intellectually conservative and draw on a restricted range of stereotypical elements (a point also made with regard to reconstruction paintings in Moser and Gamble, 1997). In a complementary study, James examines the contemporary use of reconstruction images, noting how their very fixedness and their apparent transparency ('this is the past as it was') can create

difficulties at a time when ideas about interpretation suggest fluidity and multiplicity of viewpoints. In another point which can be applied more widely to other modes of representation, he also notes how reconstructions may deliberately *not* be used, not so much as a response to the theoretical difficulties attendant on their use as noted above, but more prosaically because they are associated with children's books and hence are unscholarly. In this way, the non-use of interpretive devices can be a means of limiting access to knowledge of the past to those already initiated into its mysteries.

For others, such as Pearce (Chapter 1), the opening up of museums to a variety of perspectives can mean inviting in voices that are not from a traditional curatorial background to bring their own particular visions to 'invigorate the collections'. She outlines a number of initiatives where artists have constructed museum displays in order to bring an entirely new way of viewing museum collections, one beyond the traditional cultural-historical sequence. She also pursues her previous point about the artistic nature of museum display, by noting artistic installations that use museum-like modes of representation. If we do indeed begin to see museum displays as installations with the relationship between past and present as their subject, space can begin to open up for greater imaginative use of the medium, including participation by individuals other than curators.

Others, still, might extend this participation to allowing visitors themselves to contribute to interpretive programmes, in a manner that has become familiar in certain initiatives such as Glasgow's Open Museum (Museum Practice, 1996) or the 'talkback kiosk' at the Field Museum in Chicago (Simpson, 1996: 44). To whatever extent it is taken, the acknowledgement that there is more than one story to tell represents a fundamental transformation in the relationship between the museum and the public.

The museum and the public

Recent critical writings have implied a transformation of this relationship on several different levels. On one level, there is a general feeling that museum representation can only be understood sufficiently if the consumption of museum displays by visitors is incorporated in both theoretical and practical terms. This has been accompanied by a growing recognition of the importance of formally evaluating museum interpretive techniques to achieve adequate communication. As Sørensen (Chapter 7) reminds us, meaning is produced through the interaction between the display, the curatorial interpretation and what the visitor brings to the transaction. While evidence has been around for some time that visitors often bring

preconceptions (and go away with conclusions) quite different from those envisaged by the creators of the display (e.g. McManus, 1987, 1989), only recently has this information begun to have an impact on the preparation of interpretive programmes for early periods.

This has resulted in a recognition that much more research needs to be undertaken on the preconceptions that visitors bring to museums and to certain subjects before planning exhibitions (Lucy and Herring, Chapter 4). Wood and Cotton (Chapter 2) have shown, for example, how fundamental an understanding of non-specialist knowledge of prehistory has been in planning effective displays. Here it is not a case, as some would have it, of museums pandering to the lowest common denominator or 'giving the public what they want'. Rather, it is a case of museum curators taking account of existing public preconceptions and biases in order to plan how to communicate most effectively. In the case of the Museum of London's prehistoric gallery, for example, the fact that the majority of visitors associated prehistory with dinosaurs or other stereotypes such as 'cavemen' led the curators to begin the gallery with pictures of these erroneous preconceptions, and with a questioning approach which invited visitors to think about how accurate their initial ideas had been (Cotton and Wood, 1996).

This acceptance of the importance of undertaking evaluation of the public's preconceptions, likes, dislikes and patterns of consumption is symptomatic of a general shift in museology towards a more people-centred approach to early histories rather than one which is dominated by curatorial imperatives. Museum visitors are now being invited to move from being passive recipients of a single version of the past to more active participation in a process of dialogue or negotiation. Potentially, this offers a most exciting way forward for the display of early histories.

Its implications are extensive. One is that the subjects chosen for museum exhibitions, instead of being dictated purely by didactic curatorial concerns, can now be informed by the interests of the public as revealed by research on visitors and non-visitors. Again, this does not represent the much-feared 'dumbing down' of museum communication, but instead implies that museum archaeologists might have to work a little harder to present their subject matter in ways that actually interest potential visitors. Here, a departure from the traditional cultural-historical approach of much archaeological display might be fruitful, and attempts made to link archaeological evidence to wider contemporary debates on, for example, the environment, sustainability and population.

Another transformation is in the way in which visitors are now conceived as being involved in the interpretive process itself. This too can take many forms. Hands-on activities, for example, are often suggested as

a good way of involving the public in the process of interpretation. However, as Ucko (1996: x) has argued, there has been little evidence to show that this is an effective method of learning, or to show what visitors learn from a hands-on experience as opposed to any other type of inter- pretation. Owen's review (Chapter 9) of archaeological approaches to hands-on activities leads to the conclusion that their potential remains unfulfilled. Such activities tend to concern themselves either with archaeology as a technical process (sorting shards, reconstructing a pot) or with inviting visitors to confirm historical narratives by touching the exhibits, an act that has been seen (e.g. Meltzer, 1981) as a sanctification of the extant order. Owen notes that hitherto the active involvement of the visitor through hands-on activities has not been used to stimulate the visitor to think more actively or creatively about the past, although this could be a fundamental future role for such approaches. Here, as she notes, the hitherto unrealized plans of the Museum of London to develop an interpretive centre dealing with archaeological and histor- ical principles offers exciting possibilities. Just as a science centre attempts to explain scientific principles as a complement to the narra- tive displays of the history of science and technology, so too could an archaeological discovery centre, building on the lessons of the ARC in York and the Natural History Centre at Liverpool Museum, explore not just the process of doing archaeology as a technical exercise, but also the interpretation and evaluation of historical evidence itself, with the visitor undertaking much of this work, assisted by explainers or inter- preters. It is thus possible to envisage museums breaking free of the constraints of purely culture-historical glass-case and panel displays to promote more imaginative uses of collections by the public, drawing on the discovery centre concept that is already taking hold, and in particular by capitalizing on the current interest in working with metal detectorists on recording their finds.

As Pearce (Chapter 1) recognizes, another implication of the incor- poration of the visitor more centrally into museum practice is that cur- atorial power has to be shared more widely. James (Chapter 6) notes, in relation to reconstruction paintings, that this power can often be difficult to give up, linked as it is with peer group esteem and credibility. This need not, however, be something that is to be feared. Those who have shared their power in other museum fields (Ames, 1990; MacDonald, 1997) have found it both a liberating experience and one which greatly enriches the museum enterprise. It does not mean, again, that anything goes and that the curator has to find space for a multiplicity of competing voices. It rather means that curators must be open to the viewpoints and inputs of others, and see their role as being no longer purely that of an authority figure or a fount of all knowledge. The future curatorial role

might be compared more fruitfully with that of an editor, or even that of a public service broadcaster, whose aim is to allow space for a variety of perspectives on a subject but with the critical facility to separate out the credible from the spurious.

At a deeper level, the question of the overall aim of museum presentation necessarily arises as a result of the process of critical introspection. Museums have always been seen as places of education, where learning takes place and new knowledge and ideas are absorbed. Museum educators, as well as evaluators, have discussed for some time different modes of learning in museums, from the didactic to the affective. Yet, as Piccini's paper (Chapter 8) shows, it is clear that museums and historic sites can also be analysed as providing quite a different form of experience for visitors – as 'theatres' in which present social relationships are played out. As Kavanagh (1996) has pointed out, Annis's (1987) analysis of museums as symbolic spaces provides a useful conceptualization of this phenomenon. He argues that museums provide 'cognitive spaces' (the exhibitions and the ideas in them), but that they also provide 'social spaces' in which visitors interact, and 'dream spaces' in which the content of the exhibition sparks off highly personal reactions which help visitors make sense of the world. While the 'cognitive spaces' of the museum are the element most usually explored in analyses, and the formal study of the museum visit as a social occasion has begun to be explored in some detail (e.g. Falk and Dierking, 1992), the interaction of the two in producing individual feelings, memories and identities has only just begun to be analysed. This potentially offers a whole new way of looking at museums, and one which will have fundamental implications for our understanding of the relationship between museums and the public.

Conclusion

The distinguishing feature of the contributions to this book is that they are all, in some way or another, attempting to respond to the challenges of the 'post-' critique (post-structuralist, postmodernist, post-processual) in museums and archaeology in a way which seeks to maintain a positive role for museums as arenas for the discussion of the past. Areas of common ground include the recognition that an understanding of visitors' consumption of museums is fundamental to an understanding of the interpretive process, that making histories in museums is fundamentally about control of power and knowledge, that study of the histories of museum practice is essential for understanding the partiality of current approaches, and, above all, that practical ways have to be found for responding to some of the theoretical issues raised.

Bibliography

Agyeman, J. (1993) 'Alien species', *Museums Journal*, 93 (12), 22–3.

Ames, M.M. (1990) 'Cultural empowerment and museums: opening up anthropology through collaboration', in Pearce, S. (ed.), *Objects of Knowledge*. New Research in Museum Studies, vol. 1. London: Athlone Press, 158–73.

Annis, S. (1987) 'The museum as a staging ground for symbolic action', *Museum*, 151, 168–71.

Audit Commission (1991) *The Road to Wigan Pier? Managing Local Authority Museums and Art Galleries*. London: HMSO.

Bennett, T. (1995) *The Birth of the Museum: History, Theory, Politics*. London: Routledge.

Buckley, A.D. (1996) 'Why not invent the past we display in museums?' in Kavanagh, G. (ed.), *Making Histories in Museums*. London: Leicester University Press, 42–53.

Cotton, J.F. and Wood, B. (1996) 'Retrieving prehistories at the Museum of London: a gallery case-study', in McManus, P. (ed.), *Archaeological Displays and the Public: Museology and Interpretation*. London: Institute of Archaeology, University College, 53–71.

Denford, G.T. (ed.) (1997) *Representing Archaeology in Museums. The Museum Archaeologist* 22. Winchester: Society of Museum Archaeologists.

Falk, J.H. and Dierking, L.D. (1992) *The Museum Experience*. Washington, DC: Whalesback Books.

Gathercole, P. and Lowenthal, D. (eds) (1990) *The Politics of the Past*. London: Unwin Hyman.

Hodder, I. (1991) 'Interpretive archaeology and its role', *American Antiquity*, 56, 7–18.

Hooper-Greenhill, E. (1992) *Museums and the Shaping of Knowledge*. London: Routledge.

Jones, S. and Pay, S. (1990) 'The legacy of Eve', in Gathercole, P. and Lowenthal, D. (eds), *The Politics of the Past*. London, Unwin Hyman, 160–171.

Karp, I. and Lavine, S.D. (1991) *Exhibiting Cultures: The Poetics and Politics of Museum Display*. Washington, DC: Smithsonian Institution Press.

Kavanagh, G. (1996) 'Making histories, making memories', in Kavanagh, G. (ed.), *Making Histories in Museums*. London: Leicester University Press, 1–14.

Leone, M.P., Potter, P.B. and Shackel, P. (1987) 'Towards a critical archaeology', *Current Anthropology*, 28 (3), 283–302.

Lumley, R. (ed.) (1988) *The Museum Time Machine: Putting Culture on Display*. London: Routledge.

MacDonald, S. (1997) 'Interpreting city history', in Kavanagh, G. and Frostick, E. (eds), *Making City Histories in Museums*. London: Leicester University Press, 58–79.

Macdonald, S. and Fyfe, G. (eds) (1996) *Theorizing Museums: Representing Identity and Diversity in a Changing World*. Oxford: Blackwell.

10

McManus, P. (1987) 'It's the company you keep . . . The social determinants of learning-related behaviour in a science museum', *International Journal of Museum Management and Curatorship,* 6, 263–70.

McManus, P. (1989) 'What people say and how they think in a science museum', in Uzzell, D. (ed.), *Heritage Interpretation.* vol. 2, *The Visitor Experience.* London: Belhaven Press, 156–65.

McManus, P. (1996) *Archaeological Displays and the Public: Museology and Interpretation.* London: Institute of Archaeology, University College.

Meltzer, D. J. (1981) 'Ideology and material culture', in Gould, R. J. and Schiffer, M.B. (eds), *Modern Material Culture: The Archaeology of Us.* New York: Academic Press, 113–25.

Merriman, N. (1991) *Beyond The Glass Case: The Past, the Heritage and the Public in Britain.* Leicester: Leicester University Press.

Moore, J. and Scott, E. (eds) (1997) *Invisible People and Processes. Writing Gender and Childhood into European Archaeology.* Leicester: Leicester University Press.

Moser, S., and Gamble, C. (1997) 'Evolutionary images: the iconic vocabulary for representing human antiquity', in Molyneaux, B. (ed.), *The Cultural Life of Images: Visual Representation in Archaeology.* London: Routledge, 185–212.

Museum Practice (1996) 'The Open Museum', *Museum Practice,* 1 (3), 60–3.

Pearce, S. (1986) 'Objects as signs and symbols', *Museums Journal,* 86 (3), 131–5.

Pearce, S. (1987) 'Objects in structures', *Museums Journal,* 86 (4), 178–81.

Pearce, S. (1990) *Archaeological Curatorship.* Leicester: Leicester University Press.

Shanks, M. and Tilley, C. (1987) *Re-constructing Archaeology: Theory and Practice.* Cambridge: Cambridge University Press.

Simpson, M. (1996) *Making Representations.* London: Routledge.

Stone, P.G. and MacKenzie, R. (eds) (1990) *The Excluded Past: Archaeology in Education.* London: Unwin Hyman.

Stone, P.G. and Molyneaux, B.L. (eds) (1994) *The Presented Past: Heritage, Museums and Education.* London: Routledge.

Thomas, J. (1995) 'Where are we now? Archaeological theory in the 1990s', in Ucko, P. J. (ed.), *Theory in Archaeology: A World Perspective.* London: Routledge, 343–62.

Ucko, P. J. (1996) 'Foreword', in McManus, P. (ed.), *Archaeological Displays and the Public: Museology and Interpretation.* London: Institute of Archaeology, University College, ix–xi.

Vergo, P. (ed.) (1989) *The New Museology.* London: Reaktion Books.

Yoffee, N. and Sherratt, A. (eds) (1993) *Archaeological Theory: Who Sets the Agenda?* Cambridge: Cambridge University Press.

1

Presenting Archaeology

Susan M. Pearce

Introduction

In the University Museum, Vancouver, there is an exhibition, custom-made by an independent artist, which features five figures set in front of an eye-catching run of windows. The figures are in human form. They are of ceramic, each created by assembling miscellaneous and fragmentary shards into a holistic shape. The assemblage is, of course, a metaphor for the museum; and the human form is, perhaps, a symbol of the informing presence of the collector, or the curator, or the viewing visitor, or all of these, including the artist. Everything which these ceramic figures represent is the substance of what I want to discuss in this chapter.

Excavating

The genealogy of archaeology is now beginning to be written (see, for example, Hides, 1997), and difficult though much of its detail is, the main lineaments are emerging. The idea of 'archaeology' and the techniques which produce it in practice are part of an episteme which emerged, very broadly, in the decades around 1700, together with scientific rationalism: both were seen to depend upon material evidence and reasonable deduction, and both were predicated upon the effort to create narratives of time, space and difference which had a bearing on the notion of the essential self whose existence could be fixed within the intersecting configurations they constructed. The self, the consciousness of each of us of ourselves as individuals, is to be seen not as a 'given', outside the field of history, but as itself part of the genealogy, as a precipitate of the surrounding discourses, here including archaeology as a method of creating a link between individual and past. The self is a site of conflict, not an external upon which conflicts play, and archaeology as the discourse which produces an intelligible ancient past – a narrative of origins – is one of the players. Hence its successive appearances as supportive of Anglican ideals, Biblical Christianity, 'blood and folk' nationalism, and

(today) cultural relativism and uninvasive parallel development, and the successive visions of selfhood which these narratives engender.

The practice of archaeology is, therefore, historically fixed in the complex discourses of the eighteenth century (and like other contemporary discourses from the mid-century onwards it has its Gothic side, a story which needs telling), and of the Romantic at the end of the century, the repercussions of which we are still sorting out. Its power involvements are those of contemporary capitalism, changing with each generation, but gathering the momentum which created the great northern European middle class.

Within the same complex lies the birth of the public museum (Hooper-Greenhill, 1992; Bennett, 1994). We can now understand how the museum as institution was part and parcel of the same episteme featuring the rational individual with his assured place in the scheme of things, rendered intelligible by language referring to apparently external material evidence for its verification. This has the effect of taking special authority away from the museum, or any other institution, and replacing it with a rhetorical mode in which each museum is charged with the necessity to explain itself and make the public case for the value of whatever it thinks it has to offer.

For museums, the basis of authority is the power to arbitrate upon material culture, to decide what is 'valuable' or 'interesting' and what is not, to endeavour to add the former to the museum's holdings, and to construct it into meaningful patterns, which, of course, reinforce the estimable quality of the original decisions. We should not forget that 'decide' carries the sense of 'to cut out, or to cut away': the good is top-sliced and the dross finds its own level. Overall, therefore, we can perceive a cycle of / material meaning / museum as institution / power / popular respect / power / ability to define material meaning / which is self-fulfilling, and which draws its strengths from cultural, as opposed to natural, traits.

The notion of the self produced as rational, operative within a constructed field of progressive time and differentiated 'natural' spatial biological order, and the museum as its institutional *alter ego*, are the starting points for this analysis. Historically, both are tied to the eighteenth century, and so, inevitably, contribute to how we of the late twentieth century can understand them. The approach taken here is to posit a series of metaphorically related circumstances, each of which involves the same pieces of material culture (Figure 1.1). These are the original making community, crucial but beyond the scope of discussion here; the differential survival of its goods through time; the collection of its 'archaeological' remains; the practices of curatorship within the museum; aspects of contemporary museum display; and what the visitor sees. Each of the last four will engage us in turn.

Indigenous Community	Survival	Collectors	Museum	Contemporary Museum	Contemporary Visitors
Making and using material culture, with all its own complexities and ironies	Differential survival of material culture which becomes the indigenous past	Pursuing archaeological methods deemed appropriate; 'colonial' relationship with past indigenous community	Receives donations. Collected material undergoes curatorial accession, care, display	Self-reflecting parodying; ironic juxtapositions; post-colonial irony	See a mix of orthodox displays and contemporary spurts of deconstruction

Figure 1.1 A diagram representing the metaphorical relationships of the process of material culture from its own society to that of the museum-visiting public.

Episodes of occupation

'Collecting' is here used as an omnibus term to embrace all the practices through which archaeological material has been accumulated over the past two centuries or so. It includes excavation, fieldwork, private purchase and exchange, metal detecting, and any other method through which objects of the ancient past are accumulated, inside and outside museums.

For some collectors, happiness is a feeling of harmony between their private valuations of what they have gathered together and public perceptions of value, represented by exactly the cycle of institutional power which we have just outlined (although for other collectors, it is tension which provides the thrills). A range of surveys and studies (Pearce, 1995: 159–170) have shown how private collectors regard their material as extensions, or even completions, of themselves. Within their inner lives they see their objects possessed of transforming power which can re-present themselves to themselves, and to the outer world – collections are a way of living with chaos and turning it into sense. The capacity of objects to 'take' presentation thus becomes a field for strategies through which the notion of the individual is presented.

Figure 1.2 represents this process in schematic form by suggesting the major dimensions within which each individual life is seen to be held in

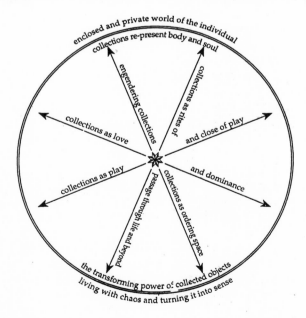

Figure 1.2 Scheme setting out the parameters of the collecting process in relation to the individual collector.

the prevailing episteme. Collections encapsulate memories and reconnect us to the momentous moments in our lives: travel, wedding, recovery from illness. For professional archaeologists the completion and publication of projects themselves create the passing phases of lives with their accompanying appointments and advancements. Collections order space, both literally in our homes and work places, and figuratively in our minds, through the spatial and intellectual patterns which they assume. We love our material, but sometimes 'the collection takes over' as collectors say, and dominates our lives. We can play about with our own material as we can with few things in our lives, and decide for ourselves how to create closures. We can work through our notions of gender and use our collections as a way of creating ourselves more as we would wish to be. Above all, collectors can hope to give, or bequeath, their collections to accredited museums, and so achieve a material immortality which is denied to humans. This, of course, is only possible if the material is deemed by curators as being of 'museum quality', and so arises the importance of the coincidence of the public and private systems.

The massed weight of archaeological storage boxes demonstrates daily the success of archaeological investigators in convincing museum staff of their claims for institutional immortality; indeed the archaeological curators themselves are frequently deeply complicit in the process, by contributing largely to the mass themselves. But the other parameters play as profoundly upon archaeological collecting, whether by excavation, fieldwork, metal detecting, or any combination of these, ancient and modern. Archaeologists love their work; nobody 'does' archaeology for the money, but for the satisfactions which the job brings. After a while, however, the collected material can come to exercise an unpleasant dominance, experienced most powerfully, perhaps, through a garage packed to the eaves with unpublished material. Similarly, gender has had, and still has, a formative role to play. The differential kinds of archaeological work carried out by women and men, linked as it is with the power structures of opportunity and perception, has begun to attract serious attention through the work, among others, of Deirdre O'Sullivan, Colin Dobinson and Roberta Gilchrist in Britain, who have analysed issues such as the gender balance in archaeology professorships in British universities.

The capacity of archaeological collections to order time requires extended treatment, but the simple point is clear enough. It is through the temporal ordering of archaeological collections that we can gain a conceptual grip on the sequence of time passing at all; and probably, more fundamentally, upon the idea that time has a sequence in which things pass, indeed that time, in our usual sense of the word, exists at all. This, it seems to me, is one of the typical elements in European culture of the

long term, of which archaeology as a study is one of the characteristic expressions (Pearce, 1995). From the angle of individual archaeologists, the study and its product enable them to fix themselves tangibly in a direct relationship to past generations of humans who are seen to recede to the beginning of the hominid species, and to understand how culture has changed to make them what they are.

Closely linked with this is the perceived capacity of archaeological material to structure space. The boxes in the garage, guilt-making though they may be, are not randomly piled (or, at any rate, it is an act of charity to suppose so). They are organized in sets or sequences which have to do partly with the passage of time, and partly with the perceived disposition of space, which will have to do with the relationship of one excavation trench to another, one grid square to another, one area of landscape to another, and so on. The very idea that to presume so is a charity shows how crucial this kind of organization is to the practice of the discipline as a whole, and what is true of personal space is even more true of institutional space, that is those museum store rooms, where sometimes immaculate organization shines like a good deed in a naughty world, and sometimes does not.

What is true of full-to-capacity racking with its marked-up boxes is also true of the boxes' contents, the ceramics, lithics, metals and other goods which together form interweaving patterns of typological, spatial connections more complex than any interlace ornament ever was. The total collected archaeological holdings, public and private, form indeed an intricate but literal system of Chinese boxes through which we understand past geo-social relationships. There is no chink between the physical and the intellectual system, because to conceive the intellectual we must see and handle the physical, but to understand the physical we must bring some intellectual concepts to bear – and these have been shaped by previous physical handling, and so the dynamic progresses.

Underlying the creation of understandings in both time and space is that most fundamental aspect of collecting, the notion of collections as play and close of play. It is archaeologists who decide – or do not decide – when the Neolithic ends and the Bronze Age begins, and it is significant that, in spite of much dissatisfaction, the mid-nineteenth-century terminology derived from the crudest overview of material distinctions still remains the only one in generally accepted usage. It is archaeologists who decide – or do not decide – that the Roman Empire ended, and that the subsequent 'period' (as Angus Wilson, once on the staff of the British Museum, tartly remarks towards the end of Chapter 4 of *Anglo-Saxon Attitudes* 'like a lot of women') shall be called the Dark Ages, or the Migration Period, or the Post-Roman phase, or whatever.

Once material has been received into the museum, it has achieved the

official *imprimatur* of value and significance conveyed by the institution and its curatorial complement. It, and by inference its collectors, have joined the charmed circle of power and authority, and henceforth it will be treated in ways which make its meaning manifest, meaning that which is thought of as 'inherent' and 'natural' but which is, in fact, a matter for deliberation and contrivance on the part of the curators.

Carry on curating

Once the archaeological collection – achieved by whatever method – has arrived in the museum, curatorial decisions have to be made about it, some obvious and others more subtly bound by the past. The key act of power in which the curatorial self is realized is that of classifying. The epistemological framework of similarity and difference is realized by the practice of labelling. The act of naming and writing down by the museum staff is the factor which determines the object's place in the collected silence of reference, and this shows that the label has more importance than the object itself: it has moved from its own reality to the constructed reality of 'the archaeological past'. The reaction of the label is therefore the site of conflict and choice in which the biographies of the discipline – archaeology – of the museum, and of the individual curator are all involved.

How this can operate may be shown by one example from Exeter City Museum. The earliest record is the old Antiquities Register, in which miscellaneous material was entered between about 1868 and 1886, and given a running accession number. Numbers 4145 to 4147, two bronze spearheads and a flat bronze plate, and 4190, a sword recorded separately, refer to the Worth (Washfield) weapon hoard, which is a crucial find for the interpretation of the later Middle Bronze Age, while 4148 refers to a palstave, known from other records to be the sole survivor of a different hoard, which was apparently found fairly near, but not with, the Worth find. Other pieces of information are added in the margin, which tell us that the three weapons were found 'in an earthwork' near the River Exe, and that the palstave was presented by a J. Worth Esq.

Nobody can now be certain of the precise composition of the two (or more) finds involved, but the find(s) have played in a range of scenarios of the past which variously highlight the typological positions of the pieces, the nature of the find as a weapon hoard, its relationship to the river valley and to the 'earthwork', and to early antiquarian activity in Devon. The whole forms a part of what one might call the contemporary sociology of the Bronze Age, itself now emerging as an important area of study, and shows how Bronze Age archaeologists, rather than archaeology, are produced (Morris, 1996).

Once a specimen is fitted with an attached label, a situation which the contemporary curator frequently (usually?) encounters, more insidious influences come into play. The label, especially the handwritten label, is the most intimate link between the object and the curator. It will remain physically tied to the piece as long as they both may live, and it bears the individual, and easily recognized, mark of its creator. Handwritten labels easily attain relic status, the museum's equivalent of the nail clippings or locks of hair through which past masters in other sacred institutions are revered, and recognized as still living amongst us. Such labels become museum material in their own right, preserved as carefully as other specimens, ostensibly for the information which they contain, but in fact equally for the contact with the great men of the past which they offer and the sense of the chain of living continuity which they embody. Such things are important in the construction of authority and bring consolation, comfort and support to each latter-day generation of curators.

One early, and typical, label is preserved on the slide the Salisbury and South Wilts Museums used to issue, showing two of their prehistoric shale cups. The handwritten label reads:

Shale Cups, Wiltshire
Early Bronze Age
See W.A.M. xliv lll
Edwards Collection

The text is interesting, suggesting as it does a uniqueness in time and place, which leads to assumptions that culture is a static set of institutions and beliefs that are produced by tradition rather than historical process. As Ravenhill has noted (1988:5):

Throughout colonial museography there was this type of assumption that the attribution of an object to the correct indigenous category constituted in itself an explanation. The enterprise of categorisation ultimately produced nice, neat lists of basic object types for ... and restricted to ... each ethnic group. This packaging of material culture on an ethnic basis served in turn to reinforce the 'reality' of colonially reified ethnicity. For material culture studies, the question of style became simply a matter of ethnic traits.

The objects are wrenched out of their own social context, in which they would have made good sense, and re-contextualized within the English mid-nineteenth-century middle class. The label trivializes the objects by its cool, anecdotal tone. Irony, superior and well-bred, is directed towards the specimen and its people. The object and its original owners are distanced away from 'us' to become 'them'. As Julian Walker has put it, drawing on his own experience of galleries: 'So too do the specimen

boxes with the glass tops, the display pins, the use of filler, and the accumulations of dust in the case corners' (personal communication).

Together, the binary star of object and label sit on display, and together they make meaning. To the viewer, the label is not the lesser of the partnership. If the label tells us that this is the rifle with which Kennedy was shot, then it is telling us to invest our attention span and ask questions such as: The only rifle? Who held it? If the label simply describes the same gun as a particular make of rifle, then it will not detain most of us. There clearly is a sense in which the object comes to illustrate the label and not the other way round, just as the history of curatorship is written in the labels which practitioners have left behind them. In other words, the label, as well as the specimen, has the status of museum artefact.

What is particularly true of labels is also true of the other elements in physical curation and display. Objects were often tied onto their display boards by cross-over strings threaded through holes in the boards, as the Wiltshire cups were, suggesting capture and constraint, followed by exhibition in the worst sense with its obvious sadomasochist connotations. Frequently, now, the objects have been detached, but the boards still survive, like so many Turin Shrouds, with their ghostly presences visible. The boards, plinths, case manufacture, internal case layout, graphics, and floor layout of cases all contribute to the making of knowledge and its protective control. The museum history of an object chronicles the construction of knowledge in which it has played a part, and the old labels, display boards, plinths and graphics are the fossils of the history of meanings. Meaning and understanding become a conglomeration of assorted life histories – of the collector, of the curator, and of the object specimen itself.

Laying-out has a double meaning, and the life histories are those of the dead, an image which has been seized by critics and artists, whose notions we will soon explore. The lesson learned by the Spanish museum community through the experience of the Natural History Museum at Banyoles, whose display of a 104-year-old stuffed southern African caused a threatened African boycott of the Barcelona Olympics, is not just political, immensely significant although this is; it has a deeper resonance. Theodore Adorno (1967) described museums as 'the family sepulchres of works of art'. Robert Harrison (1977: 140) sees the museum as 'its life, naturally ghost-like, meant for those more comfortable with ghosts, frightened by working life but not by the past'. David Mellor, briefly Secretary of State responsible for arts, museums and heritage, finds museums existing as 'twilight zones' whose still-life (a regular euphemism for 'dead') displays combine boredom with terror (1989: 16). The characteristic smell of the archaeology store – compounded of embalmed oddments, massed ceramic and preserved wood, faintly spicy and faintly dusty – is the sweet stench of mummification. Curators become cemetery-haunting necro-

philiacs compelled by a dubious romantic impulse to arrested time and decay.

Some skeuomorphs

There is now a 'museum scene', that is the desire (or fashion?) to create ironic comment upon the objects and the conventional way in which they are displayed by bringing some external influence to bear upon the exhibitions. Most of these outsiders have been artists, who view the collected materials as raw material for their own installations; some of the material has turned out to be very raw indeed. These artists are not old-speak iconoclasts, who think all museums should be burnt as the best way of coping with the corpses of dead yesterday; they are *bricoleurs* who are curious about the categories of received knowledge – which museums show more clearly perhaps than any other institution by virtue of the physicality of their holdings and the concrete patterns into which they can be formed. They are piqued by the displayed complacency and wish to disturb settled corporatist convictions by their own individualist interventions.

The first artist to do this in Britain was Eduardo Paolozzi, whose exhibition, 'Lost Magic Kingdoms' was shown at the Museum of Mankind (the Ethnography Department of the British Museum) in 1987, and subsequently toured nationally. At the invitation of Malcolm McLeod, curator of the department, Paolozzi spent three years investigating the 300,000 objects in store, most of which had never been displayed. His exhibition created assemblages which mimicked typical ethnographic displays by mixing categories of objects which would not normally be combined. As he says, 'for an artist, the thing of little value can be seen as immensely significant' (Malbert, 1995: 26). In McLeod's words the mixture was 'letting in previously neglected or despised areas and breaking down the division between museum objects and life' (*ibid.*: 25).

Paolozzi was ideally cast for this project. He is one of the best collage artists of his generation, and by applying the anarchic, free-spirited methods of collage, he produced a play on the material as material, which for him was the point of the endeavour. For this, he was taken to task by critics who would have preferred a more directly political turn to the exhibition: such critics should have given more care to the exhibit's title. 'Lost Magic Kingdoms' has a nostalgic flavour (did Paolozzi mean 'lost to the original makers and their successors' or did he mean 'lost in the museum's storage vaults' or both?) 'Magic' suggests the conjurer's sleight of hand which produces surprises; and 'Magic Kingdoms' has an unmistakable Disney ring.

Fred Wilson, a black artist based in New York, did take a more directly

political approach. In 1990 he was asked by the Museum for Contemporary Art, Baltimore, to organize an exhibition in the city, and he chose to position it in the Museum of the Maryland Historical Society, an extremely conservative institution. Wilson says that before the project he would never have dreamt of going into the place, but after spending some time there, 'I realized it was not so much the objects as the way the things were placed that really offended me' (Wilson, 1995: 27). The installation that emerged was 'Mining the Museum', which, as Wilson says, could mean digging up something rich, or exploding myths and perceptions, or making it his own.

The opening display set the emotional tone of the exhibition, with its silver globe of 1870 juxtaposed beside empty plastic display mounts labelled 'Plastic display mounts made *ca*. 1960s, maker unknown', and its two sets of pedestals, one set carrying the busts of Maryland's acknowledged heroes and the other empty, where the busts of important Maryland African-Americans should have been but are, of course, unavailable. This was also the exhibition which held the now-famous case with the label 'Metalwork 1793–1880'. It contained a group of elegant silver cups and flagons together with a pair of iron slave shackles. As Wilson says, the objects had a lot to do with each other because life does not operate in neat categories. The case has become one of those gestures which seems obvious, but only after it has been made.

An enterprise which takes the same point, but from an even freer freefall perspective, is the series of experiments at the Pitt Rivers Museum, Oxford, in which, over the past decade, artist Chris Dorsett has been joined by some 100 artists who have brought artistic licence into a creative dialogue with curatorial responsibility. Dorsett believes that, while the results have sometimes been uncomfortable for all concerned, the general consensus is that they have initiated unexpected uses of humour, fantasy, factual information and political debate.

These British and American artistic endeavours belong within a continental context which runs back to the early 1970s. About that time a number of creative artists, including Christian Boltanski, Nikolaus Lang, and Anne and Patrick Poirier, became interested in what is usually translated as 'securing evidence' (*Spurensicherung*), which is a criminological term meaning 'securing circumstantial evidence' and expresses their interest in examining what constitutes evidence and why: the first exhibition of this broad group, which took place at the Kunstverein, Hamburg, in 1974, was called '*Spurensicherung*'. Their criticism of museum dialectic was expressed through a *material* practice of ordering objects just as museums do for their own purposes – the point is important – rather than by discursive writing (Schneider, 1993; I am indebted to this article for information about these events). The artists employ the devices of collection, re-

arrangement and *fictive production* of human activities in the widest sense; *'fictive'* is significant because a strong narrative element infuses their practice.

Around 1974–75 Nikolaus Lang, who himself comes (perhaps significantly) from Oberammergau in Bavaria, labelled and arranged in boxes objects which he had found in one isolated farmstead in the countryside nearby, previously inhabited by an immigrant Swiss family named Götte. He had known the Göttes in his youth as marginal people, all dead by the time he 'excavated' and collected the traces of their lives. In his 'Box from the Götte siblings' he prepared a set of boxes in which were arranged animal bones, tools, old newspapers, household items and books, together with contemporary photographs, maps and geologic diagrams. The inspiration of the work was the nature of display in showcases in natural history and archaeological museums, but the scientific mimicry included fieldwork collection as well as display (Metken, 1977: 108).

In the following years (1976–77) Lang took the idea of fieldwork into the Tuscan countryside, classifying together Paleolithic flint artefacts, earth colours in use since Etruscan times, and contemporary erotic graffiti he found scrawled on the walls of abandoned farm houses. The hallmarks of Lang's approach are searching, observing, recording and re-enacting traces of human activities, as part academic parody, part humanistic self-identification (Lang, 1978).

Christian Boltanski is more interested in depersonalizing individual traces and objects by serializing them into anonymity. As he says:

> At the beginning of January 1973 I wrote to the directors of sixty-two art, history and anthropology museums suggesting they arrange an exhibition which would consist of all the available objects that a given individual has had around him during his lifetime, from handkerchiefs to cupboards. I asked them to concern themselves with such things as classification and labelling, but not with the choice of the person. They were to acquire the objects through an auction or by borrowing them from some one living in their area (it is indeed necessary that the objects, on each occasion, be obtained from the district in which they are being shown). The person concerned should always remain anonymous. Pieces of furniture as well as small objects under glass should be carefully arranged to a certain order, or in some cases a photographic inventory could be compiled. (Boltanski, 1973: no page numbering.)

Boltanski has repeated these inventories of private belongings of anonymous people in a number of other places, including Paris, Oxford, Baden-Baden and Amsterdam (Boltanski, 1991: 26, 36, 88) and, as Schneider (1993: 4) says:

> These individual and yet aseptically anonymous collections of personal

belongings, convey the same kind of eerie feeling one might have in an imagined situation upon walking through the Victoria and Albert Museum's 20th century collection, suddenly being confronted with a showcase containing one's *own* toothbrush, hair slide and dressing gown.

A different approach has been taken by Anne and Patrick Poirier, who have been fascinated by the notion of relics since their work on Italian Roman sites in the 1970s. Instead of making simple copies and casts of ancient material, they deliberately defamiliarized them by altering their scales and adding new elements, thus creating 'reconstructions', like that of Roman Ostia, in terms of their own imaginations. This draws attention to the arbitrariness of archaeological interpretation and reconstruction. As Schneider (1993: 6) puts it:

> By inventing their evidence, the artists point of course to the generally inventive nature of any human-made fabrication, and the fact that such 'inventions' are later re-constructed (or re-invented) according to canons of academic discipline.

All these endeavours, in their different ways, are intended to subvert the museum's dialectic by illuminating it with the beams of parody, irony and deliberate fiction. The archaeology museum is shown to be self-entranced, using 'science' to create narcissistic images in which 'keep off the grass' signs are more in evidence than flowers. Archaeology curators are enthralled by the fetishistic possibilities of the object world and the degree of displaced emotion which it can bear; they gaze voyeuristically at a self-relating past, dazzled into complacency by the ingenious circularity of the organizing method. The artists show that the curatorial narrative is merely one among the many possible.

Museum visitors

And what of the last category in the metaphorical skein, the visiting and viewing public? Cases such as Wilson's incorporation of silver plate and iron slave shackles cannot fail to shock the consciousness of all who see them: their very political crudeness ensures a powerful reaction. Similarly, when Wilson re-displayed the early Twentieth Century gallery in the Seattle Art Museum, he pushed all the art into one corner so that a Matisse bronze was in front of a marble Harp, a tall Giacometti in front of a de Kooning portrait, and so on. This gallery was 'the most disturbing, or the most engaging, to the visitors' (Wilson, 1995: 29). The clustering created a frenetic arrangement in which the individual works seemed to be struggling to breathe. When viewers asked the reason for this, says Wilson, the museum staff explained that this was the way the African and Native American collections were displayed on the floor below. We are

not told what the visitors made of this explanation, but it is clearly indicative that they asked the question.

Such questions are less in evidence through the now considerable history of the Pitt Rivers Museum self-examination. The Pitt Rivers is, of course, (among many other things) a museum of museums in which the displays exhibit a Victorian density within a wholly Victorian building and largely Victorian museum fittings. Moreover, following the typological exhibition regime laid down as a continuing condition in Pitt Rivers' original agreement with Oxford University, the material is arranged according to categories of object, not cultural origin. For the visitor, this in itself creates an unexpected juxtaposition in which European weaving equipment, for example, is displayed in the same case with similar pieces from native Africa. Most visitors lack the necessary *habitus*, in Bourdieu's term, to understand what they are looking at anyway, so the interpolation of modern pieces of commentary probably misfires; the whole thing looks so odd that the modern installations merge into the background without remark.

We clearly need to know more about what visitors make of such exhibitions and interventions. Do they see them as a breath of fresh air, capable of generating new interest and new audiences? Or are they upset and confused, unhappy to find that another supposed security has melted away? Or are they irritated by what they see as pretension on the part of self-loving poseurs, whom they would have no wish to take into their own lives? We do not know the answers to these questions, and shall not until the necessary research projects are put in hand. We may find that, in the public's eye, museums have simply offered special hospitality to yet one more privileged, self-elected group within the elitist club.

Conclusion: remains to be seen

All museum artefacts, whether of stored collections, or of 'traditional' displays, or of free-spirited installations, offer an ambivalent message. Self-reflexive museum efforts, through artists and others, may invigorate collections by showing how much magic and powerful knowledge they hold, and how exhilarating their exhibition can be. Curators are transferring some power to named artists, which is liberating in itself, and may yet take the abandonment of anonymity – one of the easier pieces of mystification – to the point where named designers, researchers and writers can be acknowledged in displays (Arnold, 1995: 39). This would help the review of exhibitions to be more like that of a film or a stage play, and might help to bring museum work into the critical market places.

But, quite possibly, the visitors may reject much of what is done because they find it not powerfully ironic, but superficial, tinny and trivial.

25

Moreover, as the Pitt Rivers installations showed all too well, museums and their material are very powerful, with an immense capacity for the absorption of aliens. After all, to turn the problematic alien into the 'Other' which supports 'Us' is, *par excellence*, the museum's art. When Wilson (1995: 29) created a set of head photographs from objects made at a time when contact between races was new, he realized that they showed a subtle blending of ethnic features, making it visibly apparent that when you depict another, you inevitably end up depicting yourself. Just this, it may turn out, is being accomplished by the artists and their supportive curators. Subversion can only exist by admitting the real presence of the values it endeavours to undermine.

There are other museum enterprises which may help to bring home the nature of collected archaeological material. Honesty in exhibition is one, giving us the kind of sincerity written into the panel texts at the beginning of the Museum of London's new prehistoric gallery (Merriman, 1995). Dorset County Museum blazed a trail here, in its archaeology exhibition of some ten years ago, with its section which began 'There is so much we do not know'. Another approach is that pioneered by the Archaeological Resource Centre (ARC) at York, with its tactile do-it-yourself archaeology exhibition and its (sadly now discontinued) chance to see archaeologists themselves at work behind glass walls like so many exhibits. The ARC's example has been, deservedly, much copied, and if it ever proves possible to bring the ARC physically closer to Coppergate's dark ride, traditional display, exposed site and gift shop (why not?) York will have something close to a full experience, offering the chance to compare pastiche direct engagement with the real thing; equally direct engagement with giftware copies; knowledge displayed, and knowledge in the process of construction.

This chapter is offered as a small attempt to peel away some of the layers of construction upon which archaeological understanding has been manufactured. This is one of a number of similar endeavours developing among the archaeological community. All need to be pursued for the increased self-understanding which they may bring. Archaeological discourse emerges as one of the narratives of the self, whether that narrative is unselfconscious 'old archaeology' or part of contemporary ironic self-reflection, such as the Vancouver ceramic self-figures with which we began.

Bibliography

Adorno, T. (1967) 'Valéry Proust Museum', in *Prisms*. London: Neville Spearman.
Arnold, K. (1995) 'Flights of fancy', *Museums Journal*, 5, 39.

Bennett, T. (1994) *The Birth of the Museum*. London: Routledge.

Boltanski, C. (1973) *Lists of Exhibits Belonging to a Woman of Baden-Baden Followed by an Explanatory Note* (exhibition catalogue). Oxford: Museum of Modern Art.

Boltanski, C. (1991) *Inventar*. Hamburg: Kunsthalle.

Harrison, R. (1977) *Eccentric Spaces*. New York: Avon Books.

Hides, S. (1997) 'The genealogy of material culture and cultural identity', in Pearce, S.M. (ed.), *Experiencing Material Culture in the Western World*. Leicester: Leicester University Press, pp. 11–35.

Hooper-Greenhill, E. (1992) *Museums and the Shaping of Knowledge*. London: Routledge.

Lang, N. (1978) *Farben Zeichen Steine* (exhibition catalogue). Munich: Galerie im Lenbachhaus.

Malbert, R. (1995) 'Artists as curators', *Museums Journal*, 5, 27–9.

Mellor, D. (1989) 'The delirious museum', *Museology*. New York: Aperture Foundation.

Merriman, N. (1995) 'Museum of London's new prehistoric gallery', in Denford, G. (ed.), *Museum Archaeology: What's New? The Museum Archaeologist 21*. Winchester: Society of Museum Archaeologists.

Metken, G. (1977) *Spurensicherung, Kunst als Anthropologie und Selbsterforschung: Fiktive Wissenschaften in dem heutigen Kunst*. Cologne: DuMont.

Morris, M. (1996) 'Towards a sociology of Bronze Age studies in England'. Unpublished PhD thesis, University of Durham.

Pearce, S.M. (1995) *On Collecting: An Investigation into Collecting in the European Tradition*. London: Routledge.

Pearce, S.M. (ed.) (1997) *Experiencing Material Culture in the Western World*. Leicester: Leicester University Press.

Prince, D. and Higgins-McLoughlin, B. (1987) *Museums UK: The Findings of the Museums Data-Base Project*. London: Museums Association.

Ravenhill, P. (1988) 'The passive object and the tribal paradigm: colonial museology in French West Africa.' Paper presented at the Workshop on African Culture at Bellagio, May.

Schneider, A. (1981) 'Kunst und Ethnologie', *Ethno-Logik,* May, 25–32.

Schneider, A. (1993) 'The art diviners', *Anthropology Today*, 9 (2), 3–9.

Wilson, A. (1960) *Anglo-Saxon Attitudes*. Aylesbury: Penguin Books.

Wilson, F. (1995) 'Silent messages', *Museums Journal*, 5, 27–9.

2

The Representation of Prehistory in Museums

Barbara Wood and Jonathan Cotton

It may be useful to begin a chapter such as this with a few definitions. We intend to refer simply to the mounting of traditional gallery displays in Britain, involving the use of combinations of objects with captions, dioramas (and other hardware including computers), together with two-dimensional information in the form of graphic panels incorporating written text and photographs. We take no account of live performers (such as, for example, flintknappers) and exclude visitor centres such as 'Celtica' in Machynlleth or the 'White Cliffs Experience', Dover, and open-air recreations of the Butser or Castell Henllys type. Even so, this still leaves us with a large number of institutions with the potential and the collections to stage displays of prehistory. These range from the nationals, such as the British Museum and the National Museums of Scotland, each with their own approaches and agendas, through the university museums, such as the Ashmolean, with their emphasis on academic teaching collections, to the local authority and independent sector museums with regional, local or site-specific concerns.

In the context of this chapter there are a number of different applications of the term 'representation' which require definition. A museum exhibition is indeed a 'representation' of the past. It is a 'sample', an 'interpretation', a 'creation'. How the museum (or indeed the academic) representation is created and the process behind it is of fundamental significance. The deconstruction of the process of representation is of increasing importance as researchers begin to comprehend and accept how personal or contemporary assumptions and concerns affect our own perceptions of the past and focus our interpretation of material (Hodder, 1986; James, 1993). Furthermore, there is the issue of the general display and interpretation of prehistoric material. In a typical display what would this material 'represent' in terms of the period of prehistory? A static, non-functioning society which can be reduced to a few products from particularly durable technologies which are now spatially, contextually and temporally isolated, or a complex and vibrant community? Can objects

28

alone ever succeed in representing the living people and societies who created them?

Similarly, we should be prepared to consider the kinds of societies which our displays 'represent'. Do museum exhibitions create anything which could be seen as a 'realistic' community? How do we interpret intangibles such as social constructs and cultural life? Do our representations show societies which could have functioned or, as recent studies show, do we create representations which could not have been viable because we do not apply practical reasoning to the technologies (Reynolds, 1979; Pryor, 1996, 1997), family life, gender balance (Claassen, 1992; Lesick, 1997; Wood, 1997a) or creative traditions shown? We also need to recognize that museum exhibitions *are* only interpretations. We choose what to represent and thus perhaps represent as much about ourselves as about the past (e.g. Crowther, 1989; Leone, 1981; Shanks and Tilley, 1992). Ultimately, what kind of representation of the study of prehistory are exhibitions and museums presenting? A clear reflection (or interpretation) of the current state of knowledge and debate, or a confusing assemblage of outdated ideas?

Finally, the term 'prehistory' is used here in the sense coined by Daniel Wilson in 1851 to cover the story of human development before the appearance of writing. In western Asia this occurred as early as 3000 BC, but in Australia, for example, as late as AD 1788 (Renfrew and Bahn, 1996: 12). In northern Europe the campaigns of Caesar in the first century BC mark the close of prehistory, while in mainland Britain – our concern here – it is traditionally taken as the Roman invasion of AD 43. The term itself is therefore a loaded Western one, redolent of colonialism, and takes no account of pre-existing oral traditions however long-lived or well-developed. In the absence of written texts archaeology supplies virtually all of our evidence. Objects, excavations and structural remains all require interpretation and 'representation' to bring them and their makers alive to museum visitors.

Prehistory and archaeology

Of the approximately 2000 museums currently open to visitors, various surveys have shown that over 500 consider themselves to have archaeological collections (e.g. Prince and Higgins-McLoughlin, 1987: 61), though figures specific to prehistory are not available. Within the museum sector, the updating of permanent displays has been afforded a high priority; a postal survey conducted on behalf of the Society of Museum Archaeologists in 1991 indicated that 73 per cent of the 145 responding institutions had refurbished archaeology gallery displays in the decade between 1981 and 1991 (Merriman, 1993, fig. 5). Again, the proportion of prehistoric galleries included in this figure is unknown.

In the museum context 'prehistory' is often, wrongly, regarded as synonymous with 'archaeology' by curators and visitors steeped in social history or fine arts (outside museums it is also often misappropriated by mystics and ley-hunters, amongst others). Many museums unfortunately conflate the two and consequently struggle to include exhibits on the processes of archaeology within displays of prehistory. Archaeological techniques are relevant to almost all galleries and might be included in many areas. Conversely, where sections of prehistoric galleries are devoted to 'hands-on' archaeological processing, tasks are confusingly often under-taken using material from later periods (e.g. at Stoke-on-Trent (Owen, 1996: 212)). While it remains true that both prehistory and archaeology are surrounded by difficult or unfamiliar terminology and require careful staging and interpretation for a mass audience (cf. Channel 4's *Time Team*, who have used the device of a querulous populist 'audience advocate' in the form of actor Tony Robinson), they are quite separate, and a section on 'archaeology' need not be an automatic element of a prehistoric exhibition. Prehistory has the further disadvantage of chronological and conceptual remoteness and, by definition, a lack of calendar dates, events or contemporary personalities (Ötzi, the Alpine Ice Man and Pete Marsh, the British bog body, have no known names!) However, this difficulty can be turned to advantage: freed from the domination of contemporary written documents, displays of prehistory are potentially (and peculiarly) well placed to explore ideas, challenge myths and pre-conceptions, and pose questions – to open up a dialogue with visitors about the way in which evidence is used, inviting them to become par-ticipants rather than passive consumers (Crowther, 1989).

In contrast to the 'civilizing' Romans, the romance of the Middle Ages, the palaces and portraits of the Tudors, and the saleable nostalgia of the twentieth century, prehistoric material is often underused, or so un-imaginatively displayed that it is bypassed. Museums devoted solely to prehistory are few and often site-specific (e.g. the Alexander Keiller Museum, Avebury, and the Museum of the Iron Age, Andover), and, while there are museums which possess extensive prehistoric collections, many do not fully exploit their material (a notable exception is the Bronze Age Gallery at Devizes Museum). A greater number incorporate a certain amount of prehistory as a necessary 'prequel' to a longer story (e.g. Colchester Castle Museum and the Museum of London), although some recent re-displays have chosen to down-play or even deliberately exclude it (e.g. the new Verulamium Museum in St Albans, Canterbury Heritage, and the Croydon 'Lifetimes' gallery which excludes everything prior to c.1820). Similarly, approaches to display vary widely across the sector, reflecting the size and mission of the individual institution, its scale of collections, level of curatorial expertise, gallery space, budget available

and the effect of other day-to-day pressures on curators (e.g. Wood, 1997b). Many local museums strive to present a picture of an area which takes no account of anything other than modern political boundaries. They are fortunate if their patch contains a useful prehistoric site, but it is unlikely that they will find themselves with one of every period. As a result some museums have resorted to replicas or loans to piece together a story (e.g. Richardson, 1988: 19); at the opposite extreme, others have found that while their galleries provide a useful overview, they say little of local relevance.

Current limitations

Despite the fact that the majority of museums with archaeological collections have re-displayed their material since the mid-1970s, and many since the early 1980s (Pearce, 1990: 144, table 10.1; Merriman, 1993, fig 5), they have all too rarely reflected the debates regarding the interpretation of the past that are taking place in academic circles. Many permanent displays still cling to modernist notions of 'progress' in a didactic, often safely consensual way which avoids difficulties and plays down the inadequacies of the evidence. Curators, it seems, often prefer to give definite answers to easy questions they themselves have posed, or perhaps worse, which no one is asking (Crowther, 1989: 44). As a result prehistory rarely rises above a procession of objects shorn of context and meaning.

Far from being the first place to go for an up-to-date synthesis of field, academic and curatorial work, presented and interpreted in the best way possible for the visiting public, the museum is for too many a port of last call or a forgotten by-product. Partly, this is a reflection of the separation that has developed between practitioners of archaeology in universities, field units, county planning departments and museums since the rescue archaeology boom of the early 1970s. Academics seem curiously uninterested in exploiting the rich potential of many museum collections and often fail to take account of material culture in their work or that of their students (e.g. Saville, Chapter 10). On the other hand, many field archaeologists regard museums as little more than dumping grounds for completed archives. Such attitudes not only betray ignorance of museum collections and curatorial expertise but also of the aims of museums themselves – to serve the needs of the general visitor. Many archaeologists are simply not interested enough in reaching a wider audience. The *Time Team*, for example, with an estimated audience of 3.5 million viewers, has been mischievously described by the anonymous commentator Ichneumon as 'anodyne pap' in *The Field Archaeologist* (1996: 29), although members of the public regard it as 'addictive and exciting' (Nick Cater, pers. comm.). A small-scale 'snapshot' postal survey of a dozen or so of the

commercial archaeological teams competing for work in the London area conducted by Jonathan Cotton confirmed that the 'general public' come well down the scale of potential 'end-users' – usually after 'clients', 'local authority planners/English Heritage' and 'other archaeologists/academics'.

Many museums are, understandably, reluctant to undermine their own perceived positions of authority as 'places that know' with displays which subvert or challenge establishment views of knowledge. Most permanent galleries therefore present material in a safe chronological format with particular themes highlighted (the Red House Museum, Christchurch, focuses on 'People', 'Place', 'Time' and 'Death and Burial', for example, while the 'Victims of Time' display at Dorset County Museum uses Maiden Castle to explore the prehistoric archaeology of the county (Pearce, 1990: 153)), although other approaches are possible (e.g. thematic, site-specific, single subject). Many adopt a didactic approach and present interpretation as 'fact'. Few attempt to provide alternatives and visitors are frequently given no information which would enable them to draw their own conclusions, or challenge those given by the (usually anonymous) curator.

There are, however, notable exceptions. Less fettered by financial constraints, conformance to 'house-style' or the need for longevity, it is perhaps no coincidence that two of the most distinctive and experimental displays of recent years were temporary productions. 'Symbols of Power at the Time of Stonehenge' at the National Museums of Scotland brought a broadly Marxist approach to bear on the exploration of power and prestige in the period 3000–1200 BC (Clarke et al., 1985; Crowther, 1989; Lawson, 1987), while a cheap and cheerful (and flexible, responsive, movable and adaptable!) approach was adopted by Barbara Bender and others for a multivocal travelling exhibition exploring notions of Stonehenge (Bender, 1997). Predictably perhaps, and despite receiving great acclaim during the Edinburgh Festival of 1985, 'Symbols of Power' has left scarcely a ripple on the surface of other gallery displays, while criticism of Bender's multivocal approach has resulted in the censorship of parts of the exhibition at some venues (Bender, 1997: 57–8).

The themes on which permanent galleries concentrate often reflect a straightforward functionalist approach to material culture and reflect the preoccupations to which many curators and archaeologists are prone. Reconstructions and displays have an inherent stereotype of their own – 'Hunting', 'Trade and Exchange', 'Farming', 'Burial', for example – as well as incorporating stereotypes from recent Western societies in terms of social constructs. There is a growing awareness that museum displays have all too often simply projected contemporary assumptions on to past societies in terms of the 'value' attributed to activities and objects, the structure of communities and the function of individuals themselves (e.g.

for gender see Boyd, 1997; Jones and Pay, 1990; Moser, 1997; Sørensen, Chapter 7; Wood, 1996; for questioning of interpretations see Barrett, 1995; Hodder, 1986; Shanks and Tilley, 1992). Individual research interests have resulted in galleries and books which concentrate on the acquisition of goods, power and prestige, for example, while a preoccupation with the expansion of control and social organization is a legacy of nineteenth-century archaeologists (Trigger, 1994). Thus galleries are often structured around the concepts of 'chiefdoms', 'tribal units' and 'warfare' (and the material remains which can support these ideas), with less weight given to more intangible elements such as the possible contemporary ideological motivations of prehistoric societies. Equally, it is far harder to find real information relating to technologies, now almost invisible in excavation and undervalued in contemporary society, such as textile and food production, than it is to find displays dealing with metal production and warfare. The dependence on typology and classification side-steps difficult questions, and often down-plays the humanity of the material displayed.

Despite visitors' interest in individuals like themselves (see below), older people, women and children are frequently missing from prehistoric galleries or portrayed as passive observers, while men appear in specific, often dominant, roles such as 'Hunter', 'Metalworker', 'Farmer' (James, 1997; Jones and Pay, 1990; Longworth, 1994; Rumsby, 1995; Wood, 1996 and 1997a). Attempts to subvert the expected, such as the female flintknapper at the Tolson Memorial Museum (Rumsby, 1995), are doubly noteworthy (but see criticisms in Sørensen, Chapter 7), though even some recent displays continue to perpetuate the potentially alienating 'Early Man in . . .' approach.

While it is impossible to create an authentic context for any object or society in a museum, every exhibition, display or illustration can be viewed by visitors as a realistic representation. The role of the curator in choosing what should be displayed and in interpreting the evidence is pivotal in the representation of the past. For example, it is a truism that some items, mundane in their own time, are now elevated to the status of fetish by their inclusion in a museum display, while others which in all probability were symbolic or devotional and special, are reduced to the mundane through exhibition. Wooden objects, ubiquitous at the time of their production, are now so rare that small fragments are revered, while examples of the earliest copper axes which must have been objects of wonder when first made now gather dust in forgotten typological displays. These issues have been discussed elsewhere (Gathercole, 1989) but they are of fundamental importance when displaying prehistory as it is on the curator's interpretation that the general visitor and student rely (Crowther, 1989).

Defining audiences and message

According to David Keys (quoted in Ucko, 1990: xix), 'in Britain, more than 3 million people are interested in archaeology, and over a million visit more than ten sites a year. Overall there are more than 70 million visits a year to archaeological and historical sites by UK residents . . .' This kind of detail about visitors to 'historic' or 'heritage' locations is further expanded in other literature (e.g. Hooper-Greenhill, 1988; Merriman, 1991) revealing information such as visitor occupations and other leisure interests. It is only relatively recently, however, that British museums have begun to research their own visitor profiles in any greater depth (e.g. McWilliams and Hopwood, 1973; Merriman, 1989; Prince and Higgins-McLoughlin, 1987). At the same time there has also been some research undertaken into the public perception of 'archaeology' (Cambridge Research Cooperative, 1983; Merriman, 1991; Stone, 1986a and b) and limited work on the presentation of this subject in the museum context (Griggs and Hays-Jackson, 1983; McWilliams and Hopwood, 1973; Mason, 1974; Merriman, 1991; Prince and Schadla-Hall, 1987; Schadla-Hall and Davidson, 1982 and 1983). Additionally, there is some work in the field of education which includes prehistory in some form (Bonham, 1997; Clarke, 1986; Corbishley, 1986; Cracknell, 1986; Planel, 1990; Richardson, 1990).

This research does show that although generally people believe that the past is valuable and important and that we should know about it (Merriman, 1989: table 14.5), they do not always consider it relevant to themselves (Merriman, 1991: table 7.5). Such general visitor surveys and investigations of public opinion are valuable for defining the museum audience and their perceptions of the archaeological profession or subject matter. What they do not yet provide, however, is any detailed information regarding attitudes to, or understanding of, prehistory in particular. They do not provide any information on the effectiveness of exhibitions; nor are they in any way an evaluation of work done. They are a first step in identifying audiences and much work should follow from such surveys.

A number of critiques and reviews of finished exhibitions and/or galleries dealing specifically with prehistory have been published (e.g. Crowther, 1989; Lawson, 1987; Owen, 1996; Pearce, 1990), and students continue to undertake theses on aspects of prehistoric display (e.g. Cadbury, 1996; Owen, 1990). However, few museums set about gallery re-displays by clearly defining their audiences, the messages to be conveyed and the means by which this is to be achieved. As far as we can ascertain, the only work published which specifically considers the display of prehistoric material and the public perception of it was undertaken by Peter Stone at the Alexander Keiller Museum, Avebury (Stone, 1994), and by us at the Museum of London (summarized in Cotton, 1997; Cotton and

Wood, 1996). Both museums set about their re-displays by defining their target audiences and identifying the key messages to be imparted.

Stone's work at Avebury, which deserves to be better known than it is, concentrated on the requirements likely to be made of an exhibition by schools, although the gallery also acknowledges the needs of other groups. He studied the National Curriculum to see how the museum could be made relevant and also asked local school pupils in the range 5 to 14 years, 'what they would want a new museum display to tell them about the people who built the Avebury monuments' (Stone, 1994: 195). He also looked at the museum's visitor profile, consulted university-based archaeologists and secondary school teachers, and noted the comments and questions of general visitors.

At the Museum of London the approach was rather different. The aim of the work was not specific to children but concerned with visitors in general. The intention was not only to obtain measurable information which would help in the creation of the gallery but also to use the feedback on displays after construction as a means of measuring how effective the new gallery was. This work was divided into a number of complementary approaches, a more detailed summary of which has been published elsewhere (Cotton and Wood, 1996). The first element was intended to provide quantitative information on the perception and understanding of the term 'prehistoric'. The second was a qualitative survey which was intended to discover what visitors wanted to know about prehistory; and to provide a means of measuring how effective the gallery was by comparing answers given to questions based around the three main pieces of information which the gallery intended to transmit. This qualitative work was undertaken in both the old and new galleries. The final element of the research was a series of focus groups convened after the gallery opening (Fisher, 1995). They were used to investigate particular queries which the curators had regarding how successfully certain areas of the gallery functioned, and also to assess how far it had been successful in achieving stated aims and the transmission of information. There was also further supporting work such as tracking surveys, unsolicited comment cards filled in by visitors, and casual observations in the gallery.

The results of this range of work make clear that even for museum visitors prehistory is an unknown quantity. In the period February to November 1992, leading up to the closure of the old prehistoric gallery in 1994, a sample of 1836 visitors were asked the question: 'What does the word "prehistoric" mean to you?' The range of replies (set out in the Appendix) bore out our gut feeling that most visitors had little or no knowledge of prehistory and little concept of what life at that time might have been like. In the qualitative survey the range of answers offered to questions asking: 'What kind of people do you think lived in Britain

before the Romans?' ranged through answers such as 'hunter gatherers and later tribal groupings with farming and animal domestication', to 'wore sack cloth', 'died of the cold', 'monkey people', and 'Anglo-Saxons'. The understanding of the time covered was similarly hazy. Answers to a multiple-choice question about how long people had lived in Britain ranged between 5000 and 5 million years.

The qualitative research at the Museum of London highlighted similar visitor interests to those identified by Stone at Avebury (1994). At Avebury the overwhelming majority wanted to know about 'social, religious and practical things that are central to [the visitor's] own world . . .' (1994: 195). The issues which concern visitors in both surveys reflect a basic interest in other people's lives, e.g. What were their houses like? Where did they go to the toilet? What were the sanitary arrangements? Religious beliefs? What did they eat and how did they get their food? Were there any shops? Family life and structure? Stone also found that children and adults were interested in much the same questions, a conclusion supported by anecdotal evidence at the Museum of London.

To date therefore we have only a small amount of detailed research specific to the museum interpretation of prehistory, but that which we do have is consistent. Visitors of all ages want to know about people, about daily life and about social constructs in so far as they might have affected the social and domestic life of individuals like themselves. The prehistory which is currently presented in museums is not, and cannot be, objective 'truth' (whatever that is) but is rather a politicized product of the present and, as we have shown, it is rarely in tune with the needs of the visitor. As much as any other period, prehistory has been appropriated by those responsible for its interpretation. Galleries reflect consciously or unconsciously the interests of their creators and their time (e.g. Trigger, 1994). As was noted on the panel entitled, 'Can you believe what we say?' at the Museum of London, 'This gallery is a reflection of our present' — a sentiment echoed by others (e.g. Leone, 1981: 5).

How then can we make the displays of prehistory informative and accurate while simultaneously sparking and maintaining the interest of the museum visitor? The research undertaken at Avebury and the Museum of London points the way forward. While current museological and archaeological research interests should inform the content of displays, what is needed now is direct work with existing and potential audiences. We need to understand what if anything 'prehistory' means to people, what they want from displays, how exhibitions work and whether they are effective (e.g. Bower, 1995; Merriman, 1991). Only with this kind of information to hand can curators feel confident in the approach to and construction of displays.

The way forward . . .

Although often couched in obscure language, postmodernist thinking does have the potential to inject new intellectual energy into the representation of prehistory (and much else) within the museum. This need not imply a descent into relativism, as several commentators have suggested (e.g. Durrans, 1993: 49–50; Saville, Chapter 10), where 'anything goes'. Rather museums should be seen as places which instigate dialogues, pose questions and explore ideas regarding the nature of knowledge; and where curators can be liberated to use their particular expertise to act as facilitators, commentators and even arbitrators. This would go some way towards re-establishing the relevance of the museum in intellectual terms, and answer some of the doubts raised by Longworth (1994) and, more recently, Saville (1997; Chapter 10). It would also serve to reforge meaningful links between museums and other relevant institutions such as the universities and archaeological practitioners, whence comes much of the new thinking and new data.

Relevance should be the key. There is a fine line to be drawn between creating a past in which modern visitors can find enough that is familiar to enable them to relate to both people and material culture, and a past which is equally possible but which incorporates elements now so foreign that the past becomes completely alien (e.g. James, 1997: 34). The work at the Museum of London and Avebury illustrates clearly that visitors need to find a link with the distant past in order to begin to comprehend it. It is the human and the individual which they seek (Bower, 1995: 35), best summed up by teachers commenting on the proposals for the Museum of the Iron Age in Andover as the need for 'empathy' (David Allen, pers. comm.).

The limited research published so far identifies the spheres of visitor interest which should form the core of our displays. On a practical level, there are steps which museums could take in order to make their displays more responsive and relevant. Flexible, updatable displays and closer liaison with other branches of archaeology, greater use of collections by academic and non-academic researchers, and (as noted above) a wider use of curatorial expertise would all go a long way to making museums more relevant forums for discussion of the interpretation of prehistory (e.g. Cotton and Wood, 1996; Longworth, 1994; Saville, 1997 and Chapter 10; Wood, 1997b). Objects in the galleries at Avebury and the Museum of London that can be touched are closely tied into the exhibition and allow direct connection with the past (a feature too of Glasgow Museums' successful touring prehistory exhibition 'In Touch with the Past' (Batey, 1995)). Prominence given to objects with a precise provenance provides a spatial link with the past while the juxtaposition of ancient and modern objects helps visitors 'to see the ancient artefacts as reflections of their

counterparts in use today' (Bower, 1995: 36). Despite pressure from some quarters to put more objects on display, it is increasingly clear that it is not quantity but contextualization which is important. Above all, evidence presented honestly and open-endedly invites visitors into the interpretive process, and allows them opportunities to challenge both the views of the curator and their own preconceptions.

It remains to be seen, of course, how the next generation of museum prehistoric displays grapples with (or ignores) the various strands of postmodern thinking (Hull and East Riding Museum, the British Museum and the National Museums of Scotland are all currently researching for new displays, for example (e.g. Clarke, 1996)). Some of the nationals, in particular, may find it harder to challenge the ortho-doxy of certainty so carefully constructed and nurtured within their walls, and we may well continue to have to look to temporary displays for the polemical 'gadfly' challenge to what Barrett tellingly labels the 'tedium of display' (1995: 6). If museums and curators wish to retain, even perhaps reclaim, their relevance in the wider heritage market, a little soundly based, up-front intellectual experimentation may not be such a bad idea.

Bibliography

Barrett, J. (1995) *Some Challenges in Contemporary Archaeology*. Institute of Field Archaeologists, Archaeology in Britain Conference 1995, Oxbow Lecture 2. Oxford: Oxbow Books.

Batey, C. (1995) 'In touch with the past at Glasgow Museums', in Denford, G.T. (ed.), *Museum Archaeology: What's New? The Museum Archaeologist* 21. Winchester: Society of Museum Archaeologists, 19–23.

Bender, B. (1997) 'Multi-vocalism in practice: alternative views of Stonehenge', in Denford, G.T. (ed.), *Representing Archaeology in Museums. The Museum Archaeologist* 22. Winchester: Society of Museum Archaeologists, 57–60.

Bonham, M.M. (1997) 'Artefacts in school history', in Denford, G.T. (ed.), *Representing Archaeology in Museums. The Museum Archaeologist* 22. Winchester: Society of Museum Archaeologists, 86–93.

Bower, M. (1995) 'Marketing nostalgia: an exploration of heritage management and its relation to human consciousness', in Cooper, M.A., Firth, A., Carman, J. and Wheatley, D. (eds), *Managing Archaeology*. London: Routledge, 33–9.

Boyd, B. (1997) 'The power of gender archaeology', in Moore, J. and Scott, E. (eds), *Invisible People and Processes: Writing Gender and Childhood into European Archaeology*. Leicester: Leicester University Press, 25–30.

Cadbury, T.H. (1996) 'Stones again? Interpretations of the Palaeolithic in British museums and visitor centres'. Unpublished MA dissertation, School of World Art and Museology, University of East Anglia.

Cambridge Research Cooperative (1983) 'The national survey of public opinion towards archaeology', *Archaeological Review from Cambridge*, 12(1), 24–6.

Claassen, C. (1992) 'Questioning gender: an introduction', in Claassen, C. (ed.), *Exploring Gender Through Archaeology: Selected Papers from the 1991 Boone Conference*. Monographs in World Archaeology No. 11. Madison, WI: Prehistory Press, 1–9.

Clarke, D.V., (1996) 'Presenting a national perspective of prehistory and early history in the Museum of Scotland', in Atkinson, J.A., Banks, I. and O'Sullivan, J. (eds), *Nationalism and Archaeology*. Glasgow: Cruithne Press, 67–76.

Clarke, D.V., Cowie, T.G. and Foxon, A. (1985) *Symbols of Power at the Time of Stonehenge*. Edinburgh: HMSO.

Clarke, P. (1986) 'What does archaeology have to offer?' in Cracknell, S. and Corbishley, M. (eds), *Presenting Archaeology to Young People*. CBA Research Report 64. London: Council for British Archaeology, 9–12.

Corbishley, M. (1986) 'Archaeology, monuments and education', in Cracknell, S. and Corbishley, M. (eds), *Presenting Archaeology to Young People*. CBA Research Report 64. London: Council for British Archaeology, 3–8.

Cotton, J.F. (1997) 'Illuminating the twilight zone? The new prehistoric gallery at the Museum of London', in Denford, G.T. (ed.), *Representing Archaeology in Museums. The Museum Archaeologist* 22. Winchester: Society of Museum Archaeologists, 6–12.

Cotton, J.F. and Wood, B. (1996) 'Retrieving prehistories at the Museum of London: a gallery case-study', in McManus, P. (ed.), *Archaeological Displays and the Public: Museology and Interpretation*. London: Institute of Archaeology, University College, 53–71.

Cracknell, S. (1986) 'Introduction', in Cracknell, S. and Corbishley, M. (eds), *Presenting Archaeology to Young People*. CBA Research Report 64. London: Council for British Archaeology, 1–2.

Crowther, D. (1989) 'Archaeology, material culture and museums', in Pearce, S.M. (ed.), *Museum Studies in Material Culture*. Leicester: Leicester University Press, 35–46.

Durrans, B. (1993) 'Cultural identity and museums', in Southworth, E. (ed.), *'Picking up the Pieces': Adapting to Change in Museums and Archaeology. The Museum Archaeologist* 18. Liverpool: Society of Museum Archaeologists, 42–55.

Fisher, S. (1995) 'How do visitors experience the new Prehistoric Gallery? Qualitative research'. Unpublished report for the Museum of London. London: Suzie Fisher Group.

Gathercole, P. (1989) 'The fetishism of artefacts', in Pearce, S.M. (ed.), *Museum Studies in Material Culture*. Leicester: Leicester University Press, 73–82.

Griggs, A. and Hays-Jackson, K. (1983) 'Visitors' perceptions of cultural institutions', *Museums Journal*, 83, 121–5.

Hodder, I. (1986) *Reading the Past: Current Approaches to Interpretation in Archaeology*. Cambridge: Cambridge University Press.

Hooper-Greenhill, E. (1988) 'Counting visitors or visitors who count?' in Lumley, R. (ed.), *The Museum Time-Machine. Putting Culture on Display.* London: Routledge, 213–32.

Ichneumon (1996) 'Ego te sconcere', *Field Archaeologist*, 26, 29.

James, S. (1993) 'How was it for you? Personal psychology and the perception of the past', *Archaeological Review from Cambridge*, 12(2), 84–100.

James, S. (1997) 'Drawing inferences: visual reconstructions in theory and practice', in Molyneaux, B.L. (ed.), *The Cultural Life of Images: Visual Representation in Archaeology.* London: Routledge, 22–46.

Jones, S. and Pay, S. (1990) 'The Legacy of Eve', in Gathercole, P. and Lowenthal, D. (eds), *The Politics of the Past.* London: Unwin Hyman, 160–71.

Lawson, A.J. (1987) 'Symbols of power: an exhibition and catalogue', *Scottish Archaeological Review*, 4(2), 127–33.

Leone, M.P. (1981) 'Archaeology's relationship to the present and the past', in Gould, R.A. and Schiffer, M.B. (eds), *Modern Material Culture: The Archaeology of Us.* New York: Academic Press, 5–14.

Lesick, K.S. (1997) 'Re-engendering gender: some theoretical and method-ological concerns on a burgeoning archaeological pursuit', in Moore, J. and Scott, E. (eds), *Invisible People and Processes: Writing Gender and Childhood into European Archaeology.* Leicester: Leicester University Press, 31–41.

Longworth, I. (1994) 'Museums and archaeology: coping with the Chimaera', in Gaimster, D. (ed.), *Museum Archaeology in Europe. The Museum Archaeologist* 19/Oxbow Monograph 39. Oxford: Oxbow Books/Society of Museum Archaeologists, 1–8.

McWilliams, B. and Hopwood, J. (1973) 'The public of Norwich Castle Museum 1971–2', *Museums Journal*, 72(4), 153–6.

Mason, T. (1974) 'The visitors to Manchester Museum: a questionnaire survey', *Museums Journal*, 73(4), 153–7.

Merriman, N. (1989) 'The social basis of museum and heritage visiting', in Pearce, S.M. (ed.), *Museum Studies in Material Culture.* Leicester: Leicester University Press, 153–71.

Merriman, N. (1991) *Beyond the Glass Case.* Leicester: Leicester University Press.

Merriman, N. (1993) 'The use of collections: the need for a positive approach', in Southworth, E. (ed.), *'Picking up the Pieces': Adapting to Change in Museums and Archaeology. The Museum Archaeologist* 18. Liverpool: Society of Museum Archaeologists, 10–17.

Moser, S. (1997) 'Museums and the construction of an identity for archaeology: dioramas and the presentation of early prehistoric life', in Denford, G.T. (ed.), *Representing Archaeology in Museums. The Museum Archaeologist* 22. Winchester: Society of Museum Archaeologists, 83–5.

Owen, J. (1990) 'An assessment of the messages conveyed by Palaeolithic dis-plays in selected Thames Valley museums.' Unpublished MA dissertation, Department of Museum Studies, University of Leicester.

Owen, J. (1996) 'Making histories from archaeology', in Kavanagh, G. (ed.), *Making Histories in Museums*. Leicester: Leicester University Press, 200–15.

Pearce, S. (1990) *Archaeological Curatorship*. Leicester: Leicester University Press.

Planel, P. (1990) 'New archaeology, new history: when will they meet? Archaeology in English secondary schools', in Stone, P. and MacKenzie, R. (eds), *The Excluded Past: Archaeology in Education*. London: Unwin Hyman, 271–81.

Prince, D.R. and Higgins-McLoughlin, B. (1987) *Museums UK: The Findings of the Museums Data-Base Project*. London: The Museums Association.

Prince, D.R. and Schadla-Hall, R.T. (1987) 'On the public appeal of archaeology', *Antiquity*, 61, 69–70.

Pryor, F. (1996) 'Sheep, stockyards and field systems: Bronze Age livestock in eastern England', *Antiquity*, 70, 313–24.

Pryor, F. (1997) 'Urban diggers and rural prehistory', *British Archaeology*, 23, 14.

Renfrew, C. and Bahn, P. (1996) *Archaeology: Theories, Methods and Practice*. London: Thames and Hudson.

Reynolds, P. (1979) *Iron Age Farm*. London: British Museum Publications.

Richardson, B. (1988) *Archaeological Collections in London*. London: London Museums Service.

Richardson, W. (1990) ' "Well in the Neolithic . . .": teaching about the past in English primary schools in the 1980s', in Stone, P. and MacKenzie, R. (eds), *The Excluded Past: Archaeology in Education*. London: Unwin Hyman, 282–92.

Rumsby, J. (1995) 'The new archaeology galleries at the Tolson Memorial Museum, Huddersfield', in Denford, G.T. (ed.), *Museum Archaeology: What's New? The Museum Archaeologist* 21. Winchester: Society of Museum Archaeologists, 66–9.

Saville, A. (1997) 'Thinking *things* over after the 1995 SMA Conference', in Denford, G.T. (ed.), *Representing Archaeology in Museums. The Museum Archaeologist* 22. Winchester: Society of Museum Archaeologists, 101–10.

Schadla-Hall, R.T. and Davidson, J. (1982) 'It's very grand but who's it for? Designing archaeology galleries', *Museums Journal*, 82(3), 171–5.

Schadla-Hall, R.T. and Davidson, J. (1983) 'No longer can the objects speak for themselves', in White, A. (ed.), *Archaeological Display*. London: Society of Museum Archaeologists, 20–34.

Shanks, M. and Tilley, C. (1992) *Re-Constructing Archaeology: Theory and Practice* (2nd edn). London: Routledge.

Stone, P.G. (1986a) 'Interpretations and uses of the past in modern Britain and Europe: Why are people interested in the past? Do the experts know or care? A plea for further study', in Layton, R. (ed.), *Who Needs the Past? Indigenous Values and Archaeology*. London: Unwin Hyman, 195–206.

Stone, P.G. (1986b) 'Are the public really interested?', in Dobinson, C. and Gilchrist, R. (eds), *Archaeology, Politics and the Public*. York: Department of Archaeology, University of York, 14–21.

Stone, P.G. (1994) 'The re-display of the Alexander Keiller Museum, Avebury, and the National Curriculum in England', in Stone, P.G. and Molyneaux, B.L., *The Presented Past: Heritage, Museums and Education*. London: Routledge, 190–205.

Trigger, B.G. (1994) *A History of Archaeological Thought*. Cambridge: Cambridge University Press

Ucko, P.J. (1990) 'Foreword', in Gathercole, P. and Lowenthal, D. (eds), *The Politics of the Past*. London: Unwin Hyman, ix–xxi.

Wood, B. (1996) 'Wot no dinosaurs! Interpretation of prehistory and a new gallery at the Museum of London', in Devonshire, A. and Wood, B. (eds), *Women in Industry and Technology: Current Research and the Museum Experience*. London: Museum of London/WHAM, 53–63.

Wood, B. (1997a) 'Weaving, watching and waiting for something more interesting to do? Interpreting women's lives from archaeological evidence', *Atalanta*, 1, 3–7.

Wood, B. (1997b) 'Does size matter? Effective presentation of archaeology in small museums', in Denford, G.T. (ed.), *Representing Archaeology in Museums. The Museum Archaeologist* 22. Winchester: Society of Museum Archaeologists, 59–64.

Appendix: Visitor research: Prehistoric Gallery, Museum of London

Please can you tell us what you associate with the word 'prehistoric'?

Sample total: 1836 (taken between 11 February 1992 and 27 November 1992)

	N	%		N	%
Dinosaurs	527	28.7	Huts	13	0.7
Cavemen	176	9.6	Bronze Age	11	0.6
Tools/weapons	134	7.3	Celts	10	0.5
Flints/stones	134	7.3	Iron Age	9	0.5
Animals/monsters	104	5.7	Primitive life	9	0.5
Before written history	97	5.7	Pottery	9	0.5
Very old	83	4.5	Unsure	9	0.5
Stone Age	74	4.0	Before civilization	7	0.4
Hunting	36	2.0	Settlement	7	0.4
Mammoths	36	2.0	The Flintstones	5	0.3
Early man	34	1.9	Neanderthal Man	5	0.3
No response	34	1.9	Evolution	4	0.2
History/archaeology	32	1.7	Tribes	4	0.2
Pre-Roman	31	1.7	Riverside life	3	0.2
Bones	29	1.6	Anglo-Saxons	3	0.2
Before Christ	22	1.2	Jungles	2	0.1
Barbarism	20	1.1	Way of life	2	0.1
Ice Age	17	0.9	Geology	2	0.1
Caves	16	0.9	Before man	2	0.1
Ruins/relics	16	0.9	Culture	2	0.1
Stonehenge	16	0.9	Man	2	0.1
Early civilization	15	0.8	Poor sanitation	2	0.1
Fossils	13	0.7	Survival skills	2	0.1
Cave paintings	13	0.7			

3

Rule(d) Britannia: Displaying Roman Britain in the Museum

Mary Beard and John Henderson

A cartoon (Figure 3.1) provides the frontispiece to Richard Reece's *My Roman Britain* (1988) – an idiosyncratic and extremely influential *samizdat* tract that is a founding text of 'New' Romano-British archaeology.[1] Pride of place in this cartoon is given to a family of Britons, their 'nativeness' signalled as much by their aggressively 'Late Pre-Roman Iron Age' (LPRIA) thatched roundhouse as by father's unpronounceably Celtic name. While junior minds his sister and an obligingly passive porker, mother and father prop up in front of their homestead an elaborate disguise, in the form of a classical, cardboard-cut-out façade of columns and pediments – for the benefit, so it seems, of a detachment of Roman legionaries who march past, down a very straight Roman road, scattering their distinctively Roman litter behind them.

The joke here is not simply about the fragility of 'Romanization' in Britain; not simply a prompt to recognize the classical *veneer* of some parts of the province as precisely that – a *veneer*, a *façade*, behind which life went on more or less as it always had. To recognize the fragility of Romanization is also inevitably to challenge our traditional understanding of the cultural (if not the political) hierarchies of imperial Britannia. For the dupes caricatured in this cartoon are the Roman soldiers, who are comprehensively taken in as they pass by this stage-set, proud (we must assume) at their own civilizing impact on this barbarian backwater, foolishly presuming that their presence has somehow *made a difference* to the way things are here, so many miles from Rome. In fact, a few hours playing up to them and the Britons are left more or less alone by their new overlords – as much the kings of their own round castles as they ever had been. Some cardboard plus temporary collusion with Roman expectations is a small price to pay to preserve their familiar LPRIA lifestyle. But, through and beyond the Romans, the joke is really on *us*. For we have also been taken in – duped into constructing a *Roman* province out of the rubbish left in the train of such Roman march pasts, out of the coins, the amphorae, the statues and inscriptions. We have systematically failed to acknowledge the much more fleeting traces of the inhabitants and the lifestyle that really

Figure 3.1 The departure of the Roman army. (Cartoon drawn by Simon James.)

defined the character of Britain under Roman rule. In our eagerness, so
the cartoon reminds us, to pick up what the soldiers have dropped on the
road, we too have failed to reckon with that façade, and what is going on
behind it.

This cartoon captures some of the most important claims of a new
alternative orthodoxy in Romano-British archaeology.[2] Ostensibly self-
confident traditional accounts of the Romans in Britain, as in familiar
course-books such as Frere's *Britannia* (1967) or Todd's *Roman Britain*
(1981),[3] are increasingly being challenged by a set of new approaches that
call into question the very 'Romanness' of 'Roman' Britain; approaches
that (in a powerful combination of up-to-the-minute theoretical archae-
ology and post-imperialist politics) draw our attention behind the façade
to the life of the *British* under Roman occupation.[4]

In this chapter we are concerned with the impact of these developments
and changing orthodoxies on museum practice and display. Taking the
Roman galleries in the Museum of London (opened 1996) as a case study,
we ask how museum display can reflect not only such new interpretations
of Britain under Roman rule, but also the tension between different models
for understanding the history of Britain in the first four centuries CE.[5]

At the same time, we are concerned with the museum's own con-
tribution to the changing histories of Roman Britain. For museum display
not only *reflects*, it *makes* and *contests* historical understanding. Its very
economy, its concentration on the material objects that underlie any early
historical narrative, and its powerful rhetoric of display, expose the
weaknesses as well as the strengths of the historical positions it entertains.
Both the objects on view and the audience targeted for their reception
must challenge the (new) 'histories' they mean to construe. Museums have
their own distinctive dynamic: they work with, and around, their collec-
tions – and their patrons. Museums must address their locality, their vicin-
ity and their mix of clientèles. Today's museology runs the gauntlet of
interpretative debate and a culturally diverse society. What models of whose
knowledge operate here? And meant for whom? How is the Museum of
Roman London to handle a multiculturalist archaeology before a multi-
cultural public?

New Roman Britain

We referred to the accounts of Frere and Todd as '*ostensibly* self-confident'
advisedly, and with good reason. For embedded at the heart of every
narrative of Britain in the Roman Empire is a series of awkward ques-
tions, uncomfortable historical paradoxes – ever-present, just beneath the
surface of the story. What is the significance of the hybrid label 'Roman
Britain', and how does it construct the object of our study? Is Roman

Britain Roman or native? British or foreign? Part of the seamless web of 'our island story', or an ignominious period of enemy occupation? The origin of (European) 'civilization' on our shores, or an unpleasant, artificial intrusion that actually managed to postpone (British) 'civilization' for almost a thousand years? Can we avoid taking sides? And if not, whose side are we on?

The insistent duality of Boudica/Boadicea (our first national heroine/ demonized virago) has always captured these tensions with the nagging awkwardness that is their due. Her statue erected on the Thames Embankment (in the outburst of patriotic display that followed Queen Victoria's death) asks us to identify British Queen with British Queen – but only at the cost of forgetting the political cutting edge of Boudica the native freedom fighter and Victoria the Empress of a world empire that found its model in (its own construction of) the Roman Empire. Boudica may, like Victoria, have been a doughty defender of British power; she may nobly have sacrificed herself on behalf of this sceptred isle. But at the same time she was precisely the kind of nasty insurgent, arsonist and rebel that Victoria's imperial apparatus toiled to eradicate.[6] Such paradoxes are not confined to the icon of Boudica-by-the-Thames. They stalk the pages of academic narratives too, as she appears alternatively as the 'war-leader of the British confederacy' (Dudley and Webster, 1962: 48), as a noble woman spurred to revolt by the 'harsh brutality' of Roman rule (Frere, 1967: 88), or as a 'rebel' who 'paid in full for [her] atrocities' (Richmond, 1955: 33).[7]

But if the standard histories of Roman Britain try hard to paper over these cracks, the 'new' archaeology has worked in exactly the opposite direction – opening up all the cracks it can and at the same time exposing (what it sees as) the systematic occlusions, the naivety, the bad faith, and triumphalism, that underlie the traditional narratives of Britain as a Roman province.

New Roman Britain looks much more like prehistoric Britain than anyone ever imagined: in particular, urbanization (those up-market *'civitas* capitals') is seen as a much more fragile and less important phenomenon than either the Romans or most of their modern historians would like to admit; and the other markers of Roman culture (from hypocausts to togas, from coins to the second declension) are cast as so many epiphenomena in an otherwise Iron Age landscape and economy. To put it at its most extreme, for all the vaunts of Roman power and influence in Roman Britain, what we find above all is still '*the British way*, which most people in Britain followed before Romanization began, kept to while Romanization was in full flood, and which came back into fashion, or rather became the general way, when Romanization was no more than a symmetrical memory' (Reece, 1988: 74).[8]

The 'new archaeology' has found this strikingly prehistoric Roman Britain (partly) because that was exactly what it *expects*, and is equipped, to find. Most of its practitioners either have their own archaeological origins in the study of prehistory; or, at least, they work and were trained in university departments where prehistory and the methods of the pre-historian define what archaeology is or should be. It is, of course, a general rule that *prehistorians find prehistory*: they would probably find something strikingly similar to prehistory if they turned their attention to much of early twentieth-century Britain; and they certainly (and unsur-prisingly) have no trouble at all finding the Late 'Pre-Roman' Iron Age still thriving in Britain under the Romans. But at the same time there is a much more loaded agenda underlying this change of direction; and a much more pointed construction of difference between the new archae-ologists and their 'traditional' predecessors (most of whom cut their teeth on Tacitus, not on the Iron Age). For to study Roman Britain *as a pre-historian* is also to refuse to study it *as a classicist*, or with the priorities and aims suggested by classical texts and by the history of Rome itself. As our cartoon had it, concentrating on the prehistoric roundhouse behind the Roman façade is in part a rejection of the grand narrative of Rome (in Britain) – with its concentration on military campaigns, imperial tri-umphs, legionary commanders, successions of governors, and all the paraphernalia of their civilizing mission/brutal oppression. In short, a decisive (and principled) vote against the 'Hadrian built a wall across Britain' tradition of Romano-British studies (cf. esp. Woolf, 1996).

It is not just a question, though, of the extension of prehistory into (Roman) history. The new orthodoxy is also based on a new definition of 'Romanization' and of what is to count as 'Roman' – whether in Britain, Gaul or anywhere in the Empire. For Reece (1988: 9) – again hitting the nail on the head, if a little too hard – the changes in the archaeological record are not changes which make Britain more like Rome (if by 'Rome' is meant the imperial capital in Italy), but more like the adjacent provinces of the Empire: 'the pottery is better compared with Gaul, the animal refuse has changed towards that of Germany or North Gaul, decoration of metal work such as enamel is common in the northern provinces, but not in the Mediterranean region … and sculpture and architecture seem to rely on the Rhineland more than anywhere else.' Romanization, if it means anything, is a process that makes Britain 'more Gaulish, more Rhinelandish, more Spanish, a little more Italian, a very little more African, and a little more Danubian'.

Behind this lies a much more fractured image than the old certainties once suggested of what did, or could, count as 'Roman'. If the old model assumed some form of 'pure' Romanness working upon the 'native' culture of Britain, we now recognize that even at the centre of the

Roman world, in Rome itself, 'Romanness' was never a 'pure' singular cultural form. It was always, by definition, *multi*-cultural, while Roman citizenship always incorporated men of widely diverse cultural and ethnic origins.[9] It follows that Romanization must at the very least have been a process of 'dialectical change', rather than one-way cultural 'influence' (Millett, 1990: 1).

'New Roman Britain' is perhaps more an archaeological state of mind than an archaeological fact. Its pure, romantic vision of rural prehistoric continuity largely uninterrupted by the few (and in any case entirely exceptional) urban communities – artificial and unrooted implants into the green and pleasant land – can be found only in the uncompromising idiosyncrasy of *My Roman Britain* (which deliberately opts for intellectual liberation against mainstream 'respectability'[10] – with its title, its private publication and its playful Socratic rhetoric); or in the self-ironizing medium of the cartoon (which, in the end, is designed to leave its viewers guessing about exactly which side of the façade they (or its author) are on). Most archaeological writing makes sure to keep some distance from anything approaching the *reductio ad absurdum* of Reece's version of Roman Britain, in its unadulterated form.[11] But as *a way of thinking*, as a prompt to the reinterpretation of the old triumphalist certainties and as a persistent reminder that there are (and were) many other stories to be told about Britain under Rome, 'New Roman Britain' informs almost all recent work in the subject. It is an orthodoxy in the sense that everyone must decide quite how far down this path they wish (or have the nerve) to go; and what the implications of New Roman Britain are on their own particular piece of the Romano-British action. This is a set of decisions which the museum too must address.[12]

The Museum of (Roman) London: from prehistory to history?

The Museum of London is a significant and interesting hybrid: the biggest local museum in the country, standing for any local museum, in any county town, anywhere; and at the same time the museum of the capital itself, and so (by inevitable extension) 'national'. It is an emblem of one particular locality in the south-east, its distinctive topography, its singular history – as well as a powerful symbol of the nation as a whole (for 'London' read 'Britain'; for 'London's history' read 'our island's story'). Within this duality, the museum also highlights those two characteristically different ways of presenting and reading Roman Britain: on the one hand as 'Britain', on the other as 'Roman'. So, for example, it enjoins us to see the period of Roman rule as a single *episode* in the bigger historical narrative that is on display, leading – gallery by gallery – from prehistory through Roman invasion to Dark Ages, Saxons, Middle Ages and beyond;

an episode that we must fit into its chronological place in 'our' grand British, national story from flint-scrapers to flappers (on which cf. Shanks and Tilley, 1992: 74-5). But at the same time – with an emphasis now on 'Roman' rather than on 'Britain' – it offers a vision of the province as one *territorial part* in the grand (il)logic of Roman imperialism, explicable in terms of its (admittedly insignificant) role in the wider contemporary *Roman* world, its politics, its cultures, its modes of production, its religions.[13]

Different categories of museum visitor tend to privilege different ways of viewing and interpreting the Roman display: tourists (for the most part non-Londoners, but with a few locals thrown in) are more likely to take the museum as a whole and, by following the prescribed route through the galleries, to insert the story of the Roman city into the total narrative of London's history – from prehistoric origins to Lord Mayor's Coach, World War II and beyond; but the second main constituency (largely local schoolchildren and their teachers, at Key Stages 2 and 3 of the National Curriculum – who during school terms account for almost half the museum's visitors) come specifically to see this gallery as part of their investigations of Rome, the Romans and Roman Britain.[14] They are meant, in fact, to keep their eyes well away from the Tudors and the 'Great Fire Experience' that follow: that is for next term's or next year's work. They are here to learn about the *Romans* (in London).

Of course, in practice, visitor behaviour may not be so neatly categorized. Many visitors aiming at the total museum narrative wilt: no one *could* properly take in the whole story in one go. For most, the choice must be where to stop, or where at least to switch off and speed up: few who start with prehistoric pre-London in the first gallery and move systematically onwards keep it up beyond the Great Fire. A good number call it a day at the ramp that leads to the lower floor of displays (so missing out on everything since Christopher Wren). It was partly in response to this pattern that in early 1997 the museum introduced the 'Catwalk' (presumably named for Dick Whittington's cat, the museum of London's ubiquitous icon), a shiny white metal trackway that follows the main visitor route, chronologically, from entrance to exit. Adjacent to each main gallery, the Catwalk features an interactive computer display, an 'object handling point' and some headline-style information on the delights in store. Getting your hands on a seventeenth-century flagon or a Victorian inkwell may encourage you to leave the track and explore the gallery you have just reached. Or it may not. For the Catwalk lets you skip a few hundred years if you want, while still providing just enough information on what you're missing to keep you in touch with the narrative thread of London's history. The slogan here is visitor *choice* and visitor *spread*: if more people are able to miss out the Tudors without losing track of the

story, then more people (that's the idea, anyhow) will make it past the Great Fire and down the stairs.

At the same time, even the most single-minded schoolteachers would have a hard job stopping their charges getting *some* sense of London's grand narrative, try as they may to hustle them straight into their particular target gallery. It's not only a question of being drawn along the Catwalk to steal a glimpse (at least) of other periods. More to the point, the main entrance to the prescribed route around the museum doubles as the entrance way into the Prehistoric Gallery. So, as our plan shows (Figure 3.2), whatever your destination (the Cheapside Hoard, Selfridge's Lift or the Anderson Shelter) you must start your visit to historic London with the flints, the hand-axes and the bones of prehistoric, pre-London man (and woman). Even if you decide not to linger very long 'before civilization', you cannot entirely avoid the questions that this gallery (explicitly or implicitly) poses.[15] Prehistory is the one period in the whole museum that *no one* is allowed to bypass completely; and it must, in particular, set the scene for Roman Britain that immediately follows.

Prehistory turns out to be a paradoxically (post)modern start to London's story. You are greeted at the gallery entrance by a cardboard cut-out of a Stone-Age Raquel Welch – in mammoth-skin bikini and slippers, one hand fetchingly adjusting her hair – from the film *One Million Years BC* (Figure 3.2.a); and to keep her company an assortment of apemen and dinosaurs (including a Flintstone-style cartoon on 'Who built Stonehenge?': answer, a party of clever dinosaurs shown here putting the finishing touches to the standing stones). Above all this, one single caption: 'These images show how our earliest history is often portrayed. But how accurate are they?'

A little further into the gallery, on the other side of the entrance way (Figure 3.2.b), a large panel headed 'Can you believe what we say?' takes up the problem of how we might judge any of those images. 'The Prehistoric London Gallery deals with the time "before history". By definition there are no written records.' How then can we reconstruct these early communities? How can we judge which of the many reconstructions on offer are better, or more plausible, than the others? How can the visitor trust (even? especially?) the version of prehistory that the museum itself is about to present and to authenticate with its carefully orchestrated displays, its labels, its claims to 'knowledge'? This panel is an attempt, so its authors have stated, 'to include rather than to exclude the visitor, to own up to the influences and biases which, inevitably, coloured the curatorial approach ... [and] to strip away some of the museum's intimidating mystique, and so "open up" the interpretative process' (Cotton, 1997: 8; cf. Merriman, 1995: 64). The question it leaves open, however, is quite how far through the museum's narrative this particular curatorial tactic is

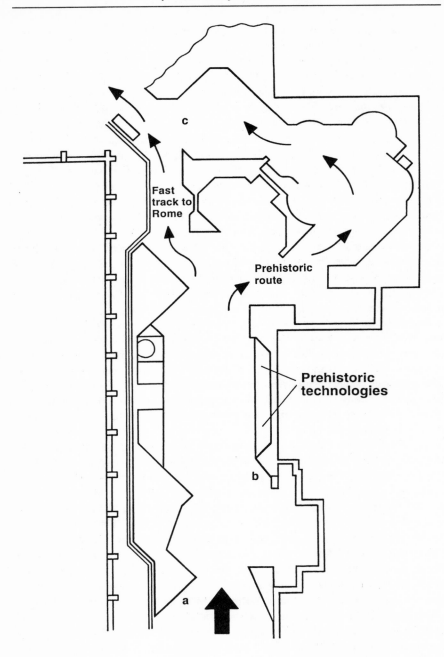

Figure 3.2 A plan of the Prehistoric Gallery, Museum of London.

supposed to extend. Is 'Can You Believe What We Say?' a perfect intro-
duction to the peculiar problems of (postmodern) prehistory – where, in
the absence of solid walls and neatly stratified ceramics (let alone writing),
any claim to knowledge is inevitably contested? Or is it also (as the double
function of this entrance way must insinuate or insist) a question prefixed
to everything that follows, right up to the Suffragettes and the Swinging
Sixties, a question for and about the museum as a whole, not just about
prehistory? We shall see.

The rest of the prehistoric display asserts modernity in a rather differ-
ent way, but no less subversively. In particular, even the most casual visitor
to the gallery (hurrying to get to the Romans, the Tudors or wherever) is
not likely to miss the repeated display tactic of mixing familiar modern
objects and tools with their prehistoric 'equivalents': a beer glass next to a
pottery beaker; a Swiss army knife side by side with some flint 'axes';
squashed aluminium cans next to a hoard of prehistoric scrapped bronze
– junk for junk. These juxtapositions do more than prompt the question
of how like, or unlike, the prehistoric inhabitants of the Thames Valley
were to 'us'. They raise the much bigger question of what constitutes
familiarity or modernity anyway; of how we can (fail to) recognize our-
selves in the distant past. Never mind the museum narrative that is to
follow, with its promise to lead us gradually to our own recognizably
familiar present day. Here we are presented with a vision of prehistory
that underscores familiarity in a different sense: in the common heritage
of humanity itself and the human condition which – then as now – makes
its tools, builds its shelters, prepares its food and chucks its waste. 'People
like us', as one caption reads. How can we not admire our distant ances-
tors who managed to fulfil all these different functions, which are at the
same time *our* functions, with the carcass of a single dead deer?[16] Or (so,
conversely, the display also prompts) should we be more sceptical at the
frozen hand of modernism imposing its own familiarity on the past,
pressing us to see 'tools' in flints, and 'drinking vessels' in pottery beakers?[17]

Within the museum's own internal logic, the Roman Gallery – just
round the corner – must challenge any such claim to 'modernity' on the
part of prehistory; and it must refuse to be upstaged by the smartness of
the prehistoric Thames Valley, or by the smartness of its display. For
(familiar, modern) London, as the *city* we know, did not start in distant
prehistory. However convenient a period label, 'prehistoric London' is a
gross contradiction in terms – or at the very least a wilfully misleading
shorthand (one used by the museum throughout its guides and informa-
tion) for the virgin *countryside*, with its trees and rivers and occasional isol-
ated settlements, that preceded any conurbation, whatever it might have
been called, on London's site (a countryside deftly conjured by the piped
bird-song that wafts gently through the Prehistoric Gallery). London

started with the Romans. On the standard historical narrative, it is Roman *Londinium* that gives us the first glimpse of our own city: the multicultural melting-pot; the thriving, bustling port (more thriving then than now, of course); the dominating river and its bridge(s); the centre of national administration; a city that survived the decline and fall of a world empire; a city that, in its destruction by Boudica, even stages 'The First Great Fire', as a prequel for 1666.[18]

Writing Roman London

Roman London – or so this story goes – was not only born, but born *modern*. And it is still with us. Londinium is not some faint prehistoric trace, whose existence depends on our imagination (or our willingness to believe the stories of archaeologists and museum curators). It is in front of our very eyes – right here. At one point in the Roman Gallery (Figure 3.3.f), in the middle of an information panel on the city's defences, that cat comes right out of the bag. 'You are now standing just outside the fort. The remains of the western wall of the fort can be seen from the window to your right.' Actually, they can't – quite. What you *can* see is a medieval tower and some much later (seventeenth- to nineteenth-century) brick-work, running along the line of the wall; but the point is well made: 'Decisions made in Roman times led to works which have affected town-planning ever since – including the lay-out of the Museum itself' (Hebditch, 1996: 258).

This particular sense of modernity, and its significant distance from prehistoric pre-London, is underscored at the very entrance to the Roman Gallery. Roman Britain is paraded to us from the very beginning as a *written culture*, which (by its very definition) leaves the illiteracy of pre-history far behind. On the left of the entrance into the gallery, the introductory panel (Figure 3.3.a) conjures up a picture of some of the inhabitants of Roman London – a motley crew, from a Roman legionary to an aggressively Celtic 'native'; but no fewer than three of these figures blazon the materials of reading and writing – two scrolls and one tablet between them. And they face the sculpted tombstone of a Roman army officer (Figure 3.3.b), who reminds us that brute conquest, Roman style, was backed up by a *literate* administration: 'His left hand holds a case of wooden writing tablets, suggesting that his duties were partly clerical.'

Within the gallery itself, the first main case (Figure 3.3.c) is also devoted almost entirely to *writing*. No escape here from the fact that the Roman province was ordered by a governing class who commemorated themselves (witness their inscribed tombstones that almost fill the case) in *writing*, and whose control and administration were founded on a tradition of *Latin literacy:* on the Latin alphabet (here displayed in its formal and

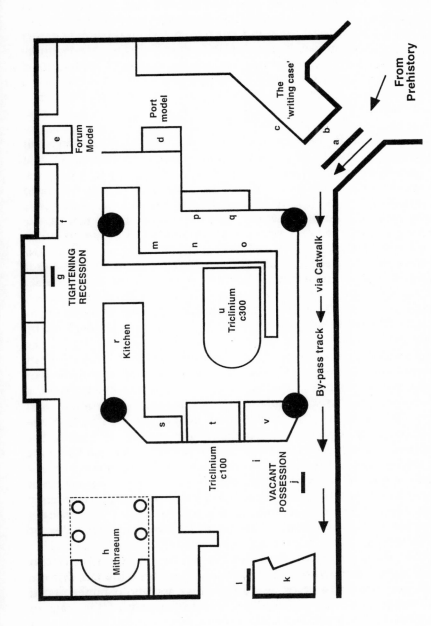

Figure 3.3 A plan of the Roman Gallery, Museum of London.

cursive variants); on marks of ownership (a lead ingot with its written stamp); on notes, registers, despatches, messages and inventories (inkwells, styli, writing tablets, graffiti). But more than that; as a Roman province, Britain entered *history* in a much more technical sense. The story of Roman Britain (unlike the prehistoric Thames Valley) is not something that must be wholly reconstructed from faint archaeological traces; part of it at least is already written for us, interpreted and explained – made *history* in other words – by Roman writers themselves. This first case reminds us of just that. One of its prize exhibits is (a replica of) the elegantly inscribed tombstone of Julius Classicianus, procurator of the province of Britain after the Boudican revolt – and the subject of a barbed half paragraph in Tacitus' narrative of the reign of Nero (*Annals* XIV. 38).[19] At last, after however many thousand years of (necessarily anonymous) prehistory, we find an individual with a name, a career and a walk-on part in the narrative of world history. Even if the monument is only a facsimile (the original is in the British Museum), it more than wins its place at the head of the show – standing for almost everything that makes a difference about *Roman* Britain.[20]

But modernity strikes also in another (discursive) guise. The headline on the large introductory panel (above the figures of the literate Romano-Britons we have already noted, Figure 3.3.a) reads as follows: 'Creating a CITY AD 43–400'. This is shortly followed by other panels headed 'PRIME SITE AD 43–60' and 'New town for green site'; and by illustrations of what all this capital investment might have looked like on the ground – an ancient new-town/garden city, with its 'mixture of Continental and native style houses', starter homes and executive villas. The Roman *city* was, so the hint goes, 'our' *city* in yet another sense: the City (capital C) of real-estate, money-making, investment and Thatcherite enterprise, with currency fluctuations, futures markets, profit and loss accounts not far behind. Whatever the familiarity embedded in the human condition that we (may imagine that we) share with prehistory, this version of modernity is much more precisely defined and much more radically 'modern' in our sense. In fact, even as we enter this gallery, we should be able to hear the (piped) human voices, the traders' shouts, the multi-lingual city hubbub, already drowning out the fading bird-song of the prehistoric green fields we have left behind with the flint axes.

These two themes that frame the entrance to the gallery leave their mark throughout the display. The main route follows a broadly chronological path: from the foundation of the city and its first inhabitants; through the destruction by Boudica; the development of the London port (with its now famous museum model, Figure 3.3.d); the building of the vast new Forum and basilicas – 'the largest ... north of the Alps'

(shown as a brand-new model, specially commissioned for the revamped galleries, Figure 3.3.e); the military and political changes of the third century (with Britain now divided into two provinces, and London the capital of 'Upper Britain'); to the final phases of 'home rule' under the would-be emperors Carausius and Allectus (displayed here on their coins minted in the province, Figure 3.3.i) and the eventual abandonment of Britain as a Roman province and of Londinium as a Roman city.

You leave the gallery past some deserted ruins, a shadowy ghost (Figure 3.3.k) – and two (apparently) conflicting messages. On the one hand, just as you pass into the passage that stands for the 'Dark Ages', the valedictory panel (Figure 3.3.l) makes one final assertion of continuity between the first London and the modern city: 'The Roman legacy was the establishment of the first major settlement on the site of the modern city of London ... The shape of the city was set by the Roman wall, built 1800 years ago.' On the other hand, there remains the nagging implication that even here 'continuity' might be rather more tenuous than is con-venient for the model of modernity being projected, that the first London might have been an embarrassingly false start. 'The end of Londinium came by quiet desertion rather than violent destruction' reads another information panel (Figure 3.3.j), under the heading 'VACANT POSSESSION'. 'London's inhabitants drifted away, leaving the town to collapse in ruins ... The secrets of Londinium stay hidden for the next 1500 years until archaeologists reveal London's origins.' Which is, just about, where we came in.

The information panels cast every one of these major phases of Roman London's history in the terms of big business, enterprise and corporate finance that we saw at the entrance to the gallery. A distinctive series of free-standing panels (in Pompeian red) divides the gallery into the his-torical phases of Roman occupation and gives each a title. The first (as we have already seen) is PRIME SITE AD 43–60; the next is CAPITAL GROWTH AD 61–200 (London's expansion as the capital of the province and its major trading port); which leads on to TIGHTENING RECESSION AD 200–85; CHANGING FORTUNES AD 286–410; and finally (as we have again already noted) VACANT POSSESSION AD 410–50. Most strikingly of all TIGHTENING RECESSION (Figure 3.3.g) captures the way the history of Roman London is here being elided with (or made sense through) the economic politics of (post-)Thatcherism, and the Europhobe anxieties of the 1990s. 'The third century was one of international uncertainty and worsening inflation' the main text of the panel reads. 'Many troops stationed in Britain were withdrawn to fight in Europe. Political unrest led Britain and Spain to declare an independent Gallic Empire in AD 259–77, but this probably had little effect on the daily life of the provinces ... A wealthy community continued to prosper

in London, although the cost of public building programmes became more burdensome to a decreasing population.'

To a degree, these economic slogans are part and parcel of an information strategy that relies on contemporary allusions, modern catchphrases and word-plays: 'On the Water-Front' (next to the port model); 'All Along the Watchtower' (by the fort); 'The Games People Play' (heading a case of Roman games and entertainment) – thus developing the rhetorical style of the Prehistoric Gallery with its 'The Good Life', 'Keeping up Appearances' and so forth. A series of gestures to street talk, which effectively subverts traditional museum jargon (no matter how embarrassingly old-fashioned it may all seem ten years into the next millennium). But at the same time the decision to articulate the whole period structure of the Roman Gallery around the catchphrases of late-twentieth-century business (playing time and again on the pun of the *City* within the *city*) is in some ways a precarious enterprise. Are we being asked to buy into this *literally*, to see Londinium as a model not only for the conurbation of London, but also for its economic base (Romans *were* proto-capitalists, making a killing in the real-estate market, before world recession prompted some tactical down-sizing)? Or are we being asked to follow through the questions raised in the Prehistory Gallery and prompted to wonder whether such contemporary terms do (or do not) offer an appropriate way of talking about enemy occupation 2000 years ago? In other words, are these strident (*over*)statements of one particular version of modernism encouraging us to reflect on the differences as much as the similarities between the Roman city and our own, and on the consequences of the very words with which we choose to describe the past? Or can we (and are we being encouraged to) read these panels straight? To return to the lessons of the Prehistoric Gallery, what happens to all the methodological doubts we learned to have in the first gallery, if we do not recognize the discursive trap set by these catchy slogans about Rome?

The role of writing in the Roman Gallery as a whole is crucial here. The assertion of the literacy of Romano-British culture that we saw at the entrance is continued throughout the displays. The (no doubt entirely illiterate) rebellion of Boudica is here accompanied by the written slogan daubed on the charred wall: 'Romans go home';[21] Carausius' breakaway empire is heralded by 'Rule Britannia' blazoned across the wall; a case displaying religion in Roman London makes much of written curses against private enemies, scratched on lead tablets. But more is at stake here than the simple ubiquity of the alphabet or the (obviously exaggerated, even cavalier) suggestion that functional literacy extended beyond the Roman administrative machine to local insurgents and private citizens down on their luck. The central claim of the Prehistoric Gallery (explicitly emphasized in its lead panel) is that prehistoric illiteracy effectively

undermines any attempt to construct an authoritative history of the period; because (so the argument went) there were no written records, our reconstruction of earliest 'London' is inevitably based on a series of contested interpretations of the faintest of archaeological traces; without writing, we can never be certain. But this inevitably raises the question of what we can *know* of periods where written records abound. Can we now tell a historical story – authoritatively? A historian's answer is, of course, that we cannot. Written records allow a different kind of story to be told, but one that is no less contested and not much less uncertain than the prehistoric version (as is clear enough from the centuries of debate on the history of Roman Britain or any other bit of Roman history one cares to name).[22] In the museum's logic, on the other hand, the advent of writing heralds the advent of an authoritative narrative: it heralds the arrival of a period about which we can *know* and speak with confidence.

In general the displays in the Roman Gallery are marked by the sheer absence of interpretive problems. As Shanks and Tilley (1992: 75) put it (thinking of the certainties of the museum narrative as a whole): 'The Museum of London quotes with objects.' We shall return to this idea; for now, it is clear enough that in the Roman Gallery the objects are regularly used to *illustrate* a historical narrative that is very rarely (effectively, *never*) shown to be contentious or debatable. More than that. From time to time the same objects (or objects drawn from the same assemblages) do duty, without comment, in contradictory stories: skulls from the Walbrook stream, for example, stand proxy *both* for the Romans decapitated by Boudican rebels *and*, under a different rubric, for native religious rituals. ('They may have been deposited there as religious offerings to British water gods.') On other occasions, the necessary objects turn out to be specially made for the show: Classicianus' tombstone (for all its centrality in the display and the argument) is a replica; and, under 'religion' again, the necessary 'quote' for the cult of Cybele turns out to be a replica of some metal 'castrating clamps' (or so this offending tool is conventionally designated).

In the Roman Gallery, then, the objects are deployed (or *made*) to exemplify a story – a story that can seem uncontentious precisely because it is itself underwritten by all the various forms of writing (from brick-stamps to 'history') displayed from the gallery entrance onwards. This offers a strong incentive to read the economistic modernism of the display panels 'straight'; and so a strong incentive to swallow whole the image of Londinium as the model of the familiar modern city. Of course, a determined visitor may choose to take the Prehistoric and Roman Galleries as a pair, both 'designed to assist the visitor in understanding how archaeologists have arrived at their conclusions' (Hebditch, 1996: 258, on the relationship between the two galleries before their refits in 1994

and 1996): the first focusing on the contested interpretation of the material evidence; the second on the discursive practices of archaeological description (what words best represent the past, in its familiarity or difference?) But there is overwhelming pressure *not* to react in this way, but to accept the authority of the written word – whether as object of museum display or as vehicle of 'information'. The lesson of the first main case in the gallery (the 'writing case') was, after all, to see the collaboration between *power* and the *power of writing*: Roman dominance was asserted – or so we were shown there – in its literate administration and in its claims to be able to make (i.e. *write*) history; the pens (which wrote the tax demands) no less mighty than the swords (which, more often than not, dangle from the soldiers purely for decoration).[23] This lesson must implicate also the words on the information panels and labels, and *their* claims to explanation and authority. And, at the same time, it is bound to suggest that we have now left the 'problems' of prehistory behind, as simply irrelevant this side of the Roman conquest. Writing has made all the difference – so *read it straight*.

New Roman Britain – on display?

Another strand in the history of successive displays about Roman London has been the stimulus from archaeological fieldwork and research. Haverfield's synthesis of the evidence from Roman London was no doubt used for the first London Museum displays at Lancaster House. They were later improved by Wheeler in the light of his own work ... The post-war displays in both the Guildhall and London Museums drew on W. F. Grimes' work ... and also on Peter Marsden's fieldwork. (Hebditch, 1996: 253)

Hebditch's review of the history of museum displays of Roman London (pre-1996) traces a close link between display case and archaeological research. It is not only that new fieldwork literally provides new objects to fill the cases, to oust the old favourites – though, of course, that is a part of it. New research contributes to historical reinterpretations of Roman London (or Roman Britain more widely) that the museum incorporates and follows. Inevitably, it might seem, in the case of the Museum of London; for, in a museum that is committed to historical narrative, once you change the story, you (must) change the museum. In the rest of this chapter, we explore how far the New Roman Gallery does reflect the New Romano-British orthodoxy outlined earlier; but at the same time, assuming a more dynamic model of museum display than Hebditch, we shall consider the ways in which the museum itself challenges that orthodoxy and (in part because of its commitment to 'quoting with *objects*') exposes some of the systematic occlusions of New Roman Britain.

The museum displays of Haverfield's Roman Britain, of Wheeler's or Grimes', have long been dismantled. But does the New Roman Gallery show us the Britain of Reece, or of his less uncompromising and hard-line colleagues? In part, it does. It is, in fact, an almost textbook display of one of the central certainties of the new orthodoxy: that the whole process of 'Romanization' is a much less certain, much more shifting, one than we ever used to imagine; that it has much less to do with Britain's relations with Rome, the Italian capital, and much more to do with its increasing links with 'Rome' in the shape of the north-western provinces of the empire. You could hardly find a *bona fide* Italian anywhere in this gallery; and you are explicitly told not to expect them: 'Few Roman Londoners came from Italy' explains the information panel next to the first case (the 'writing case', Figure 3.3.c). 'Administrators, soldiers and merchants were more likely to come from Germany, France and Britain itself.' 'Romans go home', we have been alerted, is a more paradoxical slogan than it might appear: at least, for most of the Romans in Britain, 'home' would have meant almost anywhere other than Rome the capital city. That certainly is the message of the people whose inscribed names and careers form the focus of the first case: Julius Classicianus from Gaul; Claudia Martina and her husband (a slave of the administration of the province) – presumably a mixed marriage, but no obvious trace of Italian provenance for either partner. The nearest we get to Rome (the city) is a small, neat inscription commemorating a man from Arezzo. And it is the same picture a few steps further on, in the case headed 'The Balance of Trade': admittedly this highlights a few luxuries from Italy (and further east), but the staples are Samian pottery from Gaul; wine from the Rhineland; fish sauce and olive oil from Spain. The port of Roman London may certainly have been (as an information panel next to the model calls it) 'The Gateway to Europe', but then as now the links between Britain and its northern European neighbours counted for much more than the odd shipment of marble from the Mediterranean. What we see throughout these displays is almost exactly Reece's vision of 'Romanization' – a growing homogeneity between the island of Britain and the nearby Roman provinces (i.e. not Rome).

Of course, the Museum has its own axe to grind here; or, at least, 'Romanization' in that new sense seems to fit very neatly with one of the themes that the Museum has made central to its presentation of London at every period. London has always been a multicultural melting-pot; never capital of a 'little England', it has always teemed (just as it does now) with immigrants, foreign languages, refugees, different religions, mixed marriages, ethnic diversity. That is (so the Museum story goes) precisely what makes it *London*. And that is precisely what makes Roman Londinium so appropriate an ancestor of the modern city. It was not, as

the old-style history tended to imply, just a load of native Celts living awkwardly with (and at a distance from) a handful of 'Roman' (in the strictest sense) overlords. It was already, to follow the new model, that familiar mix of people from all over the place getting together (in every sense) *here* – in London. Or (if you choose to load the story slightly differently, perhaps incompatibly – but never mind) it was London, always already a *European* city.

On the other hand, the total disjunction that the display parades between Roman London and its prehistoric past runs thoroughly against the grain of an equally central tenet of New Romano-British archaeology – the essential continuity between the Late Pre-Roman Iron Age and Roman Britain. The Roman Gallery allows barely a trace of any continuity *backwards* to prehistory (continuity *forwards* to modernity is, of course, another matter). Indeed the one area where such links into the past might most easily be demonstrated – peasant agriculture – is hardly visible here at all. For the London we are being encouraged to see is emphatically a *conurbation*, not even a conurbation within (and closely related to) its rural periphery and hinterland.

Significantly it is only in the Prehistoric Gallery (in their sneaky forward look to Roman Britain) that we find any explicit statement along these well-known New Romano-British lines: 'Following the Roman invasion of AD 43, most continued to farm the land as they had always done.'[24] You find no such concession in the Roman display itself. In fact, as far as Roman London goes, agriculture returns only when the 'Romans' leave – a mark of desolation and abandonment.

Of course, there is a clear museologic underlying this apparently sharp split between prehistory and Rome. The Museum is committed to a view of London as a *city*, and to a narrative of its development which celebrates certain aspects of that *citiness* (the bridge, the port, the multicultural melting-pot, the name) as central to *London* at any period at all. It would be a high price for the Museum to pay to ignore those aspects as they are found in Roman London and to cancel out the 'origins' of the (recognizable) city as we know it, in favour of a tenuous vision of Iron Age continuity. But suppose it were to decide to do just that (and to start its story of London the capital at some other more or less plausible date – the founding of St Paul's, for example, in or just outside 'Lundenwic' in 604). How then would it display the Roman period? How would it make the point of continuity between prehistory and Rome?

Certainly not by displaying the objects in its collection. Certainly not by having on show the mosaic floors, the inscribed texts, the written curses, the sculpted tombs, the inkwells, the stamped amphorae. Those would all have to be kept well out of sight, making way for more of prehistory, plus some strikingly empty cases.

Maybe, you could conclude, that this is precisely the weakness of museum history: that it must 'quote with *objects*'; that it is horribly inadequate in telling any tale that cannot be illustrated with artefacts (coins, bone-pins, massive building blocks); that it reduces history to what can be *shown*. But on the other hand, so the counter-argument goes, the surviving objects must represent a challenge to any story (however theoretically compelling, or romantically engaging) that cannot be told *with* them. Roman London and its surviving remains do (ineradicably) run against the grain of the most radical arguments for continuity between Roman Britain and its past. Take, for example, writing. So far, we have queried the emphasis put on the literacy of Roman Britain as a source of authority in the construction of a historical narrative. But we have not questioned its undeniable presence in Roman Britain or the difference that (even restricted) literacy makes to any social and political group. No doubt only a tiny proportion of the inhabitants of the Roman province could read or write (forget 'Romans go home'); but, nonetheless, the presence of an imperial power exercising its control through writing (not just the age-old sword) meant a radical break with the past – a radical break that the Museum certainly ought to be (and could hardly avoid) portraying.

Or take urbanism. The most hardline of New Roman-British archaeologists attempt to see the towns of Roman Britain as an ill-rooted, transient phenomenon. What then of London? It can, of course, be slipped conveniently into the 'transient' category (for, after all, Roman London did in the end fade away). It can be regarded as an exception (as capital cities in some sense always can be). Or it can be ignored (significantly perhaps, Richard Reece himself, when assigned the task of writing an article on 'How to interpret Roman London?', in fact writes about something completely different – archaeological method (Reece, 1996: a characteristically idiosyncratic defence of unfashionable 'trench archaeology'). But the display of Roman London in the Museum, and the narrative possibilities that go with it, must always stand against such superficially plausible tactics; must always refuse to be written off as transient or to be ignored – 'exception' or not.

It is not a question, in other words, of the Museum 'failing' to follow the tenets of up-to-the-minute archaeological theory; or of being 'constrained' by its own function as museum; or of some weakness of nerve on the part of its curators, still attached to the display of their prize treasures. The Museum (and its objects) represents a major challenge to any picture of prehistoric continuity in 'New Roman Britain'. The opportunity that this gallery misses is not the opportunity to show Roman Britain as crucially and importantly different from what went before; it is the opportunity to make explicit its own role in those interpretative debates. Strikingly, not one information panel or label alerts the

visitor to rival versions of the story, or to the Museum's reasons for presenting things this way. Here the single authoritative text wins all.

Multicultural London: a case study?

There is one part of the Roman Gallery we have not yet explored – in fact, by far the most widely known section of the display, and its star attraction. In the entrance hall to the Museum as a whole, just before the Prehistoric Gallery, various devices (taped information announcements, poster displays, illuminated timelines) are arranged to help visitors plan their visit, and (in particular) to answer the question: 'What should I see if time is short'? The answer is clear: 'If your time is limited follow the Catwalk, dropping on and off to see gallery favourites – Roman Interiors, Victorian Shops, The Great Fire Experience, The Lord Mayor's Coach'. These 'Roman Interiors' – replicas of a Roman kitchen, two Roman *triclinia* (dining rooms, one *c.* 100 CE, the other *c.* 300 CE), as well as a street of shops and craft workshops) are at the centre of the gallery, a detour from the main chronological path. But they are old favourites (much of this display has been taken over from the previous version of the gallery). For many, they steal the show.

You can enter this section of the gallery at two points. If you turn left, up a ramp, just after the model of forum and basilica, you come almost directly to a row of shops and workshops: in enclosed cases on your right, a glassmaker's workshop (Figure 3.3.m), a shoemaker's (Figure 3.3.n) and a carpenter's (Figure 3.3.o); on your left some replicas of Roman market scales, free to load and try your hand at balancing (Figure 3.3.p); followed by (behind glass again) a cutler's store (Figure 3.3.q), and underneath, in drawers you are encouraged to open, more cutlery (plus the cutler's lunch) waiting to be discovered.

If you continue on this path, you will shortly come round – via a back route – to the other major area of reconstructions; but many visitors arrive at this point instead by interrupting the chronological tour just as they reach the 'Tightening Recession' of the third century, taking a left turn, past a reconstructed donkey-mill. The first (open) display is a 'Roman kitchen' (Figure 3.3.r), with its hearth, its pots and pans, and (in an enclosed case next to it) an array of (mostly replica) Romano-British food: some figs, pears, a dead hare. This leads on past a display of jewellery and dressing-table equipment (and more drawers to open) (Figure 3.3.s) to a mock-up dining room of *c.* 100 CE (Figure 3.3.t) with its mosaic floor, painted walls, dining couch and cupboard; and opposite (Fig 3.3.u), the biggest and grandest room of all – a dining room two hundred years down the road, with a couch again, a rather more spectacular mosaic floor and wall painting, table and high-backed chair (whose occupant we shall

meet shortly). Around the edge, the barrier that keeps the unwary public from trampling over the priceless (= pricey) mosaic doubles as an information panel – on plastering technique, paints and hypocausts. With all this to take in, you may not even notice the poor family's hovel, tucked away in the corner, safely behind glass (Figure 3.3.v).

The rhetorical style of this section of the display is a close match for the modernism we have already seen: 'How the Other Half Lives', 'The Food Chain', 'In Good Decorative Order', 'The Latest in Modern Kitchens' – they all press home the real-estate analogy, while bowing discreetly in the direction of the less advantaged. Although there is less direct reference to literacy and the written word, it is here – in the palpable 'reality' of these rooms – that we finally cash in the authority of writing set up from the very beginning of the gallery. For it is the *knowledge* bought with that authority that allows us here to enter Roman Britain for ourselves, direct and unmediated. We stand at the balance and weigh our sacks just like a Roman, because (so the implication goes) we *know* how Romans weighed, their systems of calibration, their scientific principles, the operations they (must have) carried out. We can find the cutler's lunch, because we *know* what a cutler would have eaten at his shop *c.* 200 CE. There is something much more 'real' here than in the prehistoric dioramas (where, in any case, we had been alerted by the assurance that no animals had been killed to make the display, that the whole lot was 'fake'). And it is a 'reality' enhanced by the general absence of any human figures from the display. However, on a number of Sunday afternoons throughout the year, a 'real' (well, living, breathing) Roman sits in the high-backed chair of the large *triclinium* ready to get real with visitors, and *talk*. It is her interaction (for she is a woman, Martia Martina), and the implications of her role for (particularly) the multicultural themes of the whole gallery's display, that we explore to conclude this chapter.

'Multiculturalism' is always easier to say than to display. We have already pointed to the slightly awkward (even if convenient) elision in the Roman Gallery between the culturally mixed image of Roman Britain that is central to New Romano-British archaeology and the modern multiculturalism that defines contemporary London. In fact, at various points in the chronological sequence of displays, the awkwardness of that elision comes into view. Nowhere more clearly than in the section on the religions of Roman Britain (slotted, slightly uneasily, into the gap between the 'Tightening Recession' and the 'UDI of Carausius'), whose centrepiece is the material from the most famous building ever excavated in London: the Walbrook Mithraeum (Figure 3.3.h). Here (under the heading 'East and West') we are suddenly confronted with a quite different model of cultural interaction than has been suggested before: a vision of the mystic 'orient' and its exotic deities (Mithras, Cybele, Isis, eventually Jesus Christ)

gradually infusing the more down-to-earth religious traditions of Rome and the West; just the kind of weird cults to become 'popular in cosmopolitan London'. But it is the role of the walking, talking Roman woman and her interaction with her audience that more than anything threatens to subvert the claims of a 'multicultural' Roman city; or, at least, threatens to expose the museum's multicultural gloss as the old story of glamorous, (classically) sophisticated and uncontentious Roman London under another name.

She sits on the chair in that room, (inevitably) *writing* on wooden tablets: we later discover that she is in the middle of a letter to her soldier boyfriend. When she chooses to notice, and to be surprised by, the vast throng of visitors who have apparently poured into the house, she introduces herself as Martia Martina – a freed slave, now maidservant to the lady of the manor, who is actually out just now, but is expecting us, and has asked Martia Martina to look after us till she gets back.

Martia Martina turns out to be an apt voice for the Museum's display, especially as we find out more about her. Originally Scottish (well, 'Caledonian', as she explains), she was sold into slavery in a Roman army camp by her parents at the age of eight – they couldn't afford to feed her. She was brought to London, and has since been granted her freedom by her rich master, although she continues to work in the house as a lady's maid. With any luck, and with her master's permission, she'll soon marry her soldier. Neatly spanning the categories of British and Roman – rich (where she now lives) and poor (how she was) – she can speak to the audience from every side of the social, political and cultural divide. The outsider's insider – someone whose very position commits her always to explain and interpret; someone whose lecture to us (for that in the end is what it will be) can still strike a plausible rhetorical chord. Run through the difficulties of visitor interaction with the notional occupant of the poor hovel, or with Martia Martina's swaggering master, Rufus Martius Comitialis: although both might make some powerful museum theatre ('**** off, this is private property', 'Throw them out'), neither could act as our cultural tour-guide with any rhetorical, or political, plausibility at all. ('WE only have one room in our little house, but many people in our city are lucky to live in much grander surroundings; I once went into the mansion of...'). Martia Martina on the other hand – with all the spirit of the traditional lady's maid who does (in)advertently spill the beans on her betters – can speak about them, to us. She can stand as perfect proxy, tame as tame can get, short of bathos.

Her account of herself (which can scarcely change from one performance to the next) stresses both the unfamiliarity and the familiarity of Roman London – and specifically of its Romanness. 'What's your name?' she asks her listeners. 'Julie' comes the reply. 'Oh, so you're a slave then. No?

But if you've only got one name you must be a slave. Oh, you've got two names. So you've been freed. Ex-slaves (like me) have two names. Anybody got three names? A Roman citizen then.' Straight from the scenario of introduction, via a (drastically over-simplified) account of Roman nomenclature, to Roman social hierarchy. And so it continues. We get some suggestions for what we might all like to eat while we're 'waiting' (including the perennial joke of 'stuffed dormice') that bring the predictable gasps of disgust, and a passing reminder that guests in this culture normally bring their own hardware ('You *have* brought your knives with you?') We are gently interrogated about our religion ('What are the names of your gods?'); learn a bit about Mithraism ('I shouldn't tell you this, it's really very secret. My master belongs, but no women are allowed.'); and discover that Martia Martina fears herself to be the victim of a curse ('My name's been written down backwards on a piece of lead'), all because the maid across the road has her eye on the same Roman soldier.

But all this unfamiliarity is set within a frame of familiarity that we are assumed readily to recognize. The house has an efficient form of central heating – and, as always, it's terribly costly to run (in this case you have to keep a slave piling up the fire night and day and 'my master complains bitterly'), but the mistress insists on running it because (being from sunny Gaul) she likes it hot. She has other familiar (female) extravagances too – shopping (for emeralds if possible, 'I expect that's where she is now'); and having her hair done (it can take hours for Martia Martina to pin it up the way she wants – a dead ringer for the latest *Roman* style, not to mention all that henna). But if this doesn't strike a chord, then there are always the shows at the amphitheatre: boxing, wrestling, acrobatics, juggling and of course – 'Who's *your* favourite gladiator? Wolf ... you mean Lupus.' Gladiators are popular wherever (whenever?) you are.

This whole account is expertly integrated into the rest of the gallery display. There is hardly a topic touched on by Martia Martina that does not link to something that is on show: from the Mithraic sculptures to the acrobat's leather panties (if that's what they are: shades of Raquel Welch?) in the case on 'The Games People Play'. The observant visitor will even find that Martia Martina was correct to fear that she had been cursed – for there is indeed a tablet with her name written mysteriously backwards among the curses on display. And you could hardly fail to spot the close match between the social relations she describes and the cultural mix that we have seen as defining the version of Roman Britain on display here: a native Britain, sold into slavery, now freed and sporting a very 'Roman' name and hoping to marry a boy from the legions, serving a Roman citizen master from we don't know where, married to a woman from Gaul. Martia Martina's little speech effectively rearticulates the display we have walked through. It turns the visual narrative of the museum cases back into words.

As it does so, it reveals a much more fragile side to the Museum's version of multiculturalism than we might have expected. It reveals the uncontentious cosiness that lurks under the Museum's social, cultural and ethnic melting-pot. It is not just that Martia Martina seems happy to act as the voice of a culture that enslaved her: enthusing about the foods we have 'from all over the empire' and enjoining her listeners not to 'feel sorry' for her enslavement (she is after all a lot better off in a centrally heated house in Roman London than in the wilds of Caledonia); it is not just that in the end, as it finds a voice, the character of this mixed city turns out to be as 'Roman' as you could wish (from Mediterranean-style dining arrangements to the 'Roman empress' hairstyle that fashionable London ladies look to imitate); it is not just a question of the actress letting her hair down after her display and agreeing 'out of character', as we overheard on one occasion, with some grateful visitors that 'Yes, it was a nice era, the Romans – after they left the whole place became filthy again'. It is also a question of multiculturalism losing its bite.

Multiculturalism signals tension and contestation as much as it signals a great happy melting-pot. In fact, that particular image of inter-cultural harmony is itself a response to (and dependent on) inter-cultural dissent: it is an optimistic repackaging of 'difference' into 'admixture'. Here, in the display and its verbal gloss, almost every trace of the violence and dissent of cultural difference has been erased, to produce a London of happy look-alike Romans worried about their boyfriends or the cost of the central heating. A picture which in the end has much more in common than it perhaps would like to imagine with the traditional, always upwardly mobile, accounts of everyday life in the civilised *Roman* world. No room here to imagine those cartoon Roman Britons with their sub-terfuge, their resistance, the balloons of resentment or relief we should try imagining coming out of their heads.

Of course, that may be part of the point. Within the politics of con-temporary multiculturalism the Museum has its own part to play in pre-senting an image ('real' or not) of cultural harmony and a history of the city as one of constant admixture – no matter how far back you go. It may well be a principled decision, an ideological choice in a racially divided culture, to present racial/cultural mixture not only as ever present, but as how the city has forever (successfully) defined itself. But there are con-sequences for this vision of Roman Britain, as our final parable will show.

Multiculturalism on Tuesday

Martia Martina does not only materialize on Sunday for the Sunday afternoon crowd of visitors. During the week she talks to school parties, who are the other main category of visitor. Her act is much the same then

as at weekends; the differences largely come in the form of a few 'targeted jokes' about Roman teachers being slaves. But for all the similarities, the change of audience changes the show — and indeed takes apart the message. As we saw, one Tuesday.

Martia Martina did her stuff in the usual way: the greeting, the welcome to London, the gestures of hospitality ('I hope you'll soon make lots of friends here because we have people from all over the empire'). Then the same question about single names and the joking, mock-miscomprehending response — 'Oh, so you're a slave then.' There was one crucial difference, however. The school party that we watched was from south London; and the girl (aged about eight) who volunteered her single name was of African-Caribbean descent (like more than half her classmates; the rest were of Asian descent).

This question (like those that followed on religion, and 'funny' foods) instantly exposed the cosiness of the multicultural vision that the display risks espousing. It's a vision that goes down well in the easy, admiring banter of the largely white Sunday afternoon crowd. But it looks distinctly vulnerable at the real, sharp edge of multicultural London.

Acknowledgements

This chapter could not have been written without the help of Jenny Hall and Nick Merriman. In particular, Jenny gave us a run-down on the reception of her new display and pointed us towards the supplementary impact of the Catwalk and Martia Martina's performance.

Notes

1. Reece's home-grown postmodernism makes precise reference to his important book very difficult. He reserves the right to rewrite and republish without signalling changes: 'This means that there is no guarantee that "Pot 3" in one copy is the same as "Pot 3" in another, so detailed references are pointless. Just say "an idea I got from *My Roman Britain*" and if editors niggle tell them to get stuffed.' Against the letter, but in the spirit, of these high principles we have done no such thing.

2. A leading light of New Romano-British studies, Simon James, drew the now famous cartoon, which appeared (for example) in a Cambridge Classics Tripos paper (1993), with the question: 'Would you agree with the comment made by this cartoon on the Romanisation of Britain?' We use the term 'orthodoxy' against the grain of another founding text of these new approaches: Millett (1990: xv): 'While th[is] book is partly designed as an "alternative Roman Britain" it does not aspire to be a "new orthodoxy"'. We see it as *both* 'alternative' *and* 'orthodoxy'.

3. The tradition stretches back (in all manner of guises) through Richmond (1955) to predecessors such as Haverfield and Collingwood.
4. Millett (1990: xv) explicitly refers to himself (and his readers) as 'members of the post-imperial generation'; more bluntly, Reece (1988: 8) in a memorable discussion of Fishbourne writes of the Roman 'palace' as 'a Romanizing blot on the landscape'.
5. Beard and Henderson (1997) explore the pre-1996 Roman Gallery, adumbrating some arguments made here. We have chosen not to compare the 'old' and 'new' displays systematically – though anyone who compared our two essays would get a fair picture of the differences. For further information on the 1976–96 display, its curatorial philosophy and its predecessors (in the old Guildhall Museum and elsewhere), see Hebditch (1996).
6. If the couplet inscribed beneath the statue ('Regions Caesar never knew/ Thy posterity shall sway'; W. Cowper) was meant to help smooth over the awkwardnesses, it signally fails. If the point is that twentieth-century Britain is to be a *bigger* power than the Roman empire against which Boudica fought (and lost), then ... what?
7. Deary (1994: 46–7) puts the arguments at their starkest, in a strip-cartoon of exchanges between a 'rotten Roman' and a tartan-trousered (brainless) Briton, ending:
 '(RR) "The brutal British tortured prisoners, you brainless Briton. Boudica's army would burn, hang and even *crucify* prisoners!"
 (BB) "And who *taught* us about crucifixion?"
 (RR) "Er ... the Romans?"
 (BB) "Exactly, so *we* win the argument."
 (RR) "Ah, but *we* won the battle." '
8. LPRIA culture is symmetrically upgraded, so that Roman Britain is much more like LPRIA because LPRIA never was the muddy primitive place we used to suppose.
9. Of course, the Romans also constantly told this story of ethnic diversity about themselves. That, at least, is one significance of the tale of Aeneas and the mythic foundation of the Roman race from Trojan exiles.
10. 'I wanted to set out, for the first time in my life, what I wanted to say, in the way I wanted to say it' (Reece, 1988: iii).
11. Not just a discreet distance: despite (or perhaps because of) its enormous *samizdat* influence, Reece (1988) was hardly reviewed; rarely explicitly cited, it lurks under allusions to 'radical new approaches' and 'prehistoric paradigms'.
12. Potter and Johns (1992) foreground this decision, from a specifically museological perspective: 'We are far from being against new approaches ... and there are in this book more than a few echoes of some current thinking of this sort. However, nearly forty years' experience between us in the British Museum, curating the Romano-British collections, have undoubtedly coloured our views. We live with exotic finds.' (9–10).

13. A very similar duality is discussed in Reece (1996): 'Commentators on Roman Britain have usually started *either* from the material remains compared through archaeology and starting from Britain ... *or* compared with written evidence starting from Italy' (p. 41). He cites Morris (1982) (transparently entitled *Londinium: London in the Roman Empire*) as the classic example of the second approach; he might also have picked on Salway (1981): 'Much that is scattered and incoherent when viewed from a Romano-British viewpoint alone falls into place observed in its context as part of the evidence for the age as a whole' (p. vii; also quoted by Hebditch, 1996: 261).

14. Our two principal categories of visitor reduce to its bare essentials the range of *seven* visitor types identified by the Museum's own surveys (see, for example, Cotton, 1997: 7). We have excluded 'special users' (lecture audiences, corporate hospitality); researchers; 'non-users' (the potential visitors who don't actually get through the front door); and we have conflated 'local' and 'foreign' tourists.

15. As is clear on the plan (Figure 3.2), the main route leads right past the first cases of the Prehistoric Gallery (notably the display of prehistoric technologies). Those pressing on to later periods can then veer left and bid prehistory goodbye; for the full story of prehistory (the interior of a prehistoric house, metalworking, social change, the development of trading contacts, the first Roman 'invasions') you take a right turn, follow the detour and rejoin the main route at 'c'.

16. A dead deer is strategically placed in a case opposite the display of prehistoric technologies, in the middle of a gory scene of hunting, with a (stuffed) rook apparently pulling out the poor creature's intestines. We should have been prepared for this parade of butchery by a small note under 'Can you believe what we say?': '(No birds or animals have been killed for the displays in the gallery)'.

17. This issue is briefly touched on in Cotton (1997: 9). It is seen, in its most unsettling form, in the horribly plausible suggestion that a large number of so-called flint 'tools' are in fact off-chippings, the unintentional by-products of larger scale flint working – in other words, junk, not tools at all.

18. In Beard and Henderson (1997: 69), we noted that particular symbolic significance attaches to the First Fire in a museum that makes the Great Fire (Experience) the crucial turning-point on the way to the 'real' modernity located on its lower floor (from Christopher Wren and New St Paul's onwards). Despite its paltry archaeological traces, Boudica's fire is here brought to eye-catching prominence by the theatrical 'charring' of the wall around the relevant case (itself headed 'Chariots of Fire').

19. Although Classicianus is traditionally praised for gentle conduct towards the British insurgents, Tacitus has no truck with his disloyalty towards his tough-it-out superior, Suetonius Paulinus.

20. This part of the display does not stress the connection with Tacitus, but it is made clear in the Boudica case, just opposite (Figure 3.3.d). Significantly, the prehistoric galleries manage to treat Julius Caesar's invasion of Britain (they call it a 'visit') without mentioning that we have Caesar's own auto-biographical account in his *Gallic Wars*. Prehistory is committed to its own illiteracy.

21. Echoes too, no doubt, of *The Life of Brian*.

22. To put it more strongly, the proliferation of writing itself encourages and legitimates competing versions of the past. It is as much a vehicle of interpretative dispersal as of univalent authority.

23. Especially the tomb-sculpture of the soldier who supervises the entrance to the gallery (p. 55) – more concerned with his tablets than with his weapons.

24. The panel grudgingly continues: 'Others joined the growing population of the new Roman town of London.'

Bibliography

Beard, M. and Henderson, J. (1997) 'Representing Rome', in Denford, G.T. (ed.), *Representing Archaeology in Museums. The Museum Archaeologist* 22. Winchester: Society of Museum Archaeologists, 65-70.

Cotton, J. (1997) 'Illuminating the twilight zone: the new prehistoric gallery at the Museum of London', in Denford, G.T. (ed.), *Representing Archaeology in Museums. The Museum Archaeologist* 22. Winchester: Society of Museum Archaeologists, 6–12.

Deary, T. (1994) *The Rotten Romans*. London: Scholastic.

Dudley, D. and Webster, G. (1962) *The Rebellion of Boudicca*. London: Batsford.

Frere, S. (1967) *Britannia: A History of Roman Britain*. London: Routledge and Kegan Paul.

Hebditch, M. (1996) 'The display of Roman London', in Bird, J., Hassall, M., and Sheldon, H. (eds), *Interpreting Roman London: Papers in Memory of Hugh Chapman*. Oxford: Oxbow Books, 253–61.

Merriman, N. (1995) 'Displaying archaeology in the Museum of London', in Denford, G.T. (ed.), *Museum Archaeology: What's New? The Museum Archaeologist* 21. Winchester: Society of Museum Archaeologists, 60–5.

Millett, M. (1990) *The Romanization of Britain: An Essay in Archaeological Interpretation*. Cambridge: Cambridge University Press.

Morris, J. (1982) *Londinium: London in the Roman Empire*. London: Weidenfeld and Nicolson.

Potter, T. W. and Johns, C. (1992) *Roman Britain*. London: British Museum Press.

Reece, R. (1988) *My Roman Britain*. Cotswold Studies vol. 3. Cirencester: Cotswold Studies at the Apple Loft.

Reece, R. (1996) 'How to interpret Roman London?', in Bird, J., Hassall, M. and Sheldon, H. (eds), *Interpreting Roman London: Papers in Memory of Hugh Chapman*. Oxford: Oxbow Books, 39–42.

Richmond, I.A. (1955) *Roman Britain*. Harmondsworth: Penguin.

Salway, P. (1981) *Roman Britain*. Oxford: Oxford University Press.

Shanks, M. and Tilley, C. (1992) *Re-constructing Archaeology: Theory and Practice* (2nd edn.). London: Routledge.

Todd, M. (1981) *Roman Britain 55BC–AD400: The Province Beyond Ocean*. London: Fontana.

Woolf, G. (1996) *Times Literary Supplement*, 12 April 1996, 8.

4

Viewing the 'Dark Ages': The Portrayal of Early Anglo-Saxon Life and Material Culture in Museums

Sam Lucy and Clare Herring

Introduction

The early Anglo-Saxon period in Britain (*c.* fifth to seventh century AD) saw a number of important cultural changes – changes such as the introduction of Christianity, the beginnings of state formation and the foundations of urbanism (Bassett, 1989; Hodges, 1989a). However, recent research has suggested that academics and museum professionals often assume a level of popular knowledge about this period which is unjustified. Museum visitor surveys have shown that there is confusion among visitors about precisely when the Anglo-Saxon period was. Furthermore, apparently well-informed visitors are unable to articulate any contribution the period might have made, and all too often contrast it unfavourably with the Roman and Norman periods (Herring, 1993).

Although it could be argued that this lack of understanding of either the basic chronology or influence of the period has arisen through the (non-)teaching of this period of history in schools, visitor surveys suggest that it is not generally remedied by viewing displays about the Anglo-Saxon period. There appears to be an inconsistency between the stated aims of curators, who express a sincere commitment to the representation and interpretation of the material culture, and their seeming reluctance to evaluate whether those aims have been met.

This problem arises from a number of sources. Displays are often couched in a language and style which precludes most museum visitors from understanding the information and ideas which are being expressed. The permanent nature of many museum displays, and the high cost of re-display and conservation, means that many museums are still presenting an extremely old-fashioned view of Anglo-Saxon life and material culture, using lengthy texts and dense displays of small objects which take no

account of recent research (research which is itself rarely aimed at a non-academic audience).

Moreover, it has recently been recognized that the study of the Anglo-Saxon period was both instrumental in, and defined by, the development of English nationalism and national identity (Lucy, 1998; MacDougall, 1982). The way in which the Anglo-Saxon period is portrayed in many museums is a reflection of an implicit political narrative. This chapter investigates the representation of Anglo-Saxons in museums in this light, and then looks at misconceptions of the period commonly held by visitors, through an examination of Anglo-Saxon displays in twelve museums spanning a national, regional and local spectrum (Herring 1993; see Appendix). It will then consider how museums might portray this period more accurately and effectively, in terms of the content and style of exhibits; and how the material culture might be made both relevant and interesting to the general public, while remembering that the visitor may come with a very basic level of (possibly misconceived) knowledge.

Nationalism and the Anglo-Saxons

The historical narratives which are implicitly or explicitly expressed in museum displays are by their very nature dependent on past and current ideas within Anglo-Saxon scholarship (indeed, some of the foremost Anglo-Saxon scholars in the late nineteenth and twentieth centuries were not university lecturers but museum curators). However, the important role played by Anglo-Saxon studies in supporting the burgeoning English nationalism of the eighteenth and nineteenth centuries is, as yet, little appreciated by archaeologists and museum curators (though see the work of historians, such as Burrow, 1981; Kliger, 1972; and Smith, 1987). It is important that this relationship – between academic ideas and their expression in museum displays – is both understood and made clear.

The idea that the English were an identifiable 'race' descended from the Germanic tribes called Angles, Saxons and Jutes (who invaded eastern Britain in the fifth and sixth centuries AD) has a history which stretches back to the sixteenth century. (Before this, it was the Trojans who were seen as ancestors of the Britons.) This idea has been identified as an 'origin myth' (MacDougall, 1982), which became elaborated in the course of its use as political and religious propaganda in debates about parliament, the church and the monarchy (MacDougall, 1982; Lucy, 1998). This elaboration saw it transformed towards the end of the nineteenth century into its most virulent form, whereby the Victorian racial purity of the English (whose moral and physical characteristics were linked directly to those of the 'Anglo-Saxon' tribes) was dependent on the complete destruction of the native British in the fifth and sixth centuries (see, for

example, Freeman, 1869; Green, 1874). The early medieval history of Britain was thus defined in a later nineteenth-century atmosphere of nationalistic antagonism, which contrasted 'Celt' (i.e. the French and the Irish) unfavourably with 'Anglo-Saxon' (Colley, 1992; Curtis, 1968). National characteristics became defined accordingly.

It was in this period of national definition and opposition that Anglo-Saxon archaeology began to develop as a discipline. The research topics of the historians became the research topics of the archaeologists, and re-evaluations of the material culture of the early medieval period bolstered the growing affections of the historians for 'pure' Germanic origins for the English. The origins of Victorian democracy and independence were seen to reside in the earliest English settlements, and those settlements were identified by the archaeologists through the ever-increasing numbers of furnished cemeteries which were excavated during the nineteenth century. The important research questions were thus seen as the nature and progress of the invasions, the distinction of different tribal areas of Saxons, Angles and Jutes, and the fate of the native population (Lucy, 1998: 12).

Although nowadays, the total extermination of the native Britons is no longer considered likely (Hills, 1979: 313; Hamerow, 1994: 164), the field is still largely reliant on a conception of early medieval ethnicity which sees tribal groupings in biological and nationalistic terms, as fixed entities linked by common language, culture and blood-relations (Lucy, 1998: 12). It still sees these tribal groupings as the subject of history, rather than examining how people came to identify themselves with them.

Such conceptions can be seen clearly in the layout and narratives of some museum displays which represent the incoming 'Anglo-Saxons' as a dominant force, destroying all traces of British population and culture. For example, at Liverpool Museum the following explanatory text is found, under the heading 'The End of Roman Britain':

> c450AD more and more Angles and Saxons arrived, often fighting the Britons for land. British society began to change as many people left the towns to set up new homes in the prehistoric hillforts ...
> Eventually the Saxons settled into most of what is now England. Most Britons wanted nothing to do with the foreign settlers, and lived either in Wales and Cornwall, or in quite separate settlements in England.

Similarly, at the Museum of London (although elsewhere quite up-to-date in its interpretation of events in this period) the following comes under the heading 'Settling In':

> In Eastern Britain ... the Anglo-Saxons took land by force from the native British people, or settled down to farm alongside them ... British peasants may have worked for Anglo-Saxon landlords, others may have fled to the West.

Such pictures of disjuncture are emphasized by the many displays which deal with Roman Britain quite separately from Anglo-Saxon England (often in different areas of the museum, as at Newcastle and Liverpool), implicitly suggesting that the latter is entirely uninfluenced by the former. Even when the visitor is encouraged to follow a chronological sequence, differences between periods are still sometimes implied by the use of different presentation styles.

The continued use of the term 'The Dark Ages' exacerbates these problems, encouraging the picture of an obscure, gloomy period wedged between the supposed civilization which took place under Rome, and the achievements of the High Middle Ages. Museum representations of the period have played a role in promoting and legitimizing this term. At Liverpool under the heading 'What are the Dark Ages?' comes the statement:

> The name the Dark Ages is used by historians to describe the fifth and
> sixth centuries in Britain because we know so little of what happened.

Such perceptions are often echoed, and even emphasized, in the physical ways in which the material is presented. The style used at Liverpool – black writing on white boards with black and white photos and a cream background – does little to dispel the implied lack of colour in the period.

Problems of access

A museum visit should be a holistic experience which involves both learning and enjoyment and, at best, stimulates a desire to know more and ask questions. However, before any experience can take place, the individual must negotiate the purely practical problems of access to the museum and orientation within it. Only then can the more difficult problem of engaging the interest of the visitor and enhancing the experience begin. The Anglo-Saxon displays of some museums are not always easy to find. The large national museums often lack clear plans to guide the visitor through the galleries. Indeed, only two of the twelve surveyed had informative and cheap museum guides which could serve this purpose.

The isolation of some Anglo-Saxon displays from contextually relevant material (at Liverpool, for example, where it is surrounded by the brightly lit Ince Blundell Marbles and strong ethnographic and Egyptian displays) might be seen to reflect the view of this period as a 'Dark Age', rather than as one of decisive historical importance. Obviously, not all displays can be equally prominent, but they can be located where they are relevant to the surrounding material, and therefore can be viewed in historical context. The layout of some displays is also confusing. At the Museum of London, the text panels only make sense if one zigzags from side to side of the 'corridor' in which most of the Anglo-Saxon display is situated.

Visitors with little or no prior knowledge of the topic must be given the tools to access the information that the museums (and archaeologists) present. Recent research indicates that not only are there sections of the population who, for whatever reasons, feel unable to use museums (Merriman, 1989a; Prentice, 1994) but also that many displays do not dispel popular misconceptions. Some might still be characterized as exclusive. Reading material culture as a text is not an inherent skill, but one that has to be learned (James, Chapter 6).

Many of the curators interviewed admitted that, in designing the displays, they had assumed a certain level of background knowledge of the period by the public, which proved subsequently to be a mistake:

> We need to get over the chronological sense of the period better; many of the letters I receive from the public reveal that they are confused who the Anglo-Saxons were and whether they came before or after the Romans or the Normans.

> The public are often not sure about who we are talking about, whereas they all know about the Romans.

While this necessarily reflects on the efficacy (or otherwise) of formal education systems, it must also seriously call into question some of the language and methods used in communicating archaeological and historical information to museum visitors. Obviously many of the technical terms and phrases which archaeologists use are not familiar to the general public. In several museums, such as the British Museum and the Ashmolean Museum, Oxford, the artefacts are even expected to 'speak for themselves', identified just by name, date and provenance, with no attempt to link them into explanations of wider events and historical processes (James, Chapter 6). Such displays invariably assume the visitors' knowledge of the implicit historical framework being relied upon when they identify artefacts as simply 'Bronze brooch 6th Cent AD' (seen in the Museum of Antiquities, Newcastle). This treatment contrasts with the extensive Roman display in this museum, with elaborate reconstructions (including one of an entire Mithraeum), life-size models of Roman soldiers, and a hands-on section dealing with Roman cooking.

As illustrated above, where a written narrative is presented displays tend to reflect the traditional preoccupations of archaeologists (agendas which were defined in the nineteenth and early twentieth centuries) – the identification of tribal areas, in terms of the material culture associated with Angles, Saxons and Jutes, and the linking of those regional groupings with similar material on the Continent. These preoccupations do not, however, seem to be shared by many of their visitors. When visitors at Jewry Wall Museum, Leicester, were asked what more they would like to know about the Anglo-Saxons, replies tended towards the more everyday

side of life (see also Wood and Cotton, Chapter 2, on prehistory). They wanted to know about 'their homes', about 'what they ate and their day-to-day life'. At the same museum, when asked what they particularly liked about the displays, younger people often replied 'the fact that everything they dug up was from Leicestershire', reflecting a local interest. Reconstructions were invariably popular – at Leicester the Anglo-Saxon family tableau is still on display (despite academic criticism of its inherent gender stereotyping). The reconstruction of the Glen Parva burial also prompted comments from visitors, especially older ones: 'I wonder how they chose what was buried with her and if she had discussed it with her family before dying'. Such comments must make museum archaeologists question the political and nationalistic narratives which they (knowingly or otherwise) embed in their displays. They may also go some way towards explaining the popularity and success of 'visitor attractions' such as the reconstructed Anglo-Saxon village of West Stow.

The notion that the past is 'good for you' grew out of nineteenth-century attempts to educate the masses (Hudson, 1987: 18). One of the results of this has been a widespread attempt to present the past, both in museums and heritage organizations, in such interpretative ways that 'everyone' can understand. However, it is now well known that visitors can leave displays with fundamental misconceptions as intact as when they entered (Herring, 1993; Holman and Burtt, 1987; Wood and Cotton, Chapter 2). Our survey found that many of the important aspects of the period were almost completely invisible to the visitor. For example, when asked if they thought the period had made any contribution to Britain as we know it today, most visitors, even well-educated ones, answered in the negative. 'No, I don't think there was much influence from the period as it was so short' was one teacher's view after visiting Bede's World. There was evidence of considerable confusion as to when all this 'actually happened', just that it 'was an awful long time ago'. Sometimes there appeared to be no conception of the length of the Anglo-Saxon period. While this was understandable after seeing a very specific early cemetery collection like that at Liverpool, it was less so at Leicester where the display followed a chronological sequence from 'The First Settlers' through to 'The Church and State'.

Problems of displaying the early Anglo-Saxon period

Within the complexity of the interaction between visitor, museum and object, displays of the early Anglo-Saxon period have particular problems. Like prehistory (see Wood and Cotton, Chapter 2), and in contrast to the earlier centuries of Roman Britain and the Later Medieval period, the years between AD 400 and AD 700 do not have a high profile of visible remains.

Due to the poor survival of timber buildings, and the forms of archi-
tecture current at that time, there are no great villas or houses, no forts or
castles to impinge on public awareness. Furthermore, many of the extant
artefacts are small and few major pieces, particularly of gold works, sur-
vive (Dodwell, 1982). This lacuna in tangible remains presents difficulties
for interpretations which rely on artefacts for their display potential.

Displays of Anglo-Saxon archaeology are thus usually constrained by
the nature of the objects which comprise museum collections – generally
grave goods, often excavated in the nineteenth or early twentieth century,
many of which lack detailed contextual records. Most museums contain
very little associated with settlement material (a minor part of the
archaeological evidence until recent years, and one which is, in addition,
difficult to place in context in the limited space of the display case), or
evidence associated with conversion, state formation and urbanization.
Many displays thus draw heavily on this burial evidence. As described
above, such evidence is often employed in traditional narratives of Anglo-
Saxon conquest and immigration, yet this is patently not what visitors are
primarily interested in. It fails to engage them. A related issue is the
generalizing tendency of many Anglo-Saxon displays. The lack of material,
other than that from burials, means that other aspects of life, such as
settlements or farming, about which much less is known, are assumed to
be the same over broad areas. There is little opportunity to explore the
local or regional distinctiveness which seems to resonate with visitors.

In addition, there is the problem of the limited nature of many
museum collections. Depending on past and current acquisition policies,
and the extent of its collecting area, a museum's holdings will vary wildly.
In the nineteenth century, before the rise in popularity of things Anglo-
Saxon, collecting habits often biased museums away from early medieval
objects and placed more emphasis on the Classical Greek and Roman
worlds (a bias which can still be seen at Newcastle). For example the
British Museum's trustees declined to purchase the Faussett Collection of
Kentish material in 1854, with one trustee being heard to remark that he
'did not think we wanted a heap of Saxon antiquities in the Museum!'
(Rhodes, 1990: 41). The subsequent uproar, with questions asked in
Parliament, reflects changing priorities during this period – away from
exclusively classical remains towards national ones.

The distribution of the material itself also has a major effect. Museums
in Kent, such as Maidstone, are often strong on evidence from cemeteries,
while some of those in the north, such as Bede's World, have evidence
primarily relating to monastic contexts. With the extremely limited extent
of inter-museum lending, such differences are inevitably going to con-
strain the nature of the displays which can be mounted. The success of
temporary exhibitions, such as 'The Lost Kingdom' at Scunthorpe

Museum, 'The Making of England' at the British Museum, and 'The Golden Age of Northumbria' at Newcastle, which can bring together objects from diverse locations and display them in appropriate and detailed contexts, must suggest that the role of the museum in disseminating information about periods of the past perhaps needs rethinking.

In addition, Anglo-Saxon archaeology has itself undergone some radical alterations in the last twenty years. The main research questions can be seen to have altered, reflecting wider changes in archaeology as a whole. The remainder of this chapter will examine the possibilities for re-presenting the Anglo-Saxon period within the museum context, concentrating first on the importance of knowing who its visitors are and what they require from the museum, and then reviewing a range of both practical and theoretical innovations in museum display which might be brought to bear. While museum curators are, of course, well aware of the possibilities of innovative modern display techniques (although often short of the funding necessary to implement them), we would argue that a fundamental problem remains. Our survey highlighted that many museums do not give the public what they want, and there seems to be a reluctance on the part of museum curators to acknowledge how little information they actually communicate to the visitor. We would argue that detailed visitor surveys are fundamental if this problem is to be tackled.

Know your visitor

What does the average man do in a museum? He wanders aimlessly, yes, but not blindly. His attention is drawn to this and distracted from that. He must have glimmering interests which might be fanned into overt enjoyment. Yet, this casual visitor is in the main a mystery and, if he is to be dealt with effectively, there needs to be added to the talking about him and thinking about him a deliberate observation of his behaviour. (Robinson, 1928, quoted in Blatti, 1987: 119)

This suggestion, made over seventy years ago, has, in part, been acted upon — visitors and many of their movements have been observed, and some are understood, but there is still a lot more research to be done if they are not, in many other respects, to remain a mystery to us. Visitor surveys are now commonplace in museums. For example, in the aforementioned study (Herring, 1993), all the museums were able to provide visitor numbers, and several had implemented surveys to assess their visitor profiles and demographic characteristics. However, few of them revealed anything about museum audiences in terms of the impact of displays and whether their perceptions of the period had been enhanced or changed in any way.

Systematic evaluation of projects and policies has been used in the fields of education, psychology and sociology for considerably longer than in museum work, where it has only come to prominence in the last fifteen to twenty years (Griggs, 1984: 412). Its important role within general policies of museums towards the public and the difficulties involved in its implementation have been discussed (Alt *et al.*, 1982; Griggs, 1984; Miles and Tout, 1978). In Britain, with a few exceptions such as at the Natural History Museum, the Science Museum and the Museum of London's 'Peopling of London' exhibition, studies have generally been small-scale in nature, and have aimed at assessing the teaching effectiveness of display units, often through the use of recall questions. This, involving as it does verbal answers and/or photograph or object recognition, concentrates on the characteristics of the exhibition, rather than the complex nature of the visitor's perception of it (and also runs the risk that the visitor is made to feel that it is they, rather than the display, that has failed). Nor does it acknowledge the role of past experience or knowledge within those perceptions.

It is known that museum visitors tend to be well educated, but, given the rise of the museum as a tourist attraction, they come from a wide variety of cultural backgrounds (Merriman 1989b). Following on from Bourdieu's perceptive analysis that a 'work of art has meaning and interest only for someone who possesses the cultural competence, that is, the code, into which it is encoded' (Bourdieu, 1984: 2), it is now accepted that while objects may be viewed in a variety of ways it is always within the context of each visitor's own social meanings or text (e.g. Taborsky, 1990). The term 'visitor' thus covers not only people from an enormous variety of cultural backgrounds, but people who arrive at the museum with different perceptions and levels of knowledge. Museums must also bear in mind that a large percentage of their visitors are children in school parties. With the inclusion of at least sketchy coverage of the Anglo-Saxon period at Upper Primary level in Key Stage 2 of the National Curriculum, this group must also be considered when designing information about and displays of this period. Clearly, the differing backgrounds and knowledge of visitors should be taken into account before designing displays which are intended to offer information to them.

In addition, the role of museums in education and society has changed – the visitor has become a customer (especially in the wake of entrance fees). Museums are viewed as housing historical resources, not serving as storehouses for treasures, and the interpretation of them to an interested public is now a duty, not a choice (Wickham-Jones, 1995: 134–5). Furthermore, it has recently been argued that museums should be placed at the centre of informal, as well as formal, learning for both children and adults (Anderson 1997).

Re-presenting Anglo-Saxons

The challenge, then, is how to present archaeological material in an interesting and dynamic way to a varied audience. The first step is to draw visitors in (assuming that they have been able to find the Anglo-Saxon displays). If visitors' interest is not captured at the outset, the opportunity to engage with them is lost. Out of twelve Anglo-Saxon displays surveyed, only three had introductory videos giving overviews of the period – most relied solely on wall-mounted text (Herring, 1993). At Nottingham a small local Anglo-Saxon collection is located on the Nottingham Castle site as part of a new heritage venture. A small video and time panel are the first things visitors see as they arrive in the museum, and these give a lively, albeit brief, introduction and chronology to the period. This is a visual medium that many visitors relate to, and can present a simple chronology that people can grasp easily. Such videos could also present summaries of relevant debates by enthusiastic experts – a relatively inexpensive way of providing the lively and informed human contact that many visitors express a desire for.

Documentation confirms that the attention of most visitors decreases as they progress through the displays. This is largely attributable to the lack of stimulation and variety in text and style (Griggs, 1983; Velarde, 1988; Wittlin, 1971). At Nottingham there is a mix of graphics, photo-graphs, text and hands-on presentation which attracted adults and chil-dren alike, and stimulated discussions. In contrast, the monochrome displays at Liverpool were not observed to catch the attention of any visitors walking past in the space of an hour.

A conversational style and use of personal pronouns can also help to hold visitor attention, but it is rare to find this within the text. There are a few notable exceptions. The 'Lost Kingdom' temporary exhibition at Scunthorpe even made use of humour in places, such as the insertion of 'Good Heavens, you're actually reading this!' halfway down a list of bishops and kings. At Jewry Wall Museum in Leicester the display text and graphics were designed to provide variety. For example, the more traditional type of discussion on Anglo-Saxon burials was replaced by the title 'Superstition' and posed questions to the visitors as to whether this might be one explanation for the variety of artefacts found in early pagan burials. Making displays meet public needs and expectations does not necessarily require vast financial and labour resources. Perhaps even developing simple accompanying guides to the displays (as many museums have now done for pupils and their teachers) can start to make even the most staid display more interesting and relevant.

This relates to the move which needs to be made to change the fun-damental way in which many visitors (and some archaeologists) perceive past people – that is, as our direct ancestors and therefore just like us. This

is one of the most profoundly misleading perceptions that museums perpetuate (see James, Chapter 6). A related misconception that derives from this is that our earlier ancestors were quite like us, except 'not so clever'. The only type of display which seems to make any impact on this widely held view are reconstructions. At Leicester, the reconstruction of the 'Glen Parva lady' next to the grave of a wealthy woman of the early Anglo-Saxon period, which is displayed as it was found (together with a graphic panel explaining how the reconstruction was built up from evidence), stimulated visitors to think about how death was dealt with, and emphasized the difference from contemporary attitudes. It also made plain the processes the archaeologists had gone through in reaching their interpretation, thus serving to help break down the distinction between knowledgeable expert and uninformed visitor. Such treatments contrast with those which attempt to draw direct parallels between the Anglo-Saxon and modern worlds. An example of this is the panel 'A Woman's Work' at Liverpool Museum, where, after talking of the embroidery which later Anglo-Saxon women were famous for, states that:

> Of course, they also cooked, cleaned, looked after the children, 'a woman's work is never done'.

and accompanies this passage with an illustration of a very modern-looking woman and girl kneeling on the floor of a spotless thatched hut.

The use of reconstructions in museums is a thorny issue with inherent ethical and conceptual problems, but their potential for helping to undermine popular misconceptions cannot be denied (although, of course, they may equally reinforce them, as the Liverpool example demonstrates). One of the main criticisms is that reconstructions fossilize older interpretations (James, 1996: 33), and that more recent archaeological knowledge and ideas render such interpretations obsolete. However, such criticisms can also be directed at 'ordinary' museum displays, where the ideas are inherent in the text. At West Stow Anglo-Saxon Village, an attempt is made to overcome such problems by the use of audio tapes which the visitors listen to as they walk round. Such tapes are easily re-recorded, to take account of the ideas which arise from new research, and have the advantage of being able to give an idea of the difficulties that archaeologists have encountered in trying to reconstruct the buildings (thus making transparent a part of the archaeological process). The use of the tapes also provides an opportunity to remind the public that 'we do not know what it was really like as we are twentieth-century people' (Alan Blackhurst, West Stow).

One thing many visitors have in common is familiarity with information technology. The increasing use of virtual reconstructions and interactive displays could be used to show the possible contexts of museum holdings

(James, 1996: 33). This is a medium which could easily offer the potential for the alternative interpretations of the use and significance of objects which archaeologists currently stress. Some successful examples of more recent historical displays offer different viewpoints on a particular period by personifying them with different characters (see Beard and Henderson, Chapter 3, for an example of the pros and cons of live interpretation). This may be a possible approach for displays on the Anglo-Saxon period also (a child's viewpoint may prove especially popular for younger visitors, as at Bede's World, where children can pretend to be monks). The use of information technology (which can range from the simplest audio tape to complex computerized reconstructions) may go a long way towards satisfying visitors' demands for more information and guidance.

We know that archaeological material from a local context captures visitors' interest (Merriman, 1989a: 166; Herring, 1993). This was favourably commented on by visitors to Leicester Jewry Wall Museum. Conversely, at Liverpool Museum, where the bulk of the Anglo-Saxon collections are from Kentish cemeteries, the lack of local material was seen to add to visitors' incomprehension. The use of information technology could be used to link up with catalogues and images of objects held elsewhere, to provide the local visitor with a more immediate sense of this material.

The aim of West Stow is to make the visit as holistic, lively and evocative of the period as possible, while, at the same time, attempting to dispel any stereotyped preconceptions of the Anglo-Saxon period that the public may have. A final aim is to adapt to any feedback from the public, and to implement and maintain user-friendly techniques. In other words, everything that is done at this site is aimed at 'the ordinary visitor with no prior knowledge of the period other than that possibly derived from the popular media' (Alan Blackhurst, West Stow). The following examples are typical of the comments received from respondents during informal interviews at the 'village' when asked if they had found anything out about the period that they did not know before:

This has been a real eye-opener, a most awe-inspiring visit – I never knew what clever people the Anglo-Saxons were.

I have been amazed at the level of technology and resourcefulness of these people.

I used to think that the Anglo-Saxons were simply warriors who fought all the time but they led very productive lives.

The immediacy of the experience engaged the members of the public. The direct comparison of museums with open-air reconstructions such as West Stow may be an unfair one, but the contrast with some of the comments at the museums surveyed gives food for thought.

Recent theoretical work may also affect the interpretations placed on material culture by museums. It was mentioned earlier how many displays inherently represent a nationalistic version of this period, with tribal groupings, rather than the people who constituted them, being viewed as the subjects of history. Historians, however, have cast doubt on such ideas about early medieval ethnicity. They have demonstrated that ethnic identity in this period was fluid and contingent, important only in certain situations and possibly only for certain sections of the population (Amory, 1993; Geary, 1983; Pohl, 1991). There were no 'Anglo-Saxons' in the fifth and sixth century – this term only entered common usage in the sixteenth century (Reynolds, 1985).

The process of kingdom formation is now seen as a gradual one, with the larger kingdoms described in the eighth century by Bede being the culmination of a long series of amalgamations and conquests of smaller political units (units such as those reflected in the Tribal Hidage), stretching back into the fifth century (Bassett, 1989). The Anglian and Saxon kingdoms should thus be seen as the result of a contingent historical process, rather than the inevitable result of a series of migrations or invasions. The implications of this view are that archaeologists should not expect to find these large-scale groupings in evidence in the archaeological remains of the fifth and sixth centuries. If any identities are being reflected in the material used on settlement sites and buried in graves, they are identities based on a more local level of affiliation.

In addition, studies on Anglo-Saxon art have shown how dependent these 'Germanic' styles were on late Roman provincial decorative motifs (Shetelig, 1949; Haseloff, 1974; Hills, 1979; Laing and Laing, 1997). Many scholars now place far more emphasis on cultural amalgamations in the fifth and sixth centuries, reflecting dynamic and contingent processes of change, than on inherent cultural oppositions between 'Celts' and 'Saxons' (cf. also the recent temporary exhibition at the British Museum, entitled 'The Heirs of Rome: The Shaping of Britain AD 400–900', and the recently revamped displays at the Museum of London). There has also been innovative work carried out on the political consequences of conversion to Christianity (Carver, 1989), and urban excavations over the past few decades have rewritten the history of trade and exchange in this period (Hodges, 1989a, 1989b).

In other areas of archaeology there has been recent questioning of the role which material culture is assumed to play in reflecting identity. There has been a move away from the functionalist approaches, which saw aspects of identity such as status and ethnicity as being directly reflected in material culture (so a rich grave was the burial of a rich person), towards more subtle approaches which recognize the active nature of material culture (whereby people can choose which material to use, and how to use

it). Such perspectives require the adoption of in-depth contextual approaches which attempt to make sense of patterning in the archaeological evidence in terms of how and why those patterns were formed (Lucy, 1998; Pader, 1982).

Much of the material housed in museum collections originates from burials and cemeteries. More could be made of this, not in terms of reinforcing traditional ideas about tribal groupings as it has been employed in the past, but by using it in a discussion of what it is really evidence for – a society with a completely different attitude to death. This material could be used to explore aspects of symbolism, differences in costume at different times and in different areas, as well as themes such as manufacture and production, trade, and related settlement evidence (i.e. the types of houses, farmsteads or villages that these dead people would have once lived in). Burials and death are a particularly useful way in which to connect with present-day audiences – while the concepts involved are common to most people, many aspects of Anglo-Saxon burial practice serve to highlight the gulf in beliefs between then and now.

There is a strong emphasis in recent interpretations of archaeological material on the contexts from which it derives, contexts which serve to instil meaning. Museums could play on this emphasis, by showing how this material was used – a brooch makes more sense when it is depicted as holding together a dress (as at West Stow and Leicester), than when it is pinned to a backdrop in a museum case (as at the British Museum and the Ashmolean).

Conclusions

While museums acknowledge their roles as cultural guardians and mediators of historical knowledge, they have to compete for the attention of the visitor within an arena packed with other late twentieth-century leisure activities on offer. Other problems are also emerging. It is apparent that although museums have moved a long way from the idea of the 'Cabinet of Curiosities', many still expect visitors to come with certain skills (such as the ability to interpret material culture) and certain levels of knowledge about the periods on display. Recent surveys have, however, demonstrated that these assumptions are unjustified. Although many people visit museums, they come from a wide variety of backgrounds. It seems that their desire for education and information within the museum is not generally being fulfilled. Only by evaluating the perceptions and reactions of museum visitors to displays will museum curators be able to design exhibits that are meaningful.

Given the wide variety of backgrounds, the increased use of information technology (which can readily offer different levels of interpretation

and explanation) would seem to be an obvious step, especially for the Anglo-Saxon period where so much information is derived from the contexts of the artefacts. Information technology can also be used to present the various arguments within a debate – there is no reason why museum visitors should not be able to choose between different versions of the past (as long as these versions are based on the evidence available). In addition, virtual links to other museum collections could offer information about local material.

By focusing on different aspects of the past, especially everyday activities such as birth, death, subsistence and manufacture, material held by museums can be given resonance for people for whom the traditional narratives, couched as they often are in nationalistic terms, hold little relevance. However, the question must be asked, given all these difficulties of presenting aspects of the past to the varying groups of people who visit museums (notwithstanding the fact that the majority of the population do not), whether the museum, with its static, permanent displays, is the appropriate place for that transmission of information. The popularity of temporary exhibitions, with their bringing together of material from different museum collections, their up-to-date interpretation, and, often, their relevance to local populations (cf. the success of the 'Golden Age of Northumbria' exhibition in Newcastle in 1996), must raise pertinent questions about the role of museums and the relevance of their collecting and lending policies in contemporary society.

Similarly, the lack of success of permanent displays in communicating information to visitors must also give curators food for thought. This is an important and seminal period which saw changes that were instrumental in the formation of England as we know it today, and which also played a fundamental role in terms of attitudes to English national identity. Of course, these facts are not relevant and interesting to all visitors in today's multicultural society, and are made even less so when curators have to deal with such low-profile visible remains, exacerbated by regional variations in the material available. Museum curators face many constraints in the present climate, not least financial. However, evaluations of visitor understanding are not expensive, and improvements can only be made by implementing them. This small survey revealed a marked contrast in visitor comprehension and enjoyment after a visit to a reconstruction or temporary exhibition, when compared to visits to more traditional static displays which appeared to do nothing to dispel out-dated misconceptions of the 'Dark Ages' or to enable visitors to appreciate even the most basic chronology of the period. This does raise questions about curatorial responsibilities towards visitors, which sometimes seem to be too constrained by traditional attitudes towards collections and presentation. Sadly this means that they are often not getting even the most basic

information about this important and influential period across to their visitors.

Acknowledgements

We would like to thank the curators who agreed to participate in the original research on which this chapter is based: Alan Blackhurst, John Clark, Elizabeth Hartley, Kevin Leahy, Fiona MacCarthy, Arthur MacGregor, Susan Mills, Anne Pennington, Fiona Philpott, Robert Rutland and Lesley Webster. We are also grateful to Robin Boast, Nick Merriman and Simon James for their helpful comments on various drafts of this chapter, and to Lisa Shurdom for her assistance.

Appendix: Museum details

Museums 1 to 10 were included in the original study, and visited in 1993. Bede's World was revisited in 1996. The British Museum, the Museum of London, Jewry Wall Museum, Leicester and Liverpool Museums were revisited in 1997. Two further museums (Maidstone and Newcastle) were visited in 1996, but the curators were not interviewed.

1. *Ashmolean Museum of Art and Archaeology*

Address:	Beaumont Street, Oxford
Type:	University
Display Date:	1993
Anglo-Saxon Collection:	Major collection includes the ninth-century Alfred Jewel, Minster Lovell Jewel and Risano Jewel; finest collection of ornamental metalwork (700–1100); Abingdon Sword; Sandford Reliquary; Sutton Courtenay material; material from Kent, Berks., Glos., East Anglia. 80% of Anglo-Saxon material on display.
Interviews:	Curator, Arthur MacGregor. No visitors interviewed.
Visitor Numbers (1992):	200,000

2. *British Museum*

Address:	Great Russell Street, London
Type:	National
Display Date:	1985/6
Anglo-Saxon Collection:	Major national collections. Of particular note are the

burials from Sutton Hoo, Taplow, Broomfield, Caenby and material from Kentish cemeteries such as Chessel Down and Dover. Also secular metalwork (700–1100), the Franks Casket and material from Mucking and Sleaford. 80% of Anglo-Saxon material on display.

Interviews:	Deputy Keeper, Lesley Webster.
	No visitors interviewed.
Visitor Numbers (1996):	6,500,000

3. Liverpool Museum

Address:	William Brown Street, Liverpool
Type:	National
Display Date:	1986
Anglo-Saxon Collection:	A major display of Kentish cemetery material, including the Kingston Brooch. 66% of Anglo-Saxon material on display.
Interviews:	Curator, Fiona Philpott.
	Ten visitors interviewed.
Visitor Numbers (1996):	511,717

4. Museum of London

Address:	London Wall, London
Type:	Local authority/national
Display Date:	1996/7
Anglo-Saxon Collection:	Local collections, city and environs; grave goods from Mitcham. About 10% of Anglo-Saxon material on display.
Interviews:	Curator, John Clark.
	Ten visitors interviewed in 1993; their comments no longer apply due to redisplay of collections.
Visitor Numbers (1994/5):	269,859

5. Leicester Jewry Wall Museum

Address:	St Nicholas Circle, Leicester
Type:	Local authority
Display Date:	1992
Anglo-Saxon Collection:	Local cemetery material.
Interviews:	Keeper, Bob Rutland.
	Thirty visitors interviewed.
Visitor Numbers (1995):	30,884

6. Nottingham Castle Museum and Art Gallery

Address:	The Castle, Nottingham
Type:	Local authority
Display Date:	1992
Anglo-Saxon Collection:	Material from recent excavations at Broughton Lodge, Willoughby-on-the-Wolds.
Interviews:	Marketing Officer, Richard Sandal.
Visitor Numbers (1992):	741,891

7. Scunthorpe Borough Museum and Art Gallery

Address:	Oswald Road, Scunthorpe
Type:	Local authority
Display Date:	1978
Anglo-Saxon Collection:	Manton cemetery and other local material.
Interviews:	Keeper, Kevin Leahy.
Visitor Numbers (1992):	31,453

8. The Yorkshire Museum

Address:	Museum Gardens, York
Type:	Local authority
Display Date:	1982/3
Anglo-Saxon Collection:	Extensive collections; material from York and its environs, some exceptional objects e.g. silver gilt bowl from Ormside, Gilling Sword, sculpture from York Minster. About 70% of Anglo-Saxon material on display.
Interviews:	Curator, Elizabeth Hartley.
Visitor Numbers (1994/5):	109,596

9. Bede's World

Address:	Church Bank, Jarrow
Type:	Private trust
Display Date:	1978/9 (but currently undergoing redevelopment)
Anglo-Saxon Collection:	Material from monastic site and buildings; glass, metalwork, pottery, sculpture. About 20% of Anglo-Saxon material was on display in 1993. A new phase of the museum – a demonstration Anglo-Saxon farm and accompanying displays – is now open.
Interviews:	Curator, Susan Mills. Thirty visitors interviewed.
Visitor Numbers (1995):	35,000

10. West Stow Anglo-Saxon Village

Address:	Icklingham Road, West Stow, Bury St Edmunds.
Type:	Local authority
Display Date:	Excavation 1965–1972
Anglo-Saxon Collection:	Reconstructed village.
Interviews:	Senior Ranger, Alan Blackhurst.
	Thirty visitors interviewed.
Visitor Numbers (1992):	50,000.

11. Maidstone Museum and Art Gallery

Address:	St Faith's Street, Maidstone
Type:	Local authority
Anglo-Saxon Collection:	Extensive cemetery material from Kent, including Sarre, Bifrons and Lyminge. The Faversham claw beaker is a recent acquisition.
Interviews:	None.
Visitor Numbers (1994/5):	55,000

12. Newcastle Museum of Antiquities

Address:	The University, Newcastle upon Tyne
Type:	University
Anglo-Saxon Collection:	Of scattered provenance. Some local material such as the Capheaton Bowl, and two of the Hartlepool name-stones, other material from Cambridgeshire and East Yorkshire.
Interviews:	None
Visitor Numbers (1996):	25,000

Bibliography

Alt, M.B., Gosling, D.C. and Miles, R.S. (1982) *The Design of Educational Exhibits*. London: British Museum (Natural History).

Amory, P. (1993) 'The meaning and purpose of ethnic terminology in the Burgundian Laws', *Early Medieval Europe*, 2 (1), 1–28.

Anderson, D. (1997) *A Common Wealth: Museums and Learning in the United Kingdom*. London: Department of National Heritage.

Bassett, S. (1989) *The Origins of Anglo-Saxon Kingdoms*. Leicester: Leicester University Press.

Blatti, J. (1987) *Past Meets Present: Essays about Historic Interpretation and Public Audiences*. Washington, DC: Smithsonian Institution Press.

Bourdieu, P. (1984) *Distinction: A Social Critique of the Judgement of Taste*. London: Routledge.

Burrow, J.A. (1981) *A Liberal Descent: Victorian Historians and the English Past*. Cambridge: Cambridge University Press.

Carver, M.O.H. (1989) 'Kingship and material culture in early Anglo-Saxon East Anglia', in Bassett, S. (ed.), *The Origins of Early Anglo-Saxon Kingdoms*. Leicester: Leicester University Press, 141–58.

Colley, L. (1992) *Britons: Forging the Nation 1707–1837*. London: Pimlico.

Curtis, L.P. (1968) *Anglo-Saxons and Celts*. New York: New York University Press.

Dodwell, C.R. (1982) *Anglo-Saxon Art: A New Perspective*. Manchester: Manchester University Press.

Freeman, E.A. (1869) *Old English History for Children*. London: Macmillan.

Geary, P. (1983) 'Ethnic identity as a situational construct in the early Middle Ages', *Mitteilungen der Anthropologischen Gesellschaft in Wien*, 113, 15–26.

Green, J.R. (1874) *A Short History of the English People*. London: Macmillan.

Griggs, S.A. (1983) 'Orienting visitors within a thematic display', *International Journal of Museum Management and Curatorship*, 2, 119–34.

Griggs, S.A. (1984) 'Evaluating exhibitions', in Thompson, J., Bassett, D., Davis, O., Duggan, A., Lewis, G. and Prince, D. (eds), *Manual of Curatorship: A Guide to Museum Practice*. London: Butterworths, 412–22.

Hamerow, H. (1994) 'Migration theory and the migration period', in Vyner, B. (ed.), *Building on the Past*. London: Royal Archaeological Institute, 164–77.

Haseloff, G. (1974) 'Salin's Style I', *Medieval Archaeology*, 18, 1–15.

Herring, C. (1993) 'A critical evaluation of the representation of the Anglo-Saxon Period in a group of museums'. Unpublished MPhil dissertation, Department of Archaeology, University of Cambridge.

Hills, C.M. (1979) 'The archaeology of Anglo-Saxon England in the Pagan Period: a review', *Anglo-Saxon England*, 8, 297–330.

Hodges, R. (1989a) *Dark Age Economics: The Origins of Towns and Trade AD 600–1000*. London: Duckworth.

Hodges, R. (1989b) *The Anglo-Saxon Achievement: Archaeology and the Beginnings of English Society*. London: Duckworth.

Holman, N. and Burtt, F. (1987) 'Archaeology of education', *Archaeological Review from Cambridge*, 6 (2), 110–14.

Hudson, K. (1987) *Museums of Influence*. Cambridge: Cambridge University Press.

James, S. (1996) 'Drawing inferences: visual reconstructions in theory and practice', in Molyneaux, B.L. (ed.), *The Cultural Life of Images: Visual Representation in Archaeology*. London: Routledge, 22–48.

Kliger, S. (1972) *The Goths in England: A Study in Seventeenth and Eighteenth Century Thought*. New York: Octagon Books.

Laing, L. and Laing, J. (1997) *Early English Art and Architecture: Archaeology and Society*. Stroud: Sutton Publishing.

Lucy, S.J. (1998) *The Early Anglo-Saxon Cemeteries of East Yorkshire: An Analysis and Re-interpretation*. British Archaeological Reports (British Series) 272. Oxford: Archaeopress.

MacDougall, H.A. (1982) *Racial Myth in English History: Trojans, Teutons and Anglo-Saxons*. Montreal: Harvest House.

Merriman, N. (1989a) 'Museum visiting as a cultural phenomenon', in Vergo, P. (ed.), *The New Museology*. London: Reaktion Books, 149–72.

Merriman, N. (1989b) 'The social basis of museum and heritage visiting', in Pearce, S.M. (ed.), *Museum Studies in Material Culture*. Leicester: Leicester University Press, 153–71.

Miles, R.S. and Tout, A.F. (1978) 'British Museum (Natural History): a new approach to the visiting public', *Museums Journal*, 78, 158–62.

Pader, E.-J. (1982) *Symbolism, Social Relations and the Interpretation of Mortuary Remains*. Oxford: British Archaeological Reports, British Series 130.

Pohl, W. (1991) 'Conceptions of ethnicity in Early Medieval Studies', *Archaeologia Polona*, 29, 39–49.

Prentice, R. (1994) 'Perceptual deterrents to visiting museums and other heritage institutions', *International Journal of Museum Management and Curatorship*, 13, 264–79.

Reynolds, S. (1985) 'What do we mean by "Anglo-Saxon" and "Anglo-Saxons"?' *Journal of British Studies*, 24 (4), 395–414.

Rhodes, M. (1990) 'Faussett rediscovered: Charles Roach Smith, Joseph Mayer and the publication of the *Inventorium Sepulchrale*', in Southworth, E. (ed.), *Anglo-Saxon Cemeteries: A Reappraisal*. Stroud: Sutton Publishing, 25–64.

Shetelig, H. (1949) *Classical Impulses in Scandinavian Art from the Migration Period to the Viking Age*. Oslo: Instituttet for Sammenlignede Kulturforskning.

Smith, R.J. (1987) *The Gothic Bequest*. Cambridge: Cambridge University Press.

Taborsky, E. (1990) 'Objects of knowledge', in Pearce, S.M. (ed.), *Objects of Knowledge*. New Research in Museum Studies 1. London: Athlone Press, 50–77.

Velarde, G. (1988) *Designing Exhibitions*. London: The Design Council.

Wickham-Jones, C. (1995) 'Squat grunting savages? Museums and archaeology', *Scottish Archaeological Review*, 9, 132–7.

Wittlin, A.S. (1971) 'Hazards of communication by exhibits', *Curator*, 14 (2), 138–50.

5

The Dilemma of Didactic Displays: Habitat Dioramas, Life-groups and Reconstructions of the Past

Stephanie Moser

Introduction

One of the objectives of current research in museum studies is to examine the strategies museums employ to 'naturalise the concreteness of the social and historical processes in which they participate' (Sherman and Rogoff, 1994: x). These strategies are most clearly seen in the didactic displays created by museums to communicate ideas about the world, particularly natural history, different cultures and the past. Museums, via such displays, contribute to the interpretive process, and thus, like other forms of representation, play a role in the construction of knowledge. This is especially the case for archaeology, where extensive use is made of didactic displays to convey what the past was like. This discussion outlines the history of a display type that has had a powerful interpretive role for many disciplines and has played a critical role in communicating archaeological findings. Of all the display types, the diorama, or life-size model of subjects in a landscape or setting, has a central role in bringing ideas to life. As a mode of representation this type of display reflects how museums participate in the naturalization of the social and historical processes in which they participate. The evolution of the diorama is first examined in natural history and ethnological exhibits, and then in the representation of prehistory.

The idea that representations of knowledge constitute powerful arguments in their own right has already been made in relation to archaeology and its use of visual images (Moser, 1992, 1993, 1996a, 1998; Moser and Gamble, 1997). Here it has been demonstrated that representations are not simply innocent translations of research findings, but rather, they take on a life of their own, conveying ideas that are not explicitly stated elsewhere. I suggest that the situation is the same for museum displays, especially dioramas, which communicate ideas about nature, culture and the history of humanity.

Natural history and the habitat diorama

In the sixteenth and seventeenth centuries, collectors of objects of natural history focused their efforts on monstrosities, oddities and freaks of nature. The popularity of 'curiosity cabinets' in Europe in the 1700s was criticized by scientists at the time, who argued that such collections were 'more intent on stunning boys, women and "ignorants" than upon educating scholars about nature' (Olmi, 1993: 254). Such criticisms reflected the growing interest in representing a more comprehensive picture of nature, where appreciation for the whole chain of being meant that the rare and spectacular were no longer the only subject of interest. In the late 1700s, when an interest was shown in displaying all objects of nature, museum owners began to consider opening their collections for public viewing. Owners of the early museums soon faced the problem of making their collections interesting and entertaining, which led them to invest in constructing displays that were informative and pleasing. It is in this context that a novel type of display was developed. This display, now commonly known as the habitat diorama, saw specimens placed in their natural habitats.

The introduction of habitat dioramas took place in a phase of museum evolution described by Orosz (1990: 7) as the Moderate Enlightenment Period. This occurred from 1780 to 1800, when museums were seen as places that could be socially useful because they could develop an awareness of the order and beneficence of God's creation. Pioneers in North America were the first to promote this social and educative role of museums. Pierre Eugene Du Simitière, Charles Willson Peale and Gardiner Baker all aimed to provide rational amusement and pleasurable instruction through the public display of their collections. Of these individuals, it was Charles Willson Peale who played a significant role in developing the genre of the diorama. Peale, who opened his museum in 1786 in Philadelphia, has been acknowledged as making a major contribution to the transformation of museums from showplaces to institutions of education. Sellers (1969, 1980) emphasizes Peale's interest in popular education, claiming that there was no precedent for this. Alexander (1983: 5) informs us about another important aspect of Peale's work, which was that he had a 'keen sense of humor and tried to make his museum fun to visit'. It was this attitude that inspired the development of new display strategies which aimed to reconstruct specimens in their original form. Here Peale must be acknowledged for his great mastodon display of 1802, constructed from skeletal remains excavated in New York State in 1801. This display was so popular that it had its own separate admission. In 1807 Peale added a background scene to the displays and, later, the skeletons of a mouse and other animals to make it more dramatic. In 1838 when the museum was moved to a new building, a huge

background of the mastodon's ancient habitat was painted for the display by a landscapist who was noted for his theatre curtains (Sellers, 1980: 275).

Museum historians have emphasized Peale's creation of habitat settings for birds as representing the origins of diorama display (Alexander, 1983; Wonders, 1993a,b). Here birds and smaller animals were displayed in glass-fronted cases, with modelled foregrounds and painted backgrounds. Peale justified this uncustomary technique by stating that 'it is not only pleasing to see a sketch of landscape, but by showing the nest, hollow, cave, or a particular view of the country from which they came, some instance of the habits may be given' (Alexander, 1983: 61). Another important contribution to the evolution of the diorama genre was his large grotto display. Called the 'large exhibit of pond and hill', it consisted of a large mound of earth upon which trees and many different animal species were placed. There were partridge, bear, deer and a tiger, and birds in the trees. Below the mound was a pond containing stuffed fish, geese, ducks and cranes. Alongside was a beach with shells, frogs and water snakes. At the base of the mound were piles of ores and minerals. This construction, of which sadly no picture survives, provided a striking vision of the natural world. Whilst clearly not an accurate representation, it was meant to be realistic in the sense of presenting natural history specimens in a context.

Initiatives similar to Peale's were soon introduced in Europe. In England William Bullock's museum, set up in London in 1809, featured a major habitat display termed the 'Pantherion'. Here a forest scene was recreated in which mounted animals, including a giraffe, a rhinoceros and an elephant were situated. Although animals from different continents were mixed, this representation also aimed to convey some sort of reality. The construction of such displays in England has been discussed in terms of the Victorian fascination with exotic animals encountered as a result of British imperialism (Ritvo, 1987). The display of African animals at the British Museum in the 1840s, where a giraffe was the first to be seen in England, was an important example (Caygill, 1992: 27). However, specimens such as these were often presented more as hunting trophies than didactic displays.

The habitat diorama further developed with the emergence of palaeontology as a discipline. Museums around the world followed Peale's initiative of mounting fossil skeletons in lifelike poses. The scientist Georges Cuvier, who worked at the National Museum of Natural History in France, was one of the first to become involved in this enterprise. A major development occurred when mounted skeletons were fleshed out and placed in environmental settings. The standard was set with the massive dinosaur diorama constructed for the Crystal Palace in London in 1852 (Desmond, 1974, 1975). The man responsible for constructing this masterpiece, Benjamin Waterhouse Hawkins (1854: 447), referred to the

'novel character' of his display which had no precedents of any kind. Hawkins was then employed to create similar dioramas in North America (e.g. at the Philadelphia Academy of Natural Sciences in 1868), where palaeontological display began to be treated seriously. The American Museum of Natural History, which established its own centre for vertebrate palaeontology under Henry Fairfield Osborn in 1891, became the leader in the field. By 1895 Osborn had a whole hall dedicated to fossil mammals, with many extinct animals mounted in active poses. A huge investment was made in the preparation and mounting of specimens. For instance, in 1900 Osborn had 10 to 15 preparators on staff to work on the displays. As Rainger (1991: 98) has observed, the mounting of specimens 'entailed scientific analysis, the study of technical and artistic questions, and the co-ordination of many specialised workers at great expense'. It is here that we can see the development of a specialist industry in display construction, where sculptors and illustrators developed techniques for producing models. As Rowley (1943: 301) stated, the 'up-to-date museum now has its corps of modelers and artists, who are as necessary to its existence and proper growth as the scientific staff'.

Further innovations in habitat dioramas came about as a result of the explosion in the growth of natural history museums in the late nineteenth century (Sheets-Pyenson, 1988: 4). In her history of habitat dioramas, Wonders (1993a) shows how North America and Sweden became the leaders in developing displays of native specimens in their ecological habitats. She emphasizes the role of the wilderness movement, stating that an awareness of the impact of development on the natural environment in North America resulted in a 'greater desire to impart to the museum public an appreciation of the natural-national heritage that was being damaged, diminished or lost altogether' (*ibid*: 10). This was somewhat different to Europe where wilderness areas had disappeared much earlier. Habitat groups, however, aimed to provide realistic ecological contexts for their specimens and thus teach the public to appreciate nature. Wonders concludes that the environmentalist agenda provided a radical transformation in exhibition philosophy from the nineteenth-century obsession with taxonomic interrelations of specimens. Displays now reflected a concern with the entire biological landscape and humans' relations to it.

While habitat dioramas developed in connection with the wilderness movement in general, they are more strictly associated with the development of ornithological exhibits in the early twentieth century (Rowley, 1943; Wonders, 1989, 1993b). The term 'habitat-group' was originally created in 1901 by F. M. Chapman, curator of ornithology in the American Museum of Natural History. Closely associated with the evolution of the habitat diorama was the development of taxidermic techniques at the end of the nineteenth century (e.g. Shufeldt, 1893; Browne, 1896). Taxidermy

was critical in advancing the quality and status of diorama displays, and both the Smithsonian and the American Museum of Natural History utilized techniques developed by Henry Ward's taxidermy firm in Rochester, New York (Sheets-Pyenson, 1988: 9–10).

The climax in the evolution of the habitat diorama can be seen in the Hall of African Mammals at the American Museum of Natural History, created by Carl Akeley in 1936. Alarmed by the disappearance of African fauna, Akeley sought to provide a record of these animals in an exhibition. The Hall of African Mammals presented the world of Africa via a series of dioramas of individual species. Each display presented as accurately as possible the specific environment of each animal. This was achieved through field trips and research at various locations in Africa. The expenditure on each case reflected the importance attached to this exhibit. For example, one blackberry bush cost $2000 and took eight months to make (Wonders, 1993a: 175).

The interpretation of nature

Habitat dioramas continue to have a powerful role as interpretive devices. Because they do not simply portray the natural world, but rather present an interpretation of it, they make arguments about the meaning of the specimens they display. In short, the displays tell stories about nature. While the interpretive dimension of museum displays has been addressed in discussions of the representation of other cultures (see below), the same awareness does not extend to the portrayal of nature. This interpretive dimension can be examined by looking at the issue of how certain themes or subjects are selected for display. For instance, in displaying a particular species a choice has to be made about which aspect of its life will be represented. Out of a whole range of behaviours and interactions, only one can be selected and this can often be chosen because of its visual appeal. Furthermore, because of the nature of displays as forms of entertainment, the subjects and themes are chosen for their dramatic quality. A brief survey of habitat dioramas reveals a tendency to cast many species in confrontational and aggressive contexts. This particularly has been the case with the construction of dinosaur dioramas. As Rainger (1991: 158) argues, even though the team of specialists 'drew upon the best contemporary knowledge pertaining to dinosaur morphology, habits, and environment for the exhibits they erected, they also depicted dinosaurs in dramatic situations. The mounts frequently showed animals in motion or combat and served as entertainment for the visiting public.' Furthermore, as Ritvo (1987: 253) argues, 'although the ostensible criterion by which such efforts were judged was realism, in fact the most acclaimed taxidermy made its subjects seem dangerous and powerful'. The interpretive

dimension is also seen in the display of mammals, especially primates. Gorillas, for instance, were typically made to appear as menacing as possible, a point that has been made by Haraway (1989) in relation to Akeley's exhibit. She also highlights the political aspect of the representation of nature in the Hall of Africa, arguing that the power of Akeley's exhibit lay in the fact that Africa had special meaning as the 'core of primitive nature' (Haraway, 1989: 26).

Ethnology and the life-group

While radical transformations took place in the display of the natural world, similar developments occurred in the representation of human culture in museums. The representation of ethnographic peoples in museum displays is a topic of current interest, where the politics of defining indigenous peoples in the context of ideas about race has been documented (e.g. Ames, 1992; Durrans, 1988; Kaeppler, 1992; Kaplan, 1994; Karp and Lavine, 1991). However, as Riegel (1996: 84) has observed, in exploring the political dimension of representing other cultures, museum professionals have tended to focus on the content of the exhibits, rather than on the modes of representation. While typological methods of representation were initially employed in ethnographic exhibits (e.g. Chapman, 1985), a major transformation took place at the beginning of the twentieth century when life figure groupings characteristic of a particular culture were made. Since then a fundamental interpretive mode of representation employed by ethnographic exhibits is the 'life-group', where modelled figures are assembled in a group and featured undertaking some activity. The life-group is closely related to the habitat group in the sense that both attempt to situate 'specimens' in a context, and like this major interpretive display of natural history, the life-group has an important history of its own.

The world's fairs and expositions of the 1800s provided a great impetus for developing innovative displays (e.g. Allwood, 1977; Altick, 1978; Greenhalgh, 1988; Rydell, 1984). In the anthropological sections of the fairs, modelled busts of different cultural 'types' were constructed in order to attract attention. These models, which grew out of the long tradition of waxworks in Europe and North America, were one of the major precursors to life-group displays. Peale had introduced wax figures in his museum in 1797, including models of native people from North and South America, Siberia, the South Seas, China and Africa (Alexander, 1983: 61). However, the major influence on the development of life-groups was the 'living ethnological exhibits', where communities of peoples from faraway lands were displayed in model villages. Since the 1500s native peoples had been brought back from voyages of discovery and exhibited in public

shows. Early examples include a Brazilian exhibited in Henry VIII's Whitehall around 1530, and a group of Brazilians exhibited in Rouen in 1550 (see Altick, 1978: 45; Kendrick, 1950: 121; Piggott, 1989: 73; and Boorsch, 1976: 509–10, for a visual representation of the Rouen 'exhibit'). By the 1700s London had become a popular venue for displaying native peoples, and in 1810 the famous 'Hottentot Venus' was exhibited there. By the mid-1800s Africans, Central Americans, Pacific Islanders and Australian Aboriginal people were featured at many venues. For instance, Africans were displayed in the zoological gardens of the Jardin d'Acclimatation in France in the 1870s (Schneider, 1982). By the end of the nineteenth century 'ethnographic villages', where Asian temples, Arab markets and African villages were reconstructed, had become a central feature of world's fairs (Coombes, 1994). While these were often presented as authentic, they have been described as 'honky-tonk concessions often located in the amusement sections of the fairs alongside wild animal exhibits, joyrides, and other entertainment features' (Rydell, 1984: 7). As Rydell notes, although these villages degraded and exploited the people on display, anthropologists generally testified to the ethnological value of the exhibits.

The success of the village encampments inspired museum curators to model life-groups for their anthropological exhibits at the world's fairs (Fowler and Fowler, 1991). At the Chicago Fair of 1893 the Smithsonian presented a series of life-group dioramas by Otis T. Mason who had been impressed with the living displays he saw at the 1889 Paris Exposition. It was not long before the life-group was introduced into major museums. In 1895 Franz Boas, Curator of Ethnology at the American Museum of Natural History, constructed a series of such displays in which the customs of native American Indians were featured. Originally Boas planned to construct eight life-groups with twenty-eight figures, but he increased this to another twenty groups with seventy more figures. The objective of these displays was clear – they were to attract visitors' attention and subsequently direct them to the more didactic displays. In Boas' eyes they had a role as 'glorified stop signs' (Jacknis, 1985: 100). Despite this Boas took the displays very seriously, devoting much effort into making them as accurate as possible. He had a series of photographs taken in which he posed for one of the dioramas (Hinsley and Holm, 1976). These poses were informed by a Hamatsa performance he had seen at the Chicago World's Columbian Exposition in 1893 and a visit to Fort Rupert in 1894. Boas 'clearly wanted to reproduce both actions and setting as accurately as possible for the museum display' (*ibid.*: 307).

Interpreting culture

The display of other cultures presented more obvious problems of interpretation than did the representation of nature. Ideas about race and progress clearly informed the construction of life-groups for world's fairs and museums. International expositions were aimed at displaying the economic strength and advancement of the Western nations. The basic concept at the heart of these fairs was progress, and progress could be no better demonstrated than by exhibiting non-white cultures as static and backward. Life-groups of indigenous peoples were not simply displayed because of an interest in other cultures, but for comparative purposes. The models of Indians were essentially an 'anthropologically calibrated yardstick for measuring the world's progress' (Rydell, 1984: 178). The characterization of non-Western cultures as primitive was enhanced by the stereotyping of behaviour. For example, men were often shown fighting, and women were shown weaving, making pots and cooking. Furthermore, life-groups always presented life before contact with 'civilisation' and emphasized the close relation of indigenous peoples to nature (Arnoldi, 1992: 451). The result was that non-Western cultures were presented as being little different from the animals in the adjoining habitat dioramas. Finally, these displays also emphasized the idea that indigenous peoples were vanishing and that visitors were getting a last glimpse of a dying race (Fowler and Parezo, 1993: 12).

Prehistory and the reconstruction model

In the nineteenth century museums responded to the growth of knowledge of prehistory in Europe by creating displays on the different periods of the past. The prevailing strategy of arranging artefacts to demonstrate the evolution of particular types of tools was very similar to the display of ethnographic material. However, like the anthropological curators, the archaeological professionals sought to create didactic displays in order to convey what the past was like. History museums had already begun to develop folk-life displays, where rooms were devoted to conveying different historic periods. An early example was that created by Artur Hazelius at the Museum of Scandinavian Ethnography in Stockholm in 1873. These folk-life displays were soon extended into open-air displays, and have since developed into the heritage sites of today (see Walsh, 1992). While these history exhibits influenced the creation of displays on recent periods of prehistory, it was the creation of displays for the remoter periods of prehistory that provided the greater challenge.

When an increasing amount of remains of our fossil ancestors were unearthed in Europe in the early twentieth century, museums were faced with the challenge of reconstructing what these distant ancestors may

have looked like. Influenced by the highly popular habitat diorama and life-group display, curators started to develop reconstruction models of ancient life. A few attempts were initially made at world's fairs. At the Chicago World's Columbian Exhibition of 1893, the Smithsonian presented an exhibition of people of the Stone Age (Rydell, 1984: 57), and at the World Exhibition in Paris in 1900 a life-size model of 'Pithecanthropus' (whose remains had been found in Java) was made. Models of ancestors were also connected to the live exhibits. At the Pan-American Exhibition at Buffalo in 1901 there was a show called 'The Evolution of Man', which was part of the 'Connecting Link' – a section that joined the amusements, restaurants and ethnological villages to the main exhibition hall (Rydell, 1984: 127). This show was also linked to the Wild Animal Show, which presented a live chimp as 'the missing-link'.

The first major museum exhibit on human evolution was created by Osborn at the American Museum of Natural History in the early twentieth century. However, it was not until 1933, at the Field Museum of Natural History in Chicago, that the first series of life-size reconstruction groups was built. A series of eight dioramas of our ancestors, from the Pleistocene to the beginning of the historic period, was displayed in the 'Hall of the Stone Age of the Old World'. At the time, this exhibition claimed to present the 'first authoritative life-size reconstructions ever made of a cave-man and his fellow cave-dwellers' (*Illustrated London News*, 29 June 1929: 1149). The first three dioramas present some of our early ancestors living in Europe, including *Homo erectus* and the Neanderthals (Figure 5.1). The other dioramas in the series feature rock art, a boar hunt 12,000 years ago, a stone alignment, and a Neolithic Swiss Lake Village. In 1972 one of the Neanderthal dioramas was remodelled to show that the species resembled modern humans more closely than was previously thought.

The fundamental point to make about the Chicago exhibit is that the construction of the displays involved extensive research, scientific consultation and international travel. The sculptor, Frederick Blaschke, worked with Henry Field, the assistant curator of physical anthropology, and Berthold Laufer, the curator of anthropology, to create authentic scientific representations. Blaschke and Field travelled to London to consult leading anatomists Arthur Keith and George Elliott Smith, who supervised the construction of small models of the figures. In 1927 they went, with a photographer and artist, to France to consult with the eminent prehistorian Henri Breuil, who took them to the sites depicted in the display. Models, pictures and photographs of each site were made. Everything was done to meet their aim of presenting the 'most complete and interesting picture that scientific knowledge then permitted of the lives, cultures, and physical characters of prehistoric members of the human race' (*Field Museum of Natural History Bulletin*, 1973). Their efforts

103

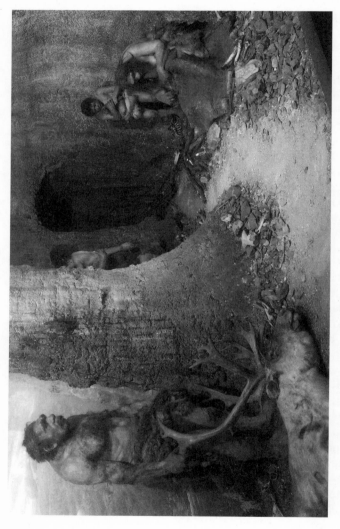

Figure 5.1 A historic diorama featuring the Neanderthals from the Field Museum in Chicago. This scene attempts to give an idea of cave life in the Stone Age, where the activities of hunting and skinning hides take place. The emphasis of the display, however, is on the appearance of this species, who were thought to be distinguished by their hunched posture and docile expression. The hairiness of these ancestors and their skin garments are also important details, helping to reinforce the idea that the Neanderthals were doomed to extinction. (Courtesy of the Field Museum Chicago. Neg. No. GEO84551.)

resulted in a highly successful exhibition; the impact of the displays on the public was profound. Not only did they attract large audiences, but they were reproduced in many popular texts on the subject of human evolution (e.g. Cole and Cole, 1940). In fact, the dioramas were so well known at the time that Thomas Mann referred to them in his novel *The Confession of Felix Krull* (Terrell, 1991: 149).

Interpreting the past

Like the natural history and ethnographic dioramas, prehistory dioramas did not simply show what 'specimens' looked like and how they lived, they were instrumental in conveying ideas about these subjects. In the case of prehistory the dioramas embodied ideas about the nature of human evolution, especially the concept of progress. Our earliest ancestors were depicted as savages with little culture, who gradually adopted the cultural traits that entitled them to human status. Toolmaking, burial and art, for instance, are celebrated events in the slow advancement of our species. The primitive, non-human status of our first ancestors is suggested by their docile expressions, their hunched postures, and the familiar club and animal skin, all reminiscent of classical images of 'primeval man' who was thought to have lived in a state of barbarity. Ideas about gender are also embedded in these seemingly innocent scenarios of ancient life. The stereotype of the female standing at the cave entrance with an infant on her hip, and the female on the ground skinning the hide are the two major images of women in scenes of the past (Gifford-Gonzalez, 1994; Moser, 1993). They are rarely engaged in anything other than 'domestic' activity; by implication, the cave is a home and the female is its caretaker. Similarly, the males are depicted as hunters and providers. They are the ones with the responsibility of leaving 'the home' to go out and encounter and conquer the harsh world. Essentially the past is presented in terms of familiar scenarios and events. We can relate to the dioramas because they show earlier forms of the cultural institutions of Western society. Furthermore the dioramas, when presented as a set or in a series, convey a simplistic linear narrative of human evolution. They suggest that one stage has inevitably led to the next, with the latter replacing the earlier, less evolved, form of existence.

Recent displays

Natural history, ethnographic and archaeological exhibits have continued to use the diorama as a major form of display. While natural history and ethnographic exhibits have addressed some of the problems of traditional dioramas, displays of the past have not made as much progress. For

instance, displays of the natural world have sought to change the emphasis on a carnivorous lifestyle and aggression between the species, and ethnographic displays no longer convey other cultures as savage and primitive. Involvement of indigenous people in the creation of exhibits has led to the production of displays that convey the diversity of their cultural heritage and contemporary existence. In contrast to this, while displays of the past have maintained their attention to scientific authenticity, they have done little to revise the traditional stereotypes and settings. The result of this is that the meanings of the displays remain unchanged. An examination of two recent displays of human evolution demonstrates that, while some positive steps have been taken, there is still much work to do.

The 'Hall of Human Biology and Evolution' exhibition, which opened at the American Museum of Natural History in 1993, and the 'Tracks Through Time' exhibition, which opened at the Australian Museum, Sydney, in 1988, are two of the most recent major exhibitions on our early past. Both are distinguished by their use of dioramas to communicate revised views of our early ancestors. The 'Hall of Human Biology and Evolution' features one diorama of our earliest ancestors in East Africa at around 3.5 million years ago, based on Mary Leakey's discovery of footprints preserved in volcanic ash at the site of Laetoli (Figure 5.2). Another represents life in the Turkana basin in north Kenya about 1.7 million years ago, and a third represents the Neanderthals around 50,000 years ago, based on a site in France. 'Tracks Through Time' features one diorama of the earliest known ancestors, based on the Laetoli site and the skeleton of 'Lucy' – the oldest and most complete skeleton of any erect walking human ancestor (Figure 5.3). Another features a different species of our early ancestors, based on work on cave sites in South Africa. The third depicts a Neanderthal burial scene, based on a site in Shanidar, Iraq, where pollen remains were thought to indicate that Neanderthals buried their dead.

Both the 'Hall of Human Biology' and the 'Tracks Through Time' exhibits seek to challenge deep-rooted stereotypes of our ancestors. They depict them as more chimp-like than human-like, as passive rather than aggressive, and as scavengers rather than hunters. Other attempts to revise traditional assumptions are also apparent. In the Turkana diorama, for instance, a couple was chosen rather than a nuclear family, the figures are black rather than European, and they are anatomically modern rather than primitive. But above all the curators of both exhibits were concerned to convey current scientific views on human evolution (Ritchie, 1988; Tattersall, 1993). Thus, they conveyed new ideas about the posture of our first ancestors and their behaviours (Moser, 1996b). Furthermore, the curators tried to restrict themselves to the evidence as much as possible. In the 'Hall of Human Biology' Neanderthal scene, for example, a female

Figure 5.2 A modern diorama of our earliest ancestors, the australopithecines, from the 'Hall of Human Biology and Evolution' at the American Museum of Natural History in New York. Based on the site of Laetoli in East Africa around 3.5 million years ago, and on skeletal evidence, this display aims to convey current thinking about the body form and posture of these people. However, the most striking feature of this scene is the gesture of affection shown between the ancient 'couple'. The decision to depict figures in this way marks an important contrast to the scenes of hunting and combat that are more typically shown. (Courtesy of the American Museum of Natural History. Neg. No. K16740)

Figure 5.3 A modern diorama of the australopithecines from the 'Tracks through Time' exhibit at the Australian Museum in Sydney. Also inspired by the Laetoli site and the skeletal remains of 'Lucy', this display attempts to represent the species as more chimp-like than human-like. While attention has been paid to research concerning the posture of the species, it is the drama of the scene, where a large sabre-tooth tiger confronts the small hominids, that captures the viewer's attention. (Courtesy of the Australian Museum.)

is shown chewing a skin because of the discovery of heavily worn front teeth; a male is shown sharpening a spear because flints were used to cut wood, and the presence of a spear is justified on the basis of the rare preservation of a wooden spear up to 300,000 years old (Tattersall, 1993: 76). Finally, the dioramas are closely linked to the data upon which they are based. In the 'Tracks Through Time' australopithecine display (Figure 5.3), for example, there is a replica of the Laetoli steps leading up to the glass front of the diorama and continuing right up to where the figures stand.

Despite the fact that the curators of these exhibits sought to challenge stereotypes and present the latest scientific findings, there is something very familiar about the displays. While the details are more accurate, the displays still rely on age-old images and themes. For instance, the cave home, the hairy male with his spear and skin garment, the female skinning the hide, the hunchback posture, and the snarling sabre-toothed tiger, have all been recycled from earlier displays. The Neanderthals in 'Tracks Through Time' have changed little from the old stereotypes in the original Chicago diorama. Furthermore, it appears that aesthetic concerns have sometimes taken precedence over scientific ones. For instance, when referring to the gesture of affection depicted in the 'Hall of Human Biology' Laetoli diorama, Tattersall (1992: 67) comments 'perhaps that pose is too anthropomorphic for some tastes, but the gifted English sculptor John Holmes produced such a vivacious result for us in his finished Laetoli figures that we frankly didn't care'. The conflict between science and aesthetic concerns is reflected in other statements made by Tattersall (1992: 62), who admits having failed to consider the 'extraordinary number of awkward decisions that would become necessary as work progressed'. While he defends the authenticity of the displays in one publication, stating that 'although I would not stake my life on many of the details I have mentioned, through careful sculpture and respect for the measured skull and body proportions, we have produced evocations of these vanished humans that bring them to life without sacrificing reasonable scientific accuracy' (ibid.: 69), he notes their hypothetical nature in another, stating that 'although their body proportions are thus presumably accurate, many details of these reconstructions are entirely conjectural' (Tattersall, 1993: 76). Thus, while he is at pains to assert their scientific veracity, at the same time he admits that they are largely hypothetical. In conclusion, it is clear that while certain developments have been made, there is a tendency to retain older formats of representation.

Future challenges

Despite their success as didactic displays dioramas have many limitations. First, they tend to produce stereotypes that have been virtually impossible

to erase from our consciousness. Second, they tend to present singular visions of the world that are formulaic and provide little room for alternatives. Third, despite the fact that these displays aim to be as scientifically accurate as possible, they still appear entirely imaginary or hypothetical. The problems of dioramas have been discussed by others. For instance, in his discussion of Boas' ethnological dioramas, Jacknis (1985: 98) states that 'despite their popular appeal, the problems they presented in scientific and artistic veracity seem to have made them not worth the great effort they entailed'. Furthermore, the status of dioramas as credible presentations versus artistic visions has long been debated. At the beginning of the twentieth century debates were held at the American Museum of Natural History concerning whether such displays were art or science (Rainger, 1991: 90). The dilemma of these didactic displays is that the portrayal of subjects and the contexts in which they are placed are often shaped more by aesthetic concerns than scientific ones. Put simply, there appears to be a division of labour – science provides the details and aesthetics provides the general context or setting in which the specimens are placed.

The issue of authenticity has been central to the continued use of the diorama. Despite their appearance as hypothetical artistic visions, dioramas are serious scientific business. The legitimacy of the interpretations made in dioramas is reinforced by the emphasis on the scientific basis of such displays. Great pains were taken to ensure that all the available evidence was used. From the days of Akeley Hall, the Boas life-groups and the Chicago dioramas, museums have invested an enormous effort in ensuring scientific accuracy. Displays were created by teams of specialists, many of whom would visit the sites upon which their displays were based to collect flora, fauna and geological data. This can still be seen, as with the recent reconstruction of the Ice-Man featured in the *National Geographic* (Roberts, 1993). Not only do we have a series of photos to show how many stages are involved in producing the reconstruction, and a description of the role played by modern computer-imaging technologies, but we also learn that no less than 600 hours were spent on producing the modelled head. All this information reinforces the scientific credibility of the reconstruction and attests to a serious financial commitment to this type of display. This investment seems understandable when we remind ourselves of the popular success of dioramas. However, it appears that their success does not stem as much from the scientific advances as from the visual spectacle they provide. Clearly museums have invested substantial time and effort into making sure displays do not stray into the realm of the imaginative; however, their very nature as visual presentations suggests they are creative, not scientific, works.

The longevity or life of these displays is also an important issue. Once

created, these interpretative visions are profoundly difficult to replace. Unlike published material they are not easily 'updated'. The addition of new text labels informing visitors of new views are unlikely to have much effect. As Tattersall (1992: 67) notes, 'an exhibit label might list as many caveats as we liked, but a concrete representation of any behavior would inevitably seem to make a rather definitive statement'.

Another critical point regarding the interpretive role of dioramas concerns the problem of realism. Boas, who had invested so much in this medium, outlined some of its limitations:

> It is an avowed object of a large group to transport the visitor into foreign surroundings. He is to see the whole village and the way the people live. But all attempts at such an undertaking that I have seen have failed, because the surroundings of a Museum are not favorable to an impression of this sort. The cases, the walls, the contents of other cases, the columns, the stairways, all remind us that we are *not* viewing an actual village and the contrast between the attempted realism of the group and the appropriate surroundings spoils the whole effect. (Jacknis, 1985: 101)

Dioramas face the dilemma of seeking to represent phenomena in the most realistic way possible not only in the sense of the accuracy of the diorama itself, but in terms of their relation to the other exhibits.

With regard to the presentation of the past, there are several general problems with the diorama genre. Although dioramas represent a genuine attempt to be scientifically rigorous they still have an 'outdated' quality. There is something about the artificial nature of a reconstructed model that makes it appear antiquated, especially in the current age of information technology and multimedia communications. Another characteristic is that they appear static, representing the past in terms of a set of single images. The problem is that of all the moments in our ancestors' lives, the ones deemed appropriate for representation are extremely limited, revealing the constraint of age-old stereotypes and a restricted set of narratives. As Pearce (1990: 158) states, because exhibitions have to be intelligible to the visitors in the most basic sense they 'usually end up preserving a stereotyped idea of the past, and confirming a particular political view of the nature of the present'. Put simply, they are conservative by nature. The settings are not only retained because of their appeal as a visually striking way of presenting the past, but because they are embedded in people's minds as the key moments or events in the story of human evolution.

Finally, dioramas raise issues about the way museum curators perceive their audiences. The presentation of the past in pre-packaged scenarios does not really encourage visitors to think for themselves; it also assumes that they want to have definitive statements made by the professionals.

These problems have generally been discussed in relation to recent writing on heritage (Walsh, 1992; Hewison, 1987). They have also been the subject of more specific critique concerning display practices (e.g. on the Jorvik Viking Centre in England see Addyman, 1990; Chabot, 1988; Schadla-Hall, 1984). One of the major observations made regarding recent representations is that, while they are technologically very innovative, they remain intellectually conservative. In the context of evaluating the role of dioramas it appears that the didactic intentions of displays are lost or subsumed by the medium of representation. Are we going to become so distracted by the potential of new display technologies that we avoid interrogating the underlying interpretive frameworks at the heart of our displays? While some recent displays, such as the one at the Museum of London, suggest that this will not necessarily be the case (Cotton and Wood, 1996), there is still cause for concern.

Considering all these problems, are dioramas still viable? At a time when people are stressing that we move away from typecasting species, and that we present multiple and alternative views of their lives, is this mode of representation still acceptable? Should dioramas be abandoned in favour of new interactive multimedia displays that convey the possibility of other realities? Can we change dioramas in a way that addresses the problems that have been raised? Because of their nature as a static form of narrative representation this is perhaps unlikely. The fact is that while dioramas do have serious problems in the way that they convey ideas about the world, they remain a highly popular means of communicating scientific findings to the non-specialist. The simple answer is that we still need them because people want them, and while there are many other ways that we could fulfil this need – such as computer images, which could be more easily updated and allow for the representation of alternative views – the life-size three-dimensional diorama remains the most striking and commanding form of display. The ideal situation would be the construction of both display types (interactive multimedia and traditional diorama), but are they compatible? These questions will slowly be answered as new display technologies such as animatronics start to provide more options for communicating our findings to a wider audience.

Acknowledgements

I would like to thank Tim Champion, Nick Merriman, Simon James and J.D. Hill for the many useful comments they provided on a draft of this chapter.

Bibliography

Addyman, P. (1990) 'Reconstruction as interpretation: the example of the Jorvik Viking Centre, York', in Gathercole, P. and Lowenthal, D. (eds), *The Politics of the Past*. London: Unwin Hyman, 257–64.

Alexander, E.P. (1983) *Museum Masters: Their Museums and Their Influence*. Nashville: American Association for State and Local History.

Allwood, J. (1977) *The Great Exhibitions*. London: Studio Vista.

Altick, R.D. (1978) *The Shows of London*. Cambridge, MA: Harvard University Press.

Ames, M.M. (1992) *Cannibal Tours and Glass Boxes: The Anthropology of Museums*. Vancouver: University of British Columbia Press.

Arnoldi, M.J. (1992) 'A distorted mirror: the exhibition of the Herbert Ward Collection of Africana', in Karp, I., Kreamer, C.M. and Lavine, S.D. (eds), *Museums and Communities: The Politics of Public Culture*. Washington, DC: Smithsonian Institution Press, 428–57.

Boorsch, S. (1976) 'America in festival presentations', in Chiapelli, F. (ed.), *First Images of America*. Berkeley: University of California Press, 503–15.

Browne, M. (1896) *Artistic and Scientific Taxidermy and Modelling*. London: Adam and Charles Black.

Caygill, M. (1992) *The Story of the British Museum*. London: British Museum Press.

Chabot, N.J. (1988) 'The women of Jorvik', *Archaeological Review from Cambridge*, 7 (1), 67–75.

Chapman, W.R. (1985) 'Arranging ethnology: A.H.L.F. Pitt Rivers and the typological tradition', in Stocking, G.W. (ed.), *Objects and Others: Essays on Museums and Material Culture*. Madison: University of Wisconsin Press, 15–48.

Cole, G. (1972) 'New Neanderthals', *Field Museum of Natural History Bulletin*, October, 6–7.

Cole, M.C. and Cole, F.C. (1940) *The Story of Primitive Man*. Chicago: University of Knowledge.

Coombes, A. (1994) *Reinventing Africa: Museums, Material Culture and Popular Imagination in Late Victorian and Edwardian England*. New Haven: Yale University Press.

Cotton, J. and Wood, B. (1996) 'Retrieving prehistories at the Museum of London: a gallery case-study', in McManus, P. M. (ed.), *Archaeological Displays and the Public: Museology and Interpretation*. London: Institute of Archaeology, University College, 53–71.

Desmond, A.J. (1974) 'Central Park's fragile dinosaurs', *Natural History*, 83, 64–71.

Desmond, A.J. (1975) *The Hot Blooded Dinosaurs*. London: Futura.

Durrans, B. (1988) 'The future of the other: changing cultures on display in ethnographic museums', in Lumley, R. (ed.), *The Museum Time-Machine: Putting Culture on Display*. London: Routledge, 144–69.

Field Museum of Natural History Bulletin (1973) 'Welcome to the Stone Age', 44 (7), 5–11.

Fowler, D.D. and Fowler, C.S. (1991) 'The uses of natural man in natural history', in Thomas, D.H. (ed.), *Columbian Consequences* (vol. 3). Washington, DC: Smithsonian Institution Press, 37–71.

Fowler, D.D. and Parezo, N.J. (1993) 'Mayans in Chicago, Mound Builders in Buffalo: archaeology at World's Fairs, 1876–1915'. Paper presented at History of Archaeology Symposium, Society for American Archaeology, St Louis, Missouri.

Gifford-Gonzalez, D. (1994) 'You can hide, but you can't run: representations of women's work in illustrations of palaeolithic life', *Visual Anthropology Review*, 9 (1), 23–42.

Greenhalgh, P. (1988) *Ephemeral Vistas: The Expositions Universelles, Great Exhibitions and World's Fairs, 1851–1939*. Manchester: Manchester University Press.

Haraway, D. (1989) *Primate Visions: Gender, Race and Nature in the World of Modern Science*. New York: Routledge.

Hawkins, B.W. (1854) 'On visual education as applied to geology', *Journal of the Society of Arts*, 2, 444–9.

Hewison, R. (1987) *The Heritage Industry*. London: Methuen.

Hinsley, C.M. and Holm, B. (1976) 'A cannibal in the National Museum: the early career of Franz Boas in America', *American Anthropologist*, 78, 306–16.

Jacknis, I. (1985) 'Franz Boas and exhibits: on the limitations of the museum method of anthropology', in Stocking, G.W. (ed.), *Objects and Others: Essays on Museums and Material Culture*. Madison: University of Wisconsin Press, 75–111.

Kaeppler, A. (1992) 'Ali'i and Maka' ainana: the representation of Hawaii in museums at home and abroad', in Karp, I., Kreamer, C.M. and Lavine, S.D. (eds), *Museums and Communities: The Politics of Public Culture*. Washington, DC: Smithsonian Institution Press, 458–75.

Kaplan, F.E.S. (ed.) (1994) *Museums and the Making of 'Ourselves'*. Leicester: Leicester University Press.

Karp, I. and Lavine, S.D. (eds) (1991) *Exhibiting Cultures: The Poetics and Politics of Museum Display*. Washington, DC: Smithsonian Institution Press.

Kendrick, T.D. (1950) *British Antiquity*. London: Methuen.

Moser, S. (1992) 'The visual language of archaeology: a case study of the Neanderthals', *Antiquity*, 66, 831–44.

Moser, S. (1993) 'Gender stereotyping in pictorial reconstructions of human origins', in Smith, L. and du Cros, H. (eds), *Women in Archaeology: A Feminist Critique*. Canberra: Department of Prehistory, Research School of Pacific Studies, 75–92.

Moser, S. (1996a) 'Visual representation in archaeology: depicting the missing-link in human origins', in Baigrie, B. (ed.), *Picturing Knowledge: Historical and Philosophical Problems Concerning the Interaction Between Art and Science*. Toronto: University of Toronto Press, 184–214.

Moser, S. (1996b) 'Science and social values: presenting archaeological findings in museum displays', in Smith, L. and Clarke, A. (eds), *Issues in Management Archaeology*. Brisbane: Tempus Press, 32-42.

Moser, S. (1998) *Ancestral Images: The Iconography of Human Origins*. Stroud: Sutton.

Moser, S. and Gamble, C. (1997) 'Evolutionary images: the iconic vocabulary for representing human antiquity', in Molyneaux, B. (ed.), *The Cultural Life of Images: Visual Representation in Archaeology*. London: Routledge, 185–212.

Olmi, G. (1993) 'From the marvellous to the commonplace: notes on natural history museums (16th–18th centuries)', in Mazzolini, R.G. (ed.), *Non-verbal Communication in Science Prior to 1900*. Firenze: Olschki, 235–78.

Orosz, J.J. (1990) *Curators and Culture: The Museum Movement in America, 1740–1870*. Tuscaloosa: University of Alabama Press.

Pearce, S.M. (1990) *Archaeological Curatorship*. Leicester: Leicester University Press.

Piggott, S. (1989) *Ancient Britons and the Antiquarian Imagination*. London: Thames and Hudson.

Rainger, R. (1991) *An Agenda for Antiquity*. Tuscaloosa: University of Alabama Press.

Riegel, H. (1996) 'Into the heart of irony: ethnographic exhibitions and the politics of difference', in Macdonald, S. and Fyfe, G. (eds), *Theorizing Museums: Representing Identity and Diversity in a Changing World*. Oxford: Blackwell, 83–104.

Ritchie, A. (1988) 'The "Tracks through Time" Gallery', *Tracks through Time: The Story of Human Evolution*. Australian Natural History Supplement No. 2. Australian Museum Trust, 33.

Ritvo, H. (1987) *The Animal Estate: The English and Other Creatures in the Victorian Age*. Cambridge, MA: Harvard University Press.

Roberts, D. (1993) 'The Ice Man', *National Geographic*, 183 (6), 36–67.

Rowley, J. (1943) *Taxidermy and Museum Exhibition*. New York: D. Appleton.

Rydell, R.W. (1984) *All the World's a Fair*. Chicago: University of Chicago Press.

Sellers, C.C. (1969) *Charles Willson Peale*. New York: Charles Scribner.

Sellers, C.C. (1980) *Mr. Peale's Museum: Charles Willson Peale and the First Popular Museum of Natural Science and Art*. New York: Norton.

Schadla-Hall, R.T. (1984) 'Slightly looted: a review of the Jorvik Viking Centre', *Museums Journal*, 84, 62–4.

Schneider, W.H. (1982) *An Empire for the Masses: The French Popular Image of Africa. 1870–1900*. Westport, CT: Greenwood.

Sheets-Pyenson, S. (1988) *Cathedrals of Science: The Development of Colonial Natural History Museums During the Late Nineteenth Century*. Toronto: University of Toronto Press.

Sherman, D.J. and Rogoff, I. (1994) 'Introduction: frameworks for critical analysis', in Sherman, D.J. and Rogoff, I. (eds), *Museum Culture*. London: Routledge, ix–xx.

Shufeldt, R.W. (1893) 'Scientific taxidermy for museums: report of the US National Museum', *Report for Smithsonian Institute 1892*, 369–436.

Tattersall, I. (1992) 'Evolution comes to life', *Scientific American*, August, 62–9.

Tattersall, I. (1993) *The Human Odyssey.* New York: Prentice Hall.

Terrell, J. (1991) 'Disneyland and the future of museum anthropology', *American Anthropology*, 93, 149–53.

Walsh, K. (1992) *The Representation of the Past: Museums and Heritage in the Postmodern World.* London: Routledge.

Wonders, K. (1989) 'Exhibiting fauna: from spectacle to habitat group', *Curator*, 32, 133–56.

Wonders, K. (1993a) *Habitat Dioramas: Illusions of Wilderness in Museums of Natural History.* Uppsala: Acta Universitas Upsaliensis.

Wonders, K. (1993b) 'Bird taxidermy and the origin of the habitat diorama', in Mazzolini, R.G. (ed.), *Non-verbal Communication in Science Prior to 1900*. Firenze: Olschki, 411–47.

6

Imag(in)ing the Past: The Politics and Practicalities of Reconstructions in the Museum Gallery

Simon James

Visual reconstruction is one of the most powerful interpretive techniques available to archaeologists. Reconstructions can put often highly fragmentary objects into a comprehensible physical, and perhaps social, context. They can communicate in ways that text, photographs, maps and plans do not. Yet they also have their limitations, and some archaeologists and museum professionals are hostile to their use. A consideration of reconstructions raises wider issues of the purpose of museum galleries, indeed of archaeological interpretation and communication in general. Professional attitudes towards them constitute something of a litmus test for issues of the petty political and cultural power underlying museology.

I should explain that I see myself as an archaeologist who sometimes draws and paints a bit and who is interested in, among other things, how we communicate our subject to outsiders. I have spent a decade as an educational curator at the British Museum; during that time I have also written a number of popular books for children and adults. Consequently my comments, as will become evident, are framed primarily against the background of larger museums and my own continuing exploration of alternative viewpoints (academic and otherwise) on these matters now commonly encountered beyond museum doors.

What are reconstructions?

This chapter is mostly about when and how visual reconstructions should be used, and the attendant problems and opportunities. (Much of the following draws on a more detailed discussion of the many issues involved in the creation of reconstructions; see James, 1997.)

The term 'reconstruction' is widely accepted to be an unhappy one,

since such illustrations are rather imaginative constructs or simulations, usually based on highly fragmentary data. They are different in kind from literal reconstruction, or restoration, where all or most of the artefacts survive to be reassembled. There is some overlap – for example the conjectural restoration of missing limbs from sculpture, and the dioramas incorporating some real antiquities in the Museum of London's new (1995) prehistory displays – but I am mostly referring to presentations which, while not incorporating actual antiquities, attempt to show them, and often their context, as they originally were. So, reconstructions are not really reconstructions, yet, as with other ambiguous terms like 'Celtic' (see below), we are more or less stuck with a time-hallowed label firmly established in common usage.

I define reconstruction broadly to mean the many kinds of static interpretive depictions, usually flat artwork representing three-dimensional objects or scenes, but the comments apply equally to models. Everything is included from a full-scale, coloured, textured diorama down to a simple sketch of how a Roman fibula worked. I am not initially covering video/computer graphic presentations, interactive systems, or live interpretations and object/replica handling, which work in different ways, although I will return to some of them later. I should also note that my comments are specific to Britain; other countries have their own, different traditions which I am not sufficiently familiar with.

Attitudes to reconstructions in museums and other contexts

Widely used in popular books, TV productions and on-site presentations, some form of reconstruction illustration or diorama is also to be seen in most archaeological museums, although the approach to and the scale of use and prominence of such scenes vary enormously. Clearly, there are resource implications for the use of elaborate reconstructions; they are inherently labour-intensive to produce, not only in the creation of the artwork itself, but (and this is where underestimates are often made) in research and preparation time (James, 1997: 39). However, there are more subtle issues than mere resources governing attitudes to the creation and use of reconstructions.

By their nature, reconstructions are images which draw on the imagination; they represent interpretation and varying degrees of informed speculation, which reflect the skills, knowledge and experience of both the archaeologist and the illustrator (usually separate people).

Reconstructions are frequently seen simply as a nice afterthought for a publication, or something to pep up an exhibition. Yet when it comes to designing them, many archaeologists rapidly become uneasy, both on general grounds and specifically regarding their employment in museum

galleries. There certainly are substantial problems inherent in reconstructions, especially complex ones (*ibid.*: 26, 33–4). The decision to commission a scene of, say, an Iron Age farm or a medieval street soon results in a barrage of questions from the illustrator or model-maker on subjects which the archaeology did not cover, and of which the archaeologist may be completely ignorant – perhaps because there is no evidence at all, particularly with regard to social aspects. 'How did they dress?' may be difficult enough, but 'How did they interact?' may seem unanswerable.

In general, the more detail it contains, the more inference and speculation an image incorporates, particularly with populated scenes. Technically good, finely detailed work conveys a subliminal air of authority, in the same manner that typeset text – on a case-label, for instance – inspires more confidence than handwriting. All too easily, a splendid painted scene may be taken as doubt-free, gospel truth about the past. In a realistic drawing or diorama which is intended to evoke a sense of how the past may have looked, how do you indicate to the viewer what is known, what is reasonably inferred, and what is a wild guess, when all looks equally solid?

One simple way of both highlighting and dealing with the question of uncertainty in reconstructions is to produce several alternatives based on the same data, showing that the evidence will bear multiple interpretations. This approach was used, for example, in the group of three variant reconstructions of a major early medieval building, Structure C12 at Cowdery's Down, Hants, published in the report on the excavations (Millett with James, 1983: figs. 70-71). These drawings were integrated with a detailed discussion of how the favoured reconstruction was devised. Such links between the archaeological evidence and the visual reconstruction are rarely made in any detail in books, still less in galleries. An excellent exception is that of the 'Glen Parva lady' in the Jewry Wall Museum, Leicester. Here the grave of a wealthy woman of the early Anglo-Saxon period is shown as it was found, next to a full-scale mannequin reconstruction including clothing, and a graphic panel explaining how the reconstruction was devised from the evidence. This approach, which shows something of the process of interpretation, is a good solution, but a relatively simple example compared with the presentation of, say, a complex settlement. The recent re-display of the Alexander Keiller Museum, Avebury, used pairs of contrasting reconstructions of neolithic people and life (flat graphics, and a 'schizophrenic' mannequin dressed half in 'plain and simple' and half in 'elaborate and sophisticated' manner) (Stone, 1994: 197–8, figs. 13.3–13.5). It is possible, then, to explain and qualify reconstructions. However, in the museum context these solutions require yet more graphics and text that compete with antiquities for gallery space.

Subtexts and metamessages

And what about more subtle messages, such as those implicit in the general appearance of human figures in reconstructions? We tend to make them look 'just like us'. This often occurs by default since, unless briefed otherwise, illustrators may do this automatically. It may be hard for either archaeologist or illustrator to imagine how to make the figures very different-looking in a convincing way.

However, the choice to make the figures close to ourselves in physiognomy, and even in hairstyles and bodily poses, may also be deliberate, to show these people were, essentially, biologically indistinguishable from us (at least since the last Ice Age) and to challenge the deeply entrenched, popular conception of the 'primitive', 'savage', or 'barbarous'. Figures which look like us subliminally help to create identification and empathy with earlier generations, encouraging a sense of respect for, rather than condescension towards, earlier cultures, and their striking achievements of which archaeological remains are perhaps our only witness. This is a key message of the new Museum of London prehistory gallery (Wood and Cotton, Chapter 2). But here an interesting clash of paradigms and aims is now arising.

Some, notably J. D. Hill, regard this empathy as fundamental to how archaeologists have conceived particular aspects of the past, particularly in Britain, with respect to those cultures we perceive as directly ancestral. His main concern is the so-called 'Celtic' Iron Age. He sees this empathetic identification as profoundly misleading since, if we think of these archaeological cultures as ancestral, we tend to assume they were like we are (or recently have been), and in important ways construe them as ourselves projected into the past (Hill, 1993). A good example of this was recently to be seen in the major exhibition 'The Celts, the Origin of Europe' at the Palazzo Grassi, Venice, where the metamessage was clear enough; the Celts were being presented as the earliest forerunners of the European Union (Kruta *et al.*, 1991: 11).

In using the past like this we deny the possible 'otherness' of cultures like those of the Iron Age, which other more critical approaches may see as surprisingly alien, utterly different from ourselves and our back-projected expectations. The problem with thinking of people in the past as 'just like us', is that we are almost certainly preventing ourselves, and others, from seeing them as clearly as we could. This new paradigm of the British past as 'Other', as truly different, is rapidly establishing itself, not only for prehistory but, if the papers and discussions at recent Theoretical Roman Archaeology Conferences are anything to go by, for the Roman period too (see Beard and Henderson, Chapter 3).

But this challenging of fundamental assumptions in later prehistory and even the Roman period poses a problem for popular communication

of archaeological information and ideas – and especially for reconstructions. The dilemma is that we may now want to say that these people were *biologically* just like us, while at the same time *culturally* quite alien. Here is an apparent contradiction, a paradox, of a subtlety I believe impossible to get across in a reconstruction drawing alone, or indeed even with a combination of objects, texts and graphics, in a conventional, static museum gallery. I suspect that here we are running up against the inherent limitations of these media. I will return to these issues later.

Such difficulties can result in general professional suspicion about reconstructions, exacerbated by encountering just plain bad drawings, or technically good work let down by inadequate research and anachronism. In the gallery context, some may resist the use of reconstructions because they fear that such images distract attention from the real artefacts. However, there are fewer objections to text, which many curators are only too pleased to provide, in reams. Text does not so obviously compete, and it represents the voice of the curator. Reconstructions are less clearly the product of curatorial thought; the viewer probably attributes them to, if anyone, the artist/illustrator. This is, then, also a question of who controls, and is *seen* to control, what goes on in the gallery. Curatorial power is another important factor to which we will return.

How do visual reconstructions work?

The nature of reconstruction illustration in particular is far less thoroughly explored and theorized than, say, the creation of museum text, although important work is now being done, notably by Stephanie Moser (1992a, 1992b, 1996, 1998; Chapter 5; Moser and Gamble, 1997). Yet visual media are of great and growing importance in our culture, especially with the growth of information technology.

Visual images appear to have instantaneous impact with little conscious effort: they are not limited by knowledge of specific spoken languages or technical vocabulary; and they can act at a distance, across the gallery, in a way a block of text cannot. Reconstructions in particular may be an especially valuable means of communicating with certain important groups of adults and children, particularly social groups who are more accustomed to visual media than text, TV and computer games rather than books.

Pictures, then, seem deceptively easy to use and to interpret. We tend to assume people know how to read them and, implicitly, that this process is natural and transparent. However, I would argue that they are read according to the spectator's own 'visual language', which may be culturally fairly specific. To take an extreme example, there is anecdotal evidence that people in some non-European societies cannot 'read' photographs,

never mind elaborate drawn projections and cutaways (Barley, 1986: 93), although this is disputed by others (Costall, 1997: 54). More generally, while young children across many human cultures seem to have considerable innate ability to identify simple drawings, 'different cultures favor different interpretations of ambiguous drawings or comment in different ways on the significance of frozen postures' (Kennedy, 1974: 83–4). Nevertheless, and crucially for us here, there is still a serious lack of research on perception of depicted events (Costall, 1997: 55). At the moment, it seems reasonable to suggest that interpreting complex images such as reconstructed scenes is an acquired cultural skill, dealing in quite elaborate visual conventions.

When presenting pictures to children, for example in books, adults typically talk with the child about what they are seeing and what it means; they provide a rich, verbal narrative context. Costall (1997: 58) notes that theorization of picture perception often neglects entirely this component, taking 'the picture to be a "finished" object, encountered by a solitary observer'.

But the visitor is often in exactly this position with a museum reconstruction, where there is no one present to expound the 'story' behind the image. There may, at best, be some textual explanation, but this is either short and over-simple, and probably not read; or it is comprehensive, and almost certainly not read. In the museum environment text, beyond headings, requires an effort few are prepared to make. This means that, even where explanation of an image is provided – and this is far from universal – it is often unnoticed or ignored. Museum reconstructions then are, I suggest, usually experienced with little, if any, explanation.

A fundamental difference between text and pictures, which may be seen either as an advantage or a problem, is that with images the message received is less guided than text; although that too can be misunderstood or consciously resisted, if not rejected. Isolated images are especially prone to being read simply in terms of pre-existing knowledge or prejudices. This question in particular – How do people actually read these images? – is in great need of more formal research.

It is very hard to predict actual responses to 'unsupported' reconstruction images, which, if they are investigated, may prove very surprising. I can only give as examples some responses from a particularly articulate group, the delegates to the WHAM (Women, Heritage And Museums) conference at the Museum of London in May 1994, to two illustrations for which I was personally responsible. These highlight resistant readings and the application of the viewer's own agenda and prejudices in interpreting a picture – which itself involves guessing about the agenda and prejudices of the illustrator and/or archaeologist.

The first of these was a line drawing of a group of hominids, intended

to illustrate interpretations of the Palaeolithic site at Boxgrove, Sussex (Figure 6.1). I drew this reconstruction for the book which accompanied the British Museum's exhibition, 'Archaeology in Britain', which was held in 1986 (Longworth and Cherry, 1986: fig. 2). The drawing did not appear in the exhibition, although it has subsequently been displayed elsewhere.

In close consultation with the excavator, Mark Roberts, I made detailed and careful preparations for the drawing, which I hoped would address some issues of stereotyping as I perceived them at the time. For example, women were shown actively engaged in the kinds of tasks which are often assumed to be male preserves, here driving off scavengers from the kill, and using a hand-axe (left-handed) to begin primary butchery. (For a detailed account of this example, see James, 1997: 40–5, figs. 2.8–2.10.) However, when the image was shown at the WHAM conference, the scene of women butchering was interpreted by one delegate as 'showing women doing the cooking, as usual'.

Further examples are provided by a painting which I commissioned from the well-known illustrator Peter Connolly for the British Museum travelling exhibition 'Celtic Britain: Life and Death in the Iron Age 500BC–AD50'. This purported to show a British noble couple of the middle Iron Age, based on archaeological data (especially from East Yorkshire cemeteries) and documentary sources (Figure 6.2). (For a more detailed account, see James, 1997: 35–8, fig. 2.6.) Reactions to the image encountered or reported to me included; 'She looks as though she is about to nag him' (from a male spectator); 'Why has *he* got all that stuff?' and 'Why is he taller than she is?' (female responses).

Such comments make the important point that *through the image alone* the archaeologist and illustrator cannot readily explain why things are depicted as they are; the unsupported image is open to reading according to the individual observer's unconscious preconceptions, or conscious agenda.

It is not argued that these examples, mostly from an articulate and closely interested group, are typical, but they are instructive. Yet how many galleries actually test audience responses to reconstructions and other components? Most people may be reading exactly the opposite of the intended message, for instance 'primitive barbarism' where 'intelligent cultural adaptation' is meant. (For some valuable examples of good practice in this area see Wood and Cotton, Chapter 2.)

Is this the whole story?

If audience response is usually neglected as part of the equation, are methodological objectives and financial limitations the whole story when it comes to decisions about the subject, size and style of reconstructions – or even their use at all? My own experience suggests not.

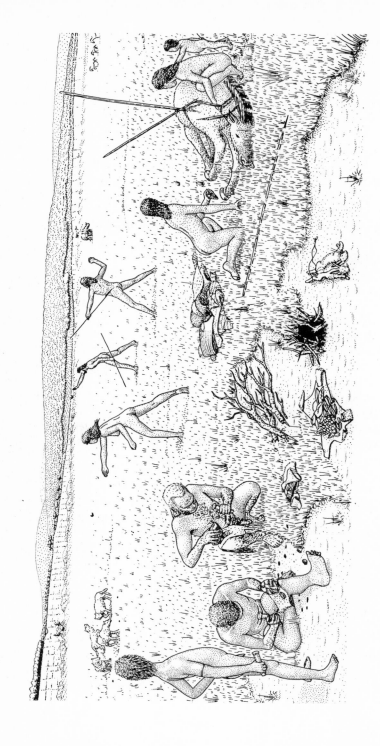

Figure 6.1 Reconstruction of the Lower Palaeolithic site at Boxgrove, Sussex, drawn by Simon James. (From Longworth and Cherry, 1986, illustration 2. Reproduced courtesy of the Trustees of the British Museum.)

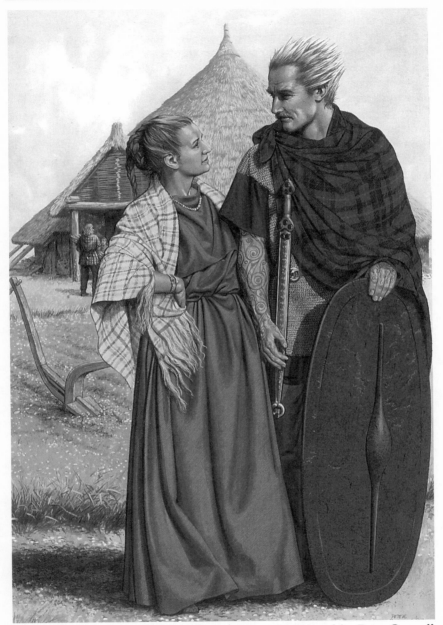

Figure 6.2 Gouache of a British Iron Age couple. Painted by Peter Connolly for the British Museum's travelling exhibition, 'Celtic Britain: Life and Death in the Iron Age 500BC–AD50'. (Reproduced by permission of Peter Connolly.)

There is also the fundamental but rarely articulated question of how archaeological curators, and museums as organizations, believe public use of reconstructions will reflect on themselves. The choice *not* to use reconstructions is often symptomatic of a wider reluctance to present interpretation, seen also in the treatment of text. Gallery text-panels and labelling may be pedantic and hyper-technical, which is explicable in terms of curatorial fear of peer criticism. But why is basic functional information, such as how and why brooches were worn in the Roman period, often omitted?

Visual reconstructions inevitably emphasize the physical and practical, never very fashionable in archaeology, and by many implicitly seen as uncerebral, trivial, *'infra dig.'* and even vulgar. If anything, this situation is now getting worse. In the past, objects meant typology; now they increasingly mean symbolism. Despite the current emphasis on social practice, the real interest remains in the underlying structures far more than in practice itself. In either climate, 'trad' or 'trendy', it is easy to see that some may regard reconstructions as inherently unscholarly.

To take a fairly recent example from the British Museum. When the recently dismantled Roman Britain Gallery (Room 40) was created in the early 1980s, curators planned to display fragmentary legionary armour and weapons mounted on two outline figures of soldiers, flanked by detailed reconstruction paintings in the same poses, which would 'fill in the gaps' in the evidence for the appearance and structure of Roman military dress. The then Director, Sir David Wilson, resisted their use, because 'this is not a didactic institution, it is a centre of academic research'. (Thankfully, the tenacity of the curators prevailed, resulting in one of the most useful and popular displays in the gallery.)

The resistance of some to reconstructions is due to a perceived association with 'kiddies' (reconstructed scenes remain particularly concentrated in children's books), and this is equated with not being 'serious'. To many, the visually interesting is for children, therefore the adult, the sophisticated, the intellectually credible, must apparently express its difference by being visually boring or obscure. Just look at almost any academic book on archaeology. In the scholarly world, visual and verbal dullness is routinely equated with credibility.

Can objects 'speak for themselves'?

Reconstructions, like other forms of gallery interpretation, might indeed distract from the authentic artefacts. Yet that is not to say, as I still sometimes hear said, that the objects 'must speak for themselves'. This is utterly fallacious. There is here an implicit and wholly erroneous assumption that it is somehow 'natural' to be able to understand archaeological objects.

This is not true of Western art, even with its relatively familiar living traditions and conventions (Berger, 1972); still less is it true of fragmentary archaeological remains from remote times and quite alien cultures.

Objects appear to 'speak' to visitors only if they create resonances with pre-existing experiences, if they can be related to prior knowledge and understanding. Those who proclaim that 'objects speak for themselves' have typically spent a lifetime working with material culture. They have conveniently forgotten, or choose not to remember, that they were children once, that the language of objects had to be learned; it is folly to assume others are so equipped. This is why displayed artefacts need interpretation, often best achieved through reconstructions of some kind.

In galleries, many uninterpreted objects mystify, and in some contexts (consciously or unconsciously) they are *intended* to mystify. Let us take what I hope is an uncontroversially remote example from the history of the British Museum, namely the decision not to restore the missing heads and limbs of the Elgin (Parthenon) Marbles after their arrival in 1816. (For a fascinating discussion of the history of the British Museum sculpture collections, see I. Jenkins, 1992.) I suggest that this decision was in part implicitly intended to limit true appreciation of the sculptures to the art-historically initiated; and, via the reverential and imposing context of their display, to create among outsiders a sense of awe and mystery as to their true, hidden meaning. The uninitiated, through a kind of intellectual peep-show, were intended to be aware of their ignorance.

Analogous practices are still common in museums (Molyneaux, 1994: 4–5). This use of control of access to knowledge and understanding leads to the creation of what Bourdieu calls the cultural capital of dominant social groups. Everyone is intended to *know* that certain types of knowledge and taste are prestigious, but only the initiated few are taught how to fully appreciate their subtleties; all others are thus taught to know their place. (See R. Jenkins, 1992, especially 128–51, for an accessible introduction to Bourdieu's approach.) Classical learning in particular was a key part of the cultural capital of the Georgian and Victorian elite; after all, this is in large measure why our society founded institutions named after temples to the Greek muses, themselves often temple-like buildings with neoclassical façades.

Of course the visuals do matter intensely in all gallery contexts; but it is often the overall ethos projected by the gallery, not the comprehensibility of the objects, which triumphs. Institutional image comes before concern for visitors' understanding of the displayed past. This may sometimes seem glaringly obvious, but where it is so, I have found both curators and gallery designers very resistant to even discussing the issue, which appears to be taboo. It lies outside the permissible field of discourse (that is, it

falls within Bourdieu's useful concept of the realm of *doxa*, the unspoken, that which, in a given social structure, is not 'visible' as a topic available for discussion; Bourdieu, 1977: 168–71). In this view, phenomena such as reconstructions represent a medium associated with low-status outsider groups, and if prominent in the gallery risk the dissipation of all-important cultural capital by making deeper ('higher') levels of under-standing too widely available. They compromise the projection of status and so their use is circumscribed or even rejected entirely.

The decision to employ reconstructions, then – *and equally the decision not to employ them* – is loaded with wider, hidden questions of control of access to knowledge, and therefore to cultural power. As much as anything, they represent judgements about a museum's self-image, and the image it wants to project.

Academic status and the wider community

Perhaps because of the particular circles I move in – conservative museums and (by comparison) fairly radical university departments – I find myself encountering strongly polarized attitudes with regard to the communication of archaeology and scholarship in general, and in museum displays in particular.

On the one hand, that which I call the 'Tablets of Stone approach' is alive and well in some museums; so to speak, we, the experts, reveal our truths to a grateful public, with no sign of process, doubt or ambiguity (some galleries still don't bother to interpret much at all). As the work of Nick Merriman and others has shown, many people still expect museums to be like this, since they remain widely associated with upper- and middle-class status to which people aspire; they want to acquire the symbolic cultural capital for themselves (Merriman, 1991: 92–5). Some visitors I have encountered are content to revere the museum from 'below', as I believe in Victorian times the 'lower orders' were intended to do. Courtesy of the academic priesthood they enjoy glimpsing deep and apparently unattainable truths. In the process, of course, they also feed academic vanity ('the sadistic satisfactions of power are matched by the masochistic conformity of many of the powerless', Eagleton, 1983: 193). However, to me, this temple/priesthood ethos is the antithesis of what museums should be about – the open communication of academic knowledge and ideas.

On the other hand, particularly among the socially theorized, there is much talk of empowerment of visitors to enable and encourage them to make their own multiplicity of readings of the past. To me this reaction to the traditional, closed (if not exclusionary) approach is very welcome in principle but sometimes too extreme. Some are apparently suspicious of *any*

attempt at interpretation, as hopelessly compromised by the power games I have outlined, and paternalistically constraining to free interpretation.[1]

Both approaches, in my view, ignore the fact that, particularly in the case of the fragmentary material culture of remote times, reading and interpreting are extremely difficult, and require much prior knowledge and experience. Completely unguided exposure to archaeological remains seems to me to be a scandalous abdication of responsibility. (Actually we come full circle; no interpretation 'imposed' is in effect the same as interpretation withheld.) It is hopelessly unrealistic to think that people will then only come up with interesting, constructive interpretations of their own making; many will be bored, others confused and alienated, while some will come up with fascist and racist readings. Few museum professionals, I think, would find these acceptable.

Of course, most actual practice falls between these two extremes, although I think largely for pragmatic reasons rather than as a result of a consciously articulated philosophical or ideological stance.

Putting visitors into the equation

I have so far deliberately concentrated on academic and museum professional-centred perspectives, because it is from these viewpoints that the subject is still usually approached. However, such views still too often arise from largely untested assumptions about how museum visitors will respond to what we present, usually based on a fairly generalized idea of who 'the public' is.

We continue to devise elaborate routes, or at least information structures, and assume 'the public' will follow them, but may never look to see if they actually do. It should be evident that we are dealing with multiple audiences; a school party, for example, clearly has needs differing from those of a coach party of foreign tourists. There is obvious value in finding out who our publics are and asking what they want to know, in addition to deciding what we want to say to them. We do not have to become slavishly reactive to every whim of popular fashion (as some fear), but we do have a duty to answer legitimate questions. Among the most common are: How did it work? What did this thing/this place/these people look like? What did they do? How did they behave? (Stone, 1986; 1994: 194–5, 205).

It seems glaringly obvious that involving visitors, engaging with them directly – professionals talking *with* them rather than *at* them – is instructive for both parties, providing feedback for better presentations. Yet this is infrequently done and, scandalously, at the end of the twentieth century, in some very large museums it is not even an issue for discussion among curators and designers.

Against this more complex background of overt and hidden academic agendas, and diverse public interests, let's look again at the possible uses of reconstructions within and beyond the museum.

Showing the workings of constructed pasts

Archaeology galleries are not windows on the past; archaeology is a process in which *we* interpret fragments in the present and apply our knowledge and imagination to create presentations of what the past *might* have been like. What archaeologists do *is* 'reconstruction', visual and otherwise. Archaeology displays are therefore also inevitably about us, and should be. The who and the how of archaeological process should be there, not omitted in a disingenuous attempt to make this process appear transparent, natural, inevitable, obvious. Reconstructions can play a key role. They are also products of archaeological interpretation and so they, too, are in part about us, about how we think, and why. We should be explicit about this.

We should be using reconstructions, then, among other means of communicating, to explore our relationship with our constructed pasts. In her keynote address to the 1995 Society of Museum Archaeologists conference, Susan Pearce described the museum gallery as the end product of the process of archaeological activity. I believe this is a fundamentally flawed view, because it seems to imply closure; the gallery opens its doors, and that is that. However, for the visitor, seeing the display is the beginning of a process (or perhaps continuation of one already underway) of understanding and learning about archaeology. Visitors must not be construed as passive consumers. A gallery is not a definitive statement, but an essay in archaeological interpretation which should be the subject of continuing dialogue for the benefit of both visitors and archaeologists (for the latter, to provide data and ideas to feed into subsequent interpretive projects). Instead of seeing components such as reconstructions as one particularly problematic end product of the complex processes of archaeological interpretation, we can use their limitations constructively as the starting point for just such a process of communication about archaeology.

But how do we turn a passive, visual conclusion into an active, or better interactive, medium of understanding, questioning and exploration? We have seen that it is very difficult to do this in a gallery; so maybe the gallery is not the best place to do it at all.

Visual reconstruction, since it is a medium which can speak to a very broad range of audiences, could be a widely applicable starting point, the hub of a multimedia presentation about archaeology, which introduces and prepares the viewer for contact with primary evidence (especially

artefacts in a traditional museum gallery) through familiarization with processes of interpretation. This should happen, as far as possible, through interaction with the primary interpreters themselves − the archaeologists.

There are various ways to do this. One of the most flexible, I suggest, is centred on multimedia computer systems. A scene could be presented on screen, with several switchable alternatives, and the possibility to zoom in on details. Imagine a full-colour version of the Boxgrove drawing (Figure 6.1), with the chance to switch between several versions, one in which the apparent gender roles are reversed; another with a very different group structure; or even one in which the wolves are trying to drive off scavenging hominids. Imagine that, if you click on details, up pop images of the artefacts and other primary evidence, and access is given to multiple lines of argument and interpretation through text, sound and video, including 'talking heads' of archaeologists explaining why they think it was so, or why they don't. Why not air conflicting opinions, which are the essence of scholarly debate? In this way we can use reconstructions both to explain and to allow interrogation, working back from a comprehensible visual conclusion to the evidence, the ideas and the process of doing archaeology.

Different media have different strengths and weaknesses, and so messages have to be matched to the most suitable so that the different components support each other effectively. A presentation like this allows us to play to the strengths of each. Ideally, there should be live interpreters present too, to help and interact directly. This kind of approach aims at enabling, 'empowering', but also challenging, showing the constraints of evidence, and the implications of ideas. It would help to demystify archaeology, revealing it as not an omniscient discipline, but as a self-critical human process which can provide deep insights, but which is inevitably culturally situated. Through this we can help people construct their own pasts but at the same time give the message that 'not all conceivable pasts are equally likely or valid'.

It might be argued that such an approach could confuse visitors, but it constitutes a more honest view of archaeology as a dynamic process, dealing in problematic arguments, not the spurious certainties which are so often served up.

Where might this take place? Such a facility should certainly be in the museum but, I would suggest, not in the gallery of artefacts itself. I imagine it placed somewhere before visitors reach the galleries − with, of course, the option to bypass it if desired. Such an IT-based presentation can also be available outside the museum, on CD-ROM or, better, on the Internet (where it can be updated frequently to take account of feedback and new developments). Then people can explore at leisure, at home, at

school, in public libraries. It may be argued that this will mean people will no longer feel the need to visit museums. I suggest that many will want to visit more, because they would acquire a better understanding for what they are going to see; and that it is an excellent way of 'hooking' currently non-museum-visiting, but IT-using groups. It can be structured as a powerful promotional medium for archaeology and for museums. The only way to see if it works is to try it out.

If our general aim is to encourage people to appreciate and to interpret archaeological objects, and to incorporate archaeological and historical knowledge as part of their understanding of their world, then we should remember that this is already rarely, perhaps never, a process which either begins or ends in the museum gallery. For most, it is a part of a wider engagement with study of the past which begins in childhood, especially in school, where many aspects of the approach outlined above are already employed.

The use of museums by schools has long been part of a truly multi-media approach to history teaching, and this is now enshrined in the National History Curriculum (Department for Education, 1995), which has had a profound impact on the museum world (Reeve, 1996: 234-5; 1997). The collections of the museum – and visits to archaeological sites – are among a range of media used for investigating the past, including books, TV/video, and computers, as well as various kinds of live teaching and interaction, which are used in combination. In particular, emphasis is placed on classroom preparation before the gallery visit, so that children arrive motivated and curious, with questions they want to answer. The British Museum has long been synchronizing its special events, schools materials and, as far as possible, exhibitions with, for example, Schools TV series.

I am confident that the kind of scheme outlined here would work, because as we have just seen many elements of such a structure already exist separately, and are well proven, or in development. For example, Newcastle University Museum of Antiquities already has a pioneering World-Wide Web version of its recent, highly successful, 'Flints and Stones' presentation, which was a combination of a conventional graphics and glass-case exhibition combined with live, first-person interpretation (Allason-Jones et al., 1995).

The kind of interaction I advocate has a long history. The earliest example of which I am aware, of a graphic reconstruction of a historical scene created specifically for public communication purposes, which was then interactively interpreted for a popular audience by a live facilitator, occurred in the second century BC. Pliny the Elder records that

L. Hostilius Mancinus, who first broke into Carthage [in 146BC] ... placed in the Forum [a painting depicting] the site of the city and his own

assaults upon it, and [was] also ... present himself ... explaining the details to the onlooking public (for which affable behaviour he was elected to the consulship in the next assembly). (Pliny, *Natural History*, XXXV, 22–25, trans. Pollitt, 1983: 51)

Evidently, this approach can pay dividends.

What is the aim?

What really is the aim, 'the question we never ask' (Schadla-Hall and Davidson, 1982: illus. 102; 1983)? A conference entitled 'Representing Archaeology in Museums' (which was the genesis of much of this book) runs the risk of not getting very far because perhaps it is addressing the wrong issue, or the right issue from the wrong angle. We may tend to see the problem of the museum presentation of archaeology somewhat in isolation, hardly surprising as we are professionals with our own professional interests, in both senses of the word; we are concerned about the medium we work with and, reasonably enough, we are also concerned with our careers in museums. This is an aspect of a wider problem that has arisen with the professionalization of archaeology. The development of specialized career frameworks can easily lead to myopia, the inability to see the potential of link-ups with related fields, other specialists and different media. And, at least in some quarters, there is a real danger of growing isolation from the public on whom we rely.

I suggest that instead of asking, 'How do we present archaeology in museums?', we should ask, 'What is the role of the museum in the presentation of archaeology?' That is, how can museum displays be integrated with all the other communication media available to us, to make our discipline available to the public at large? So far as I can see, there will always be a role for static reconstructions, in books and in galleries, just as there will always be a key place for displays of original artefacts. Yet I would suggest that, paradoxically, 'decentring' the museum gallery by adopting a much broader framework may be the most successful way to develop new, better and more effective museum archaeology presentations.

Note

1. In terms of comprehensibility, some social theorists are at least as bad as the traditionalists they attack. In their use of language they are often vastly more obscure, and are playing just the same games of power and exclusion of the uninitiated. Bourdieu is himself a prime case (R. Jenkins, 1992, especially 152–174).

Acknowledgements

I would like to thank Nick Merriman for inviting me to contribute this chapter and for his valuable comments on the draft and additional references. I am also grateful to John Reeve and Hilary Williams for information and references, and to Sam Lucy for constructive comments on the draft version. I should also like to acknowledge Peter Connolly and the Trustees of the British Museum for permission to reproduce the illustrations.

Bibliography

Allason-Jones, L., O'Brien, C. and Goodrick, G. (1995) 'Archaeology, museums and the world-wide web', *Journal of European Archaeology*, 3 (2), 33–42.

Barley, N. (1986) *A Plague of Caterpillars.* Harmondsworth: Penguin.

Berger, J. (1977) *Ways of Seeing.* London: BBC and Penguin.

Bourdieu, P. (1977) *Outline of a Theory of Practice.* Cambridge: Cambridge University Press.

Costall, A. (1997) 'Things, and things like them', in Molyneaux, B.L. (ed.), *The Cultural Life of Images: Visual Representation in Archaeology.* London: Routledge, 49–61.

Department for Education (1995) *The National Curriculum: England.* London: HMSO.

Eagleton, T. (1983) *Literary Theory: An Introduction*, Oxford: Blackwell.

Hill, J.D. (1993) 'Can we recognise a different European past? A contrastive archaeology of later prehistoric settlements in Southern England', *Journal of European Archaeology*, 1, 57–75.

James, S. (1997) 'Drawing inferences; visual reconstructions in theory and practice', in Molyneaux, B. L. (ed.), *The Cultural Life of Images: Visual Representation in Archaeology.* London: Routledge, 22–48.

Jenkins, I. (1992) *Archaeologists and Aesthetes in the Sculpture Galleries of the British Museum 1800–1939.* London: British Museum Press.

Jenkins, R. (1992) *Pierre Bourdieu.* London and New York: Routledge.

Kennedy, J.M. (1974) *A Psychology of Picture Perception.* San Francisco: Jossey-Bass.

Kruta, V., Frey, O., Raftery, B. and Szabo, M. (eds) (1991) *The Celts.* London: Thames and Hudson.

Longworth, I. and Cherry, J. (eds) (1986) *Archaeology in Britain since 1945.* London: British Museum Publications.

Merriman, N. (1991) *Beyond the Glass Case: The Past, the Heritage and the Public in Britain.* Leicester: Leicester University Press.

Millett, M. with James, S. (1983) 'Excavations at Cowdery's Down, Basingstoke, Hampshire, 1978–81', *Archaeological Journal*, 140, 151–279.

Molyneaux, B.L. (1994) 'Introduction: the represented past', in Stone, P. G. and

Molyneaux, B. L. (eds), *The Presented Past: Heritage, Museums and Education*. London: Routledge, 1–13.

Moser, S. (1992a) 'The visual language of archaeology: a case study of the Neanderthals', *Antiquity*, 66, 831–44.

Moser, S. (1992b) 'Visions of the Australian Pleistocene: prehistoric life at Lake Mungo and Kutikina', *Australian Archaeology*, 35, 1–9.

Moser, S. (1996) 'Visual representation in archaeology: depicting the missing link in human origins', in Baigrie, B. (ed.), *Picturing Knowledge: Historical and Philosophical Problems Concerning the Interaction Between Art and Science*. Toronto: University of Toronto Press, 184–214.

Moser, S. (1998) *Ancestral Images: The Iconography of Human Origins*. Stroud: Sutton.

Moser, S. and Gamble, C. (1997) 'Evolutionary images: the iconic vocabulary for representing human antiquity', in Molyneaux, B.L. (ed.), *The Cultural Life of Images: Visual Representation in Archaeology*. London: Routledge, 184–212.

Pollitt, J. (1983) *The Art of Rome, c.753 BC–AD 337. Sources and Documents*. Cambridge: Cambridge University Press.

Reeve, J. (1996) 'Making the history curriculum', in Kavanagh, G. (ed.), *Making Histories in Museums*. Leicester: Leicester University Press, 228–39.

Reeve, J. (1997) 'Museums and schools', in Anderson, D. (ed.), *A Common Wealth: Museums and Learning in the United Kingdom* (A report to the Department of National Heritage. Papers for Colloquia held for the Report in 1995). London: Victoria and Albert Museum (unpaginated).

Schadla-Hall, R.T. and Davidson, J. (1982) 'It's very grand but who's it for? Designing archaeology galleries', *Museums Journal*, 82 (3), 171–5.

Schadla-Hall, R.T. and Davidson, J. (1983) 'No longer can the objects speak for themselves', in White, A. (ed.), *Archaeological Display*. Lincoln: Society of Museum Archaeologists, 20–34.

Stone, P.G. (1986) 'Are the public really interested?' in Dobinson, C. and Gilchrist, R. (eds), *Archaeology, Politics and the Public*. York: Department of Archaeology, University of York, 14–21.

Stone, P.G. (1994) 'The redisplay of the Alexander Keiller Museum, Avebury', in Stone, P.G. and Molyneaux, B.L. (eds), *The Presented Past: Heritage, Museums and Education*. London: Routledge, 190–205.

7

Archaeology, Gender and the Museum

Marie Louise Stig Sørensen

Introduction

Archaeological exhibits gain their meaning from three main sources. One is the archaeological interpretation of the object and its associations, as indicated in its identification and other labels. Another is the museum's created significance as the object becomes part of a construction. The third is what the viewer brings to the object. This complexity means that the production of meaning within museums has been difficult to understand. Of the analyses of museums, Porter's is interesting in being one of the few informed by an explicit feminist critique (Porter, 1988; 1991; 1996). She sees the museum as formed by exhibition, curator and visitor, and proposes that it can be analysed in terms of the relations between author, text and reader (1996: 108). This stimulating approach still leaves somewhat unsolved the central problem of how meaning is created. In particular, the ways in which objects and images 'speak' are not fully covered by the comparison with text. Objects, for instance, easily provoke identification, they seek ownership, act as *aide-mémoire*. They play on tradition and recognition, and can be subject to fetishism. Objects also have aesthetic dimensions. The language of the object is multi-layered, subtle, universal and at the same time specific. (For a feminist approach to the nature of things in museums see Sandahl (1995), who approaches them as materialized emotions.) The museum object – selected, displayed and interpreted – has an extra layer added, fixing it with textual information and/or a guided interpretation or experience. The object in the museum is never 'pure', unaffected by intentions. It is being spoken for at many levels, and it becomes imbued with meaning. The relations between these different meaning-producing planes are not well understood. They do not depend upon each other; but at the same time they can affect each other, challenge or confirm apparently unrelated assumptions. Contradiction between them is also possible and does not necessarily adversely affect the 'experience' of the visitor: it may be rewarding not to 'believe' in the museum. In addition, views differ on what ought to be the meaning/

purpose of the museum visit. Some stress education, whether auto-didactic or authoritarian, while others emphasize experience and emotions as the most powerful ways of engaging with the past. Others see entertainment as a legitimate *raison d'être* for museums. Thus, the profession does not agree about the effect the museum should have (and how that can be achieved), nor is the meaning produced in the museum easily controlled or predicted. Within this complexity it is not surprising that an active engendering of the archaeological object and its exhibition has been slow in gaining ground and affecting the displays.

Where does an engendered past come from?

A relatively simple aspect of the delayed engendering of the archaeological exhibit is that the discipline of archaeology has not provided 'an engendered past' packaged ready for display. The museums have not, it may be claimed, been told how to respond to the problematization of gender in archaeology. To emphasize this point too much would be wrong, however. It too easily assumes that there is a different and more truthful version of the past to be found and presented. This emphasis on reconstruction of the past, upon there being a different version of the past through which one model can be replaced by another, easily misses the point of the feminist critique of both archaeology and of museums. The reliance upon there being *one* engendered understanding of the past and the assumption that it will be clearly expressed in the object and its immediate context will limit, and possibly be contradictory to, the project of engendering the presentation of archaeology.

In general, archaeological museums do not seem to have come to terms with how engendering implies problematizing a fundamental social relationship. If what museums should display and communicate is not static, but rather concerns relationships that were dynamic and negotiable, then a museum language that conveys this must be developed. Museums, by their very nature, will objectify society, its practices, norms and concerns, and they tend to freeze and stabilize it. The challenge is, therefore, to communicate that these 'objectified' societies were nonetheless complex and dynamic, otherwise engendering will continue to consist merely of 'adding' women to displays without affecting meaning and significance. The reliance upon the academics to produce new interpretive frameworks ignores how much of the object's meaning and significance is created in the exhibit and assigned by the visitor. Moreover, to the extent that engendering is about problematizing and questioning gender assumptions and stereotypes, the museums have their own reasons for, and means of engaging with, these issues (see also Webb Mason, 1995). Proposing that the engendering of the archaeological exhibit is both dependent upon

and the responsibility of the museum, not independent of archaeology but complementary to it, we may now begin to consider critically why the project of engendering and feminizing archaeological displays has had so little impact.

Archaeology and museum as identity

Gender concerns have as yet scarcely affected the museum. With the exception of Gaby Porter and Jette Sandahl, few museum theoreticians have seriously engaged with these issues, and fewer have been concerned specifically with the archaeological exhibit.[1] This is despite the obvious role archaeology has in naturalizing and thus legitimizing views about sex-based differences in behaviour and roles. It is obviously the case that 'The curator of archaeology has a greater gulf of experience and understanding to span' (Johns, 1996: xiii). But the archaeological object, at the same time, does not easily resist interpretation, as we know little about it in comparison to objects in historical museums. The object's time depth, therefore, does not make it neutral; on the contrary, the archaeological exhibit produces very explicit notions of significance and difference. The distance in time combines with our desire to determine origin to produce identification in a complex yet totally unrestrictive manner. Museums affect identity by providing very forceful, partially sublimated, messages about importance, contribution, roles and effect. The question of women's presence in museums and in their messages is not just a trivial matter. It influences the way we see ourselves and the roles we presume rights to. Archaeological museums, and in particular those about prehistory, are furthermore dependent on objects and images as their sources. These material forms influence the 'reading' of the exhibition enormously, and often in ways that are not clearly acknowledged: the object is evocative and can be seductive, but in itself it can provide neither analysis nor narration. This makes the archaeological exhibit particularly dependent upon and vulnerable to the meaning that the museum and the visitors ascribe to the object.

The history of men has been presented as the history of us. While the past may have been presented as an abstraction, and in that sense both faceless and genderless, people do nonetheless place themselves in it. Its apparent neutrality is denied by its effects. Analyses of how our own gender identities may affect how displays are understood and experienced are still lacking. This aspect of the discussion of the engendering of the museum experience is therefore largely based on assumptions about our tendencies to identify along lines of sex and gender.[2] It seems likely that difference in role-expectations will affect visitor experiences. Presuming this to be the case, it is commonly assumed that women read only the

story of women as their own story, and that they will relate to the general story of humankind at a more abstract and less personal level. On the other hand, since their story and the general story are much more interwoven, and due to their granted central roles in society, men are able to read it as theirs and to identify with many more of the actions and events presented in the displays. As a general phenomenon it is the case that women, in the past and as museum visitors, are reduced to observers, the ones history happens to, while men, through their active presence in the past and equation with humankind can experience history as theirs.

Appreciating that the museum affects notions of difference, significance, and rights, the need to engender the museum experience becomes more urgent. Museums reach a wide audience and their assigned authority gives their statements weight. Museums should therefore aim to present the past through both its difference and sameness to us. They can problematize our attempt at unlocking that past and separate the present from the past by challenging notions of continuity, legitimation and progress. Archaeology, despite its detachment from general education, is strongly related to concepts of origin and the sense of where and who we come from. It therefore plays a significant role in problematizing these connections.

Gender studies of the museum, or 'drawing by numbers'

The critique of the absence of women from our constructed past and in the profession was one of the first indications of feminist and women's interests affecting archaeology. The earliest concern was with visibility, and it was quickly applied also to considerations of the museum's creation of meaning and significance. These questions were voiced in the 1980s, prior to explicit feminist and gender interests affecting archaeological interpretation. The foundation of the organization Women, Heritage and Museums (WHAM) in 1984 was an early expression of these concerns, and its agenda is indicative of which issues were first identified. The organization aimed to promote positive images of women and to combat discrimination in museum collecting, exhibition and activities, and to encourage informed museum practice including campaigning for equal employment in museums and related fields (Pirie, 1985). These aims have now become mainstream issues within the field of women in museums, and most analyses of the relationship between the two have accordingly focused upon questions of stereotypes, bias and equity (see also Butler, 1996). The role of women as curators, that is the question of who selects and shapes the museum collection, has been debated in many contexts, and women's employment within the museum hierarchy generally has been analysed for many countries (e.g. Anderson and Reeves, 1994

(Australia); Grab, 1991 (Germany); Høgsbro, 1994 (Sweden); Texeira, 1991 (Portugal)). The manner in which the traditional museum obscured the role of women has also been highlighted. The stereotypic depictions of women as mothers and housewives cooking and caring through (pre)-history and the simultaneous downgrading of these activities have been repeatedly demonstrated (for preliminary studies see Chabot, 1988; 1990; Horne, 1984; Jones and Pay, 1990; Jones, 1991; Mandt, 1994; Moser, 1992; Wood, 1996). Additional work concerned with gender messages in archaeological displays is found in student dissertations and essays, which unfortunately are rarely published and thus have little means of affecting museum practice (Webb Mason, 1995).

The focus upon androcentric biases has resulted in a common assertion of the absence (Jones, 1991: 247) or invisibility of women in presentations of the past (Horne, 1984; Jones and Pay, 1990; Webb Mason, 1995). This has been an important development, but it has also introduced some potentially limiting research practices. Primarily, these approaches collapse the question of gender to being about the presence of women, and at the same time they focus upon visibility in terms of quantity. Reconstructions of prehistoric scenes and exhibitions are now commonly assessed in terms of how many women and men are presented (Wood, 1996: 56–7, but see also her discussion later in the chapter). This totally misses the point that not only are women made invisible in terms of not being present, but their invisibility arises out of their assigned insignificance in terms of the interpretive engagement with the display, that is, you don't need to engage with the women to understand what is being said about the past (Wood, 1996). Thus, women may be prominently present in a display and yet still be missing from the interpretation.

Porter is one of the few who has tried to make us aware of this process. She writes:

> In exhibitions ... women and the feminine become, literally, the frontiers by which space and knowledge are defined: they are the more distant and imprecise elements, in the background and at the edges of the picture. The figures and activities in the foreground, more fully developed and with greater consistency, are those of men and the masculine attributes ... representations of women did not 'fit' together coherently, whereas those of men were relatively congruent. (Porter, 1996: 112–13)

I read this quotation to mean that men are used to carry the narrative of the past through the exhibition space, they provide the key to our history. It is through men that change and innovation that constitute history are articulated. Men therefore become the history. Moreover, as this connection between men and history as progress and change is not made explicit but rather created through the structure of the 'narrative', it is not

immediately available for critical assessment and challenge. Furthermore, as such meaning is constructed by drawing connections between objects as well as statements and through the creation of difference and significance, then the addition of the unconnected woman does not really challenge or alter the message; they remain merely ornamental and not essential for understanding. For women to become part of history, its active practitioners rather than passive bystanders, they must become connected parts of the narrative; their contributions and lives must be incorporated and essential for a satisfying engagement with the display.

This problem is typified, for example, by many of the contributions to the conference and proceedings in celebration of the tenth anniversary of WHAM (Devonshire and Wood, 1996). The importance of WHAM and its published proceedings is not in question, but it is interesting nonetheless also to identify our shortcomings. The visibility of women (in particular within traditional male-associated activities) was the aim of the conference. But, in addition, visibility was so highly regarded that, in striving towards it, questions about how it was obtained were neglected. In emphasizing 'successful' individuals we ignored concerns with how their lives represented what women did at a particular time and disregarded how gender ideologies were involved in creating those particular situations and lives. The single woman, and at times possibly the unique woman, becomes the voice of all her contemporary sisters even when their lives may have been very different. The individual accomplishment becomes the property and potential of all women. We must ask whether we, in our desire to claim men's virtues and practices, risk erasing women's real lives? Why do we so very much want women to be smiths, and why are they so hesitantly allowed to be 'housewives'? We are still inserting women, rather than connecting them to history; at most they become sidelined, a kind of complement to the traditional account. It has been pointed out that through such procedures we miss both the opportunity of understanding history in new ways and that, 'with such a point of departure ... there is a great danger that we will continue to equate general concerns with what in reality are male concerns, so that the history of mankind tacitly remains the history of men' (Jonsson, 1993: 13–15, translation in original). We are still too focused upon the *woman*, rather than understanding the variability of *women*. Despite the best intentions, our analysis of gender representation in museums has, with few exceptions, continued to focus upon visibility and the implied connection between visibility and significance. As a consequence, the discussions have become bounded by a debilitating notion of how significance is obtained. Lind has characterized the concern with women in museums as polarized between two different needs: misery research and dignity research (1993: 6). I suggest that the engendering of the archaeological

exhibit could and should provide far more exciting and constructive challenges to the ways in which we think about and assume gender differences if it moves beyond these simple (albeit at their time important) presentist motivations. We need both a more subtle understanding of how significance is gained within exhibitions and a greater awareness of how gender must be both problematized and connected to the narrative of change and development.

Museum-speak

The problem of engendering is thus to some extent embedded in the tradition of museum-speak: the way knowledge is represented and meaning created. Fundamentally, museums are about representations and our engagement with them. But representations easily become stereotypical or symbolic rather than providing more subtle, discursive statements. This is relevant not least for archaeology where the individual, the personalized and quaint aspects of life usually do not enter into the engagement. The nature of the museum itself becomes central, as Porter has so effectively argued (1996), when considering our ability to engender the museum space and text.

There are obvious parallels between the concern with gender in museums and the move towards including other groups (typically constituted by variables such as ethnicity, social class and age) either in existing museums or in their own (Shepherd, 1994). The interest in gender is in this sense part of a general concern with representing cultural diversity. It is therefore interesting that it seems to have been even more difficult to incorporate gender in museums than many of the other 'groups'. One may wonder why this is the case. Do we understand class better than gender, and do we have a clearer notion of who makes up an ethnic group and how the group may be represented? We have probably remained somewhat unclear about what gender means and therefore what engendering the museum exhibit implies. Our analysis of the presence of women in exhibits and the attempts at 'rectifying' the situation has been too simple. It is telling in this regard that many of the calls for gender representation in museums are phrased in terms of fairness (Johns, 1996: xiii), of a more truthful (Butler, 1996: 21), or a less unjust (Hirdman, 1993: 32–3) or a less biased presentation of women's role in history, as if there was some objective account to compare against. History is not fair, and there is no correct version of anyone's role in (pre)history. We can, however, forcefully argue that the analysis of gender, as a fundamental and dynamic social relationship, is essential for understanding the changing nature of society. This will involve both a recognition and a re-evaluation of the roles of women (Butler, 1996: 21). We can also emphasize that

gender is dynamic and a process for the individual, rather than merely fixed role and labour divisions (Sofaer-Derevenski, 1997). To empower this understanding of gender, the message of the displays must become overt rather than hidden and embedded in traditional, naturalized assumptions about difference. It is important to understand how men and women – both apparently present in our displays – at present are given such different roles in the story about the early past.

The problem of concealed or embedded messages in the displays, since they themselves are products of a particular society and its gender ideology, is a substantial challenge. The display uses the language of objects and of texts, but as both are meaningful at several levels, any attempt at gender neutrality will repeatedly be undermined by an understanding of the embedded messages and by the assumptions brought to it by the visitor. For instance, words like humankind and ancestors tend to be understood as referring to males, and even simple, seemingly neutral words, such as farming may commonly be associated with male activities and thus with masculinity (Chabot, 1990; Jonsson, 1993: 19). Such links, furthermore, may not be challenged merely because a woman is shown in a reconstruction drawing. It is also common that the passive form is used primarily in connection with women and that women are referred to in ways similar to objects (Gaarder Losnedahl, 1994: 7). Similarly, it is important to recognize that many items are gender-coded, and that our interpretations are affected by notions of femininity and masculinity that exist as an undercurrent in our understanding of the world around us. In the links made by the visitor between objects and people there is often an assumed association either with men or with women. Unless the tension between assumption and message is made very explicit and unavoidable, the intended reading can easily be ignored (see for example Riegel's (1996) discussion of the failure of the 'Into the Heart of Africa' exhibition).

It is essential to recognize that many dimensions of our material constructions have embedded gender associations. For instance, analysing reconstruction drawings in terms of the number of males and females present is clearly secondary to how variables such as composition, position, image, colour and size convey impressions of strength, will and knowledge (Wood, 1996: 55–56). If the facial expression is demure and passive, even a central position in the picture does not easily communicate an active and strong person. Placed away from the focus of attention, on the other hand, an activity automatically becomes secondary (*ibid.*: 56). The homely and familiar, such as the kitchen, is superficially less exciting than the strange and dangerous, and this easily obscures recognition of its central function in the maintenance of life and society. It is also important to recognize that the entire museum is the space in which meaning is produced, and that space itself easily conveys a hierarchy of importance.

143

The display cases are in various ways spatially situated, and their internal messages may be contradicted by the messages communicated by their surroundings – by the dramatic total sceneography of the exhibition, the theatre of its outer spaces, which is often dominated by large, male-associated items of impressive dimensions and bulk that are untamed by the cases. The lasting impression may be of their largeness, negating the carefully and sensitively constructed stories of the displays themselves. That which is apparently not articulated can be still more obvious and have more impact upon the visitor than something which is articulated. This is relevant both to the phenomenon of 'non-articulated presence', such as the maleness of the boat at the Nydam exhibition discussed later, and to the silence of exhibitions. Lind, in her museum analysis, expresses this as 'Meaning is produced in what is said as well as what is not said' (1993: 6). The silence about women creates significance. It is therefore important to recognize how easily and subconsciously variables are used to create differences between women and men, differences that we inter-pret in terms of significance. We must therefore provide both the moti-vation and the information necessary for the visitor to appreciate that a different meaning can be constructed.

To provide gendered displays we must replace quantitative assessments of women's presence with qualitative analysis of how men and women are present, and what affects their presence. We must attempt to reveal the hidden messages that exist in our representations of society and the past. 'It is in relation to the opposite sex that both women's and men's history is formed, and the empty space created by the exhibition between the women and the men, is thus not really empty – but charged with mean-ing' (Jonsson, 1993: 25). The identification of this tension or space is sig-nificant, since it is here that we will find the margins where meaning can be negotiated and new gender representations emerge.

Some of the best intentions ...

Although most archaeological museums still ignore gender as a problem-atic, some displays have attempted to produce alternative gender-informed presentations of the past. Some of these aim at the presentation of women's importance and use the displays to portray a different past – one in which women are central and in which their contribution to social life is highlighted. Others engage with the issues by making the museum exhibition discursive about itself and the archaeological interpretive practice rather than focusing upon the past. They aim to make the visitors aware that the past is constructed and to make transparent how this is done and what assumptions go into its making. Below I comment briefly on a few museum displays that, each in their own way, challenged me by

stimulating unpredicted and unfamiliar responses. The aim is to give an idea of the different forms an engendered display may take.

The missing women: the Nydam Exhibition, Schloß Gottorp, Germany

The first case that I highlight was provided by a set of traditional glass cases in the Nydam exhibition. This is a display of the extraordinary Iron Age deposits of boats and weapons from Nydam, southern Denmark, now housed and exhibited at Schloß Gottorp, Schleswig, Northern Germany. One of the boats has been preserved, and its largeness and solid black timber construction totally dominate the big exhibition hall. The rest of the deposit, shown in several glass cases along the walls and standing in rows on the floor, is composed almost entirely of items of war, beautifully shaped and often even more exquisitely decorated. The visual impression is overwhelming, and it is totally dominated by war, warriors and weapons, creating explicit and obvious associations with masculinity. The archaeological objects provide hardly any means of introducing women into the display. When I visited the exhibition, a number of cases were used to show the appearance of men: their different uniforms, their dress accessories, personal equipment, the position and combination of weapons, and suggestions of regional and status differences in their dress. And then there was a big glass case showing the appearance of the contemporary women. It was left empty! There was just a small notice stating that the archaeological material did not provide sufficient data to show how the women would have been dressed. The effect was stunning. It stopped me in my tracks. It thoroughly engaged me with the question of how the women might have looked and what objects they might have owned. It suddenly made me aware of the partial nature of the exhibition. The exhibition daringly used some of its precious space to say apparently nothing – and yet it communicated so much and changed the visitor's way of relating to the entire display. It did not challenge the fact that the exhibition was about warfare and men, but it made obvious the limitations implicit in that theme. For me, this was the most effective challenge a museum has ever provided, yet it was simple, obvious and demanded few resources. Maybe it was just honest about what we know and what our exhibits are about?

The individualized women: the Wasamuseum, Stockholm, Sweden

The Wasamuseum is built around the Wasa ship, a magnificent and highly adorned royal man-of-war built by the king in 1628. It sank on its maiden voyage, and the sea water preserved it beautifully until it was lifted in 1961. A new museum was built around the ship in 1989. The information about

the building is given as follows: 'The ship and its historical background is presented via theatrical sceneography and lighting techniques. In a rather dark interior different acts of the Wasa-drama will emerge as one walks through the museum. All the time, there will be a conscious awareness of the ship in the centre' (Wasamuseet, 1988). The museum is totally focused upon the ship, which dominates the exhibition hall in a breathtaking explosive manner. Its masts soar towards the ceiling far above and its bulk stretches into the darkness. The museum provides an obviously embodied ideological sensation of power and the king(dom) that is created through space, light and mass. Upon entering, one measures one's own smallness against the rising bulk of the ship disappearing into the darkness above. It is awe-inspiringly huge, its gilded ornaments shine against the dark wood, while details are picked out by spotlights. One feels silenced, there is a hush throughout the cavern-like space around the king's ship. This again is a totally male-dominated context: the objects are masculine by association, the people who died and whose names and identities are revealed were all men, and the craft people, who lavished so much gold and labour, were also men. So how can a woman enter into the displays (skilfully provided as side-chambers as one moves up the levels of the ship's galleries) without her participation being contrived? One of the galleries manages to do so in a manner that was convincing, interesting and engaging. Using a figurehead to indicate women, this display presents a legal case brought to the court by a woman married to a sailor. The case was against her brother-in-law for not properly doing a job she had paid him for, and this real-life incident is then used to contemplate the life of women like her: married but managing on their own for years while their husbands were at sea. From the individual life we are provided with a 'window' upon some of the social and gender issues 'behind' the story of the royal ship. Further appeal comes from this being real. This is a human-interest story about someone who actually lived, whose life was shaped and affected by sea-warfare, and who most of the time was alone in running the family affairs. Although an individual, she was not unique. Rather, her story illustrates for us how women lived and were part of and affected by wider social and political history. This use of the narrative biography provides us both with a means of empathy (we can imagine the woman and feel with her) and at the same time also allows analysis and understanding by outlining the effect upon people's lives of institutions such as the navy.

The relevance of this example to archaeological displays is that we have neglected the possibility of presenting such narrative biographies. Many of the graves we have could provide glimpses of an individual person. We could tell about her age and state of health, traces on her body can reveal something about how she lived, her diet and labours. Her objects have stories attached to them; they come from somewhere, they were rare or

common, worn or new. There is potential in our data for presenting people of the past as human beings with personal lives, pains and pleasures. This would not by itself connect such individuals to the narrative of development and change; but it would make them far more real, much more engaging and thus less easy to overlook.

The celebrated women: 'The Powerful Woman: From Volve to Witch'. Stavanger Museum, Norway[3] (temporary exhibition)

This exhibition celebrated women, their roles and uniqueness, through prehistory and also showed how the introduction of Christianity undermined women's social standing. The exhibition covered 2000 years (from the Late Bronze Age to the Middle Ages) using as the structure of its story the pinpointing of certain moments that illustrate the changes in women's social standing (Lundström and Adolfsson, 1995: 6). The catalogue shows a number of striking installations from the exhibition. These acted as foci for the space in which these moments are presented, using texts (sparingly and involving different kinds, including poetic statements and traditional labels) and a selection of a few symbolic or emblematic objects. The exhibition is explicit in its use of different means of communication to construct meaning, thus making imaginative involvement possible and also some assessment of the reasoning behind the story. The catalogue stresses that imagination and exaggeration can be used constructively, and how the visual presentation has been shaped as a dramatization of women's path through history (ibid.: 6). In this exhibition women are central to the narrative, and they are presented as an opposition (or difference) to male and masculinity. This is similar to the techniques used in some of the women's museums such as in the exhibits at the Women's Museum in Århus, Denmark, discussed by Porter (1996) and Sandahl (1995). The exhibition was clearly successful in presenting a history centred upon women and their experiences. It challenged normative views of the past and allowed an explicit feminist interpretation of prehistory and history to emerge.

This was a celebration of women; and its challenging and different content made it fascinating, although one may argue that the effect was gained at the costs of subtleties and problematization. The arguments presented by the exhibit are based upon a belief in a different version of prehistory (such as women being the performers of religious rites in farming communities (Lundström and Adolfsson, 1995: 12)); but the manner of presentation causes them to appear as mere postulates if one does not share or is unsure about those beliefs. It is interesting to note that a consequence of this emphasis upon women is a tendency towards the same, age-old stereotypes about the nature of men and of women.

The exhibition was, I believe, effective, challenging and constructive, but the way it approached the past as women's story also made it one-dimensional in its probing and problematizing. The more demanding strategy of allowing both men and women a presence in the past and yet aiming at the engendering and reassessment of the female is avoided. In response, one may fear that such polarization – despite its challenges and excitement – isolates women's history, as if it can only be powerful and effective, recognized and brought into being, if there is nothing to distract us. It makes it appear as if women's past is so fragile that it needs nurturing and protection, and that it can only be recognized when detached from the rest. Jonsson suggests that such women-only exhibits, while giving women presence, paradoxically will also make them invisible in the sense that gender issues will appear as a concern only for women (1993: 15). Praising the exhibition for its sincerity and uniqueness, one may nonetheless want to argue that women's work and products must be placed in their context and be emphasized within this in order that their importance and contribution can be fully appreciated, and an engendered past rather than a women's past emerge.

Clearly, engendering is a process of understanding: it can be achieved in different ways and have many outcomes. Part of the project of an engendered museum culture may thus be that museums become rich and varied in the voices they provide, that the representation of the past happens between them rather than within just one, that visitors come to understand how we construct (pre)history as best we can, and that they learn that gender relations in the past and present are discursive and changeable.

Acknowledgements

I would like to thank Christopher Evans for our many discussions on this topic. For reading and commenting upon the paper I am grateful to Robin Boast, Christopher Evans, Joanna Sofaer-Derevenski and Sharon Webb Mason.

Notes

1. These considerations are limited to discussions of archaeological exhibits in Europe.
2. 'Sex' refers to biologically constituted identities. 'Gender' refers to culturally constructed identities.
3. 'Volve', used in the title of the exhibition, means a soothsayer, someone who can see into the future (Lundström and Adolfsson, 1995: 7). The comments on the exhibition are based on the catalogue rather than my own visit.

Bibliography

Anderson, M. and Reeves, A. (1994) 'Contested identities: museums and the nation in Australia', in Kaplan, F.E.S. (ed.), *Museums and the Making of "Ourselves".* Leicester: Leicester University Press, 79–124.

Butler, B. (1996) 'Virginia Woolf, Madonna and me: searching for role-models and women's presence in museums and heritage', in Devonshire, A. and Wood, B. (eds), *Women in Industry and Technology: Current Research and the Museum Experience.* London: Museum of London/WHAM, 19–27.

Chabot, N. J. (1988) 'The women of Jorvik', *Archaeological Review from Cambridge,* 7 (1), 67–75.

Chabot, N. J. (1990) 'A man called Lucy: self reflection in a museum exhibition', in Baker, F. and Thomas, J. (eds), *Writing the Past in the Present.* Lampeter: St David's University College, 138–42.

Devonshire, A., and Wood, B.(eds) (1996) *Women in Industry and Technology: Current Research and the Museum Experience.* London: Museum of London/WHAM.

Gaarder Losnedahl, K. (1994) 'Kvinne og museum', in *Nytt om Kvinneforskning. Feministisk museumkritik.* Oslo: Norges Forskningsråd, 5–11.

Grab, T. (1991) 'Women's concerns are men's concerns: gender roles in German museums', *Museum,* 171, 136–9.

Hirdman, Y. (1993) 'Kvinnohistoriens Historia', in *Det Dolda Budskapet. Kön, makt och Kvinnor, män i museiutställingar.* Norrköping: Arbetets Museum, 29–37.

Horne, D. (1984) *The Great Museum.* London: Pluto Press.

Høgsbro, K.-E. (1994) 'Kvinder i musealt regi', in Alenius, M., Damsholt, N. and Rosenbeck, B. (eds), *Clios døtre gennem hundrede år.* København: Museum Tusculanums, 87–109.

Johns, C. (1996) 'Foreword', in Devonshire, A. and Wood, B. (eds), *Women in Industry and Technology: Current Research and the Museum Experience.* London: Museum of London/WHAM, xi–xiv.

Jones, S. (1991) 'Presenting the past: towards a feminist critique of museum practice', *Field Archaeologist,* 14, 247–9.

Jones, S. and Pay, S. (1990) 'The legacy of Eve', in Gathercole, P. and Lowenthal, D. (eds), *The Politics of the Past.* London: Unwin Hyman, 160–71.

Jonsson, I. (1993) 'En Kvinnohistoriker går på museum. En undersökning hur kvinnor och män, kön och makt presenteras i några svenska museiutställningar', in *Det Dolda Budskapet: Kön, makt och Kvinnor, män i museiutställingar.* Norrköping: Arbetets Museum, 11–27.

Lind, M. (1993) 'En Brännande treklöver: museer, kvinnor och betydelses produktion', in *Det Dolda Budskapet: Kön, makt och Kvinnor, män i museiutställingar.* Norrköping: Arbetets Museum, 4–9.

Lundström, I. and Adolfsson, G. (1995) *The Powerful Woman: From Volve to Witch.* Stavanger: Arkeologisk Museum.

Mandt, G. (1994) 'Trenger vi en feministisk museumskritikk?' *Nytt om Kvinneforskning. Feministisk museumkritik.* Oslo: Norges Forskningsråd, 11–20.

Moser, S. (1992) 'The visual language of archaeology: a case study of the Neanderthals', *Antiquity*, 66, 831–44.

Pirie, V. (1985) 'Women, heritage and museums', *Archaeological Review from Cambridge*, 4 (1), 117–18.

Porter, G. (1988) 'Putting your house in order', in Lumley, R. (ed.), *The Museum Time Machine: Putting Culture on Display*. London: Routledge, 102–27.

Porter, G. (1991) 'Partial truths', in Kavanagh, G. (ed.), *Museum Languages: Objects and Texts*. Leicester: Leicester University Press, 103–17.

Porter, G. (1996) 'Seeing through solidity: a feminist perspective on museums', in Macdonald, S. and Fyfe, G. (eds), *Theorizing Museums: Representing Identity and Diversity in a Changing World*. Oxford: Blackwell, 105–26.

Riegel, H. (1996) 'Into the heart of irony: ethnographic exhibitions and the politics of difference', in Macdonald, S. and Fyfe, G. (eds), *Theorizing Museums: Representing Identity and Diversity in a Changing World*. Oxford: Blackwell, 83–104.

Sandahl, J. (1995) 'Proper objects among other things', *Nordisk Museologi*, 2, 97–106.

Shepherd, B. (1994) 'Childhood's pattern: appropriation by generation', in Pearce, S. (ed.), *Museums and the Appropriation of Culture*. New Research in Museum Studies 4. London: Athlone Press, 65–83.

Sofaer-Derevenski, J. (1997) 'Engendering children, engendering archaeology', in Moore, J. and Scott, E. (eds), *Invisible People and Processes: Writing Gender and Childhood into European Archaeology*. Leicester: Leicester University Press, 192–202.

Texeira, M.B. (1991) 'From strength to strength', *Museum*, 171, 126–8.

Wasamuseet (1988) *Wasamuseet. Byggnadsstyrelsen informerar*. Stockholm: Byggnadsstyrelsen.

Webb Mason, S. (1995) 'All flint and no females: gender perceptions in public presentations of prehistoric hunter gatherers'. Unpublished MPhil dissertation, Department of Archaeology, University of Cambridge.

Wood, B. (1996) 'Wot! no dinosaurs? Interpretation of prehistory and a new gallery at the Museum of London', in Devonshire, A. and Wood, B. (eds), *Women in Industry and Technology: Current Research and the Museum Experience*. London: Museum of London/WHAM, 53–63.

8

Wargames and Wendy Houses: Open-air Reconstructions of Prehistoric Life

Angela Piccini

Introduction

Open-air reconstructions become spaces of representation and are made meaningful through primary physical engagements, by both visitors and staff (cf. Lefebvre, 1991). Such social spatialization is bound up in the creation of the 'coherent subjectivity of self, in the construction and legitimisation of relationships between subjects and other subjects, subjects and social institutions (maintained partly by representations of the spatial), subjects and groups, and subjects and World' (Shields, 1991: 273–4). Because we live our lives in and around built environments those environments become bound up with how we see ourselves and others. The explicit awareness of these heritage constructions as spaces is important in that spatialization is a cultural formation embodied not in learned rules but in bodily gestures and trained postures in and toward the world which has relevance for the way in which we, as a society, remember (Connerton, 1989). In other words, hermeneutic concerns with the textual content of museums and heritage centres follow from a primary ontological relationship with the messy collection of experienced objects and space (Gosden, 1994; Macdonald and Fyfe, 1996).

These heritage sites rely on questions of the 'wheres' and 'hows' of everyday life in the past, and yet these sites are engaged with by visitors outside the sphere of their 'everyday' lives. In this chapter I will explore how we relate past and present through our physical engagements with the spaces, objects and texts of reconstructions which centre on the seemingly mundane and practical tasks of everyday life. Visitors to open-air reconstructions construct myriad pasts and appropriate what they see, hear, smell and touch to their own situated understanding of the world. Jokes about central heating, running water and cleanliness are often the norm. Gender stereotypes abound: young boys race through Iron Age villages, engaging in mock Celtic battles while young girls shyly inform

me that the thing they like best about visiting these places is seeing how the houses were furnished. Yet what is on show and what is not, and how it is presented are as much dictated by the strictures of modern health and safety regulations, crowd control and maximizing profits as by academic inquiry. Instead, open-air reconstructions of archaeological sites may be understood as theatre spaces in which people today can negotiate their own relations with each other and the world around them through making the taken-for-granted everyday profoundly meaningful in the 'safe' environment of the past.

Celts in the open air

Peter Reynolds' Butser Farm project in Hampshire is the obvious proto-type for British open-air reconstructions of late prehistoric life. Although Reynolds set up the farm as a controlled experiment to test theories of Iron Age agriculture, the site has inspired the construction of similar attractions with specific heritage orientations which fit into the folk museum tradition in Europe begun at Skansen in 1891 (Bennett, 1995: 115). In fact, most roundhouse reconstructions are based on Reynolds' work so that at sites such as Craggaunwen near Quin in Co. Clare, New Barn Field Centre near Maiden Castle, Chysauster stone village in Cornwall and myriad small-scale reconstructions throughout the UK and the Republic of Ireland, the visitor sees roundhouses which are, mor-phologically, very similar. Specific pasts are given form as generalized images based on theories shaped through a contemporary English intel-lectual exercise. Below I discuss three open-air reconstructions, two in Wales and one in Cornwall, as spaces in which specific identities are performed and negotiated, framed by a general Iron Age.

Saveoc Mill

Roger Butts runs the Early Technology programme for schools in Cornwall and uses it as a way to get Cornish children involved in their 'Celtic' past through fieldwork at Chysauster stone village and Saveoc Mill. At Chysauster children move through a time tunnel into the main field where they hear stories and participate in 'Iron Age' activities such as wattle and daubing, weaving and pot making. Butts also works with Jacqui and John Wood who own and run Saveoc Mill (near Chacewater outside Redruth) specifically for school groups who visit to augment their Key Stage 1 studies.[1] The educational focus is on helping children to form intellectual links through combining practical studies with storytelling and music in an ostensibly Iron Age setting.

At Saveoc Mill the Woods grow herbs and raise boar, goats and a

number of archaeologically faithful breeds of animal. Their site depends on interactions between visitors and themselves, as there are no interpretation panels or booklets. Schoolchildren come here to help build the village and to get a taste of 'Celtic life'. When they arrive on site they change out of their twentieth-century clothes into handspun and dyed tunics and out of their trainers into – rubber boots. Archaeological 'authenticity' has its limits. However, the children do participate in a very real way in the making of wattle and daub, and in cooking, weaving and animal husbandry. Occasionally the Woods organize special overnight events where people gather in the roundhouses to eat fire-roasted food and listen to stories from the medieval Irish *Táin*. The Woods themselves see the project as a way to get 'back to the future' through exploring simpler ways of life from the past (Jacqui Wood, pers. comm.).

The Museum of Welsh Life

In 1992 the Museum of Welsh Life at St Fagans opened its newly constructed Celtic village. It comprises three roundhouses, a granary and a chicken coop within a palisade enclosure. The three roundhouses, based on excavations from Conderton (Worcestershire), Moel y Gaer (Flintshire) and Moel y Gerddi (Gwynedd) (Figure 8.1), were reconstructed with the consultancy of Peter Reynolds. However, the on-site interpretive material does not explain the reasons for the spatial and temporal conflation involved in the juxtaposition of the roundhouses but, rather, focuses on functional approaches to the everyday Iron Age life it seeks to represent.

Visitors enter the palisade-enclosed village through an elaborated gateway. The houses themselves are situated within only a few feet of each other atop gravel and dust. Inside, torcs, Witham shield replicas, beehive ovens, looms and triskele-emblazoned articles are combined in an attempt to define a general Iron Age (G. Nash, pers. comm.). However, each house is designed with a different purpose in mind. The stone roundhouse, based on the results of the Conderton excavations, stands empty and dark, the curatorial emphasis being on structure. Across from it the Moel y Gerddi house, the smaller of the two wattle-and-daub roundhouses, displays activities of the everyday. Village interpreters who demonstrate the spinning of wool are separated from the loom and the beehive oven (which contextualize their activity) by a rope barrier. The large, central roundhouse has been designed as a meeting house with rows of benches facing into the centre where, again behind a rope barrier, still more replica examples of Iron Age material culture are displayed.

As with the whole of the St Fagans site, there is very little interpretation aside from an introductory interpretive panel (see p. 162). Visitors are left to wander in amongst the houses and make of the scene what they

Figure 8.1 The Celtic village at the Museum of Welsh Life, St Fagans (author's photograph).

will before moving on to the next site. The Celtic village is used extensively by teachers and school groups from Wales, England and France (G. Nash, pers. comm.)[2] to illustrate the British Iron Age, part of the Key Stage 1 history syllabus in the National Curriculum for both England and Wales (cf. Piccini, 1999). However, there has been recent criticism from schools concerning the usefulness of the village, which is, perhaps, surprising considering that in 1992 the village was hailed as an exciting new opportunity to bring the past alive for the half million people who visit the Museum of Welsh Life each year (G. Nash, pers. comm.).[3]

Castell Henllys Iron Age Hillfort

Castell Henllys Iron Age Hillfort is a heritage centre built on and around the remains of an inland promontory fort. Managed by Pembrokeshire National Park, Castell Henllys incorporates the reconstructed Late Iron Age site (Figure 8.2); an on-going excavation, headed by Harold Mytum of York University, of the subsequent Romano-British settlement just to the north-west; a heritage trail illustrated by interpretive panels designed and written by the Dyfed Archaeological Trust in the late 1980s; areas for wild boar and Soay sheep in order to signal possible Iron Age animal husbandry; a shop and offices; and an architectural award-winning education centre for school groups.

Male druids, warriors and farmers, and female weavers and cooks illustrate this contingent story of the past and literally frame visitors' movements. As fixed 'snapshots' of the Iron Age the panels enclose our movement along already marked paths and present suggested ways of seeing and reading specific places which are based on conventional, highly gendered accounts of Iron Age life. These static interpretive images are elaborated as visitors progress more deeply into the site to encounter both the working excavation and the reconstructed animal pens and roundhouse grouping. The excavation grounds, and seemingly reiterates, the information presented on the heritage trail by providing an intimate connection with the past in the shape and texture of layers of soil, scattered stones and bones, and apparently random patches of dark earth. The roundhouses, again based on Peter Reynolds' Butser work, then take the story above ground, their interiors filled, like the Celtic village roundhouses at St Fagans, with modern interpretations of Iron Age material culture based on finds from the whole of Britain, neither specific to one place or time nor to any one occupation period of the Castell Henllys site. The grouping spatially represents much of the information contained in the interpretive panels, thus making concrete and three-dimensional a particular, linearly narrative textual past.

Figure 8.2 Summer at Castell Henllys Iron Age Hillfort (author's photograph).

Castell Henllys Iron Age Hillfort is also an important educational site. School groups gather in the interpretive centre to be told the medieval Welsh adventures of Culwch and Olwen and are then led up to the hillfort where they learn about wattle and daub, weaving, pot making and the alleged bravado of the warring Celts. Again, as with St Fagans and in common with the narrative focus in many of the national museums, technology and its role in the Iron Age is used as a central theme both to enable an understanding of Celtic culture and to tie in with Key Stage 1 Attainment Targets for the development of simple technological skills in primary school children (cf. Piccini, 1999).

Although the three sites are all open-air reconstructions which focus on particular aspects of Iron Age life, their spatializing of the past should not be conflated. Saveoc Mill is a privately owned piece of land which has been converted by its owners into a small, specifically Celtic settlement for periodic everyday living in the present, its use contingent upon the wishes of its owners. Schoolchildren do enjoy relatively free movement as their activities necessitate a certain individual use of the site as a whole. The Celtic village at St Fagans is a relatively compact bounded space contextualized by the bounded spaces of the other buildings at the Museum of Welsh Life. In this way, the museum as a whole appears more as a series of museum galleries in the open air rather than as a cohesive outdoor space. Castell Henllys, on the other hand, is a large, self-contained heritage site, ostensibly defined by a singular 'heritage theme'. Most visitors can explore the site in ways not necessarily dictated by paths and signposts. However, the movement of school visitors is much more constrained as they have to remain in a group and follow particular paths.

Habitus

Bourdieu's theorizing of habitus is germane to any study of the ways in which the heritage industry resonates through our lives. In his attempt to transcend the opposition between 'physicalism and pyschologism' (Bourdieu, 1990: 126) – the objective/subjective debate which continues to hound theoretical writing in all disciplines – Bourdieu seeks to illuminate the strategies by which we continually negotiate and reproduce social structures as part of a never-ending cycle of identity formation. The socialized subjectivity of habitus, which is to say our reproduction of identity through structured social practice in terms of beings which 'make sense' of the world, allows us as 'agents' to actively determine our actions and practices on the basis of socially and historically constituted categories (Bourdieu and Loïc, 1992). This is not the material determinism of making our own histories in circumstances not of our own choosing, to paraphrase

Marx, but is, instead, a dialectical relationship between real structuring forces and agency, which necessarily involves an active formulation and reproduction of those structures through our individual, meaningful actions, an agency in turn given shape by the particular habitus through which we live.

Habitus has been criticized as being overly determinist, as not fully reconciling the artificial split between object and subject, between the 'real' and the social (Bourdieu and Eagleton, 1991; Bourdieu, 1990; Miller, 1995). Bourdieu himself writes of the difficulty he finds in articulating clearly what, exactly, it is that he means by habitus (Bourdieu, 1990; Bourdieu and Loïc, 1992). His efforts to clarify are dogged by endless repetition and the danger that in simplifying the argument, it is diluted and emptied of meaning. His desire to understand the interplay of the object world and our being in that world (not necessarily in the strictly philosophical sense of the 'being there' of Heideggerean *Dasein*), of our mediation of the 'real', reaches to the heart of this chapter – that the past carries with it an implicit understanding that there is something fixed to represent. Although events and processes did of course occur in the past, heritage centre representations mask their own textualizing of pastness into coherent narrative. They effectively deny the differences between the living of myriad past lives and what it means to transform that unresolvable complexity into something palpable, a meaningful story, which is central to a leisure industry literally grounded in the present.

Ethnography and Iron Age simulacra

In-depth discussions with heritage visitors used subsequently as ethnographies may problematize Bourdieu's conception of an individual's singular habitus and foreground important differences in the social practices of those who could be said to possess the same habitus, in other words, the professional and semi-professional 'middle classes' who make up the bulk of heritage centre and museum visits (Merriman, 1989, 1991). Drotner (1994) argues that the recent surge in popularity of borrowing ethnographic techniques from anthropology to detail the manners and methods of the everyday consumption of various media from television to heritage can be linked to our recent appreciation of the consumption of these media as a potential field of socio-cultural study. Because consumption is still 'strange' to the academic canon, we have seen fit to employ tried and tested methods of framing the unknown with broadly conceived ethnographies.

The term 'ethnography' needs, however, to be used with caution with its implications of a certain colonialist plundering of others' lives for academic gain (cf. Gillespie, 1995: 55 ff). It may, in fact, be inappropriate

to use the term in the context of semi-structured interviews conducted on a one-off basis at heritage sites. Certainly we need to avoid making the assumption that ethnography is a superior method of making meaning simply because of its seemingly textured and humanistic appearance (Hammersley, 1992; Wellman, 1994). Both quantitative and qualitative methods work on the principle of transforming particular instances into generalizable phenomena.

That said, actually talking to people about the meanings they make from their heritage experiences throws up questions not asked through traditional, statistically driven museum surveys and opens up new ways of understanding heritage. Since Silverstone called on us to see heritage as media (1989), the onus has been on researchers to explore the possibilities of in-depth discussion with heritage 'consumers' in order to 'trace and substantiate the interconnections made between the discourses of school and television, guidebook and spectacle as they inform specific readings' (Corner and Harvey, 1991: 73). Bagnall (1996) and the papers in Macdonald and Fyfe (1996) contribute significantly to our moving away from understanding museums and heritage centres as sites from which simply to gain some vague idea of 'knowledge'. Bagnall's paper on museum visiting in the northwest and Fyfe and Ross' ethnography of museum-goers in the Stoke-on-Trent (Staffs.) area (1996) explore the centrality of consuming heritage in identity formation and reproduction. Bagnall focuses on the importance of physical and emotional mapping in the heritage experience while Fyfe and Ross seek to problematize mechan-istic understandings of class with their argument that 'museum visiting is not an attribute of individuals so much as a social relationship that is interwoven with dynamics of households, families and life-histories' (*ibid.*: 142).

Of particular relevance to this paper, Fyfe and Ross emphasize the importance of the ways in which museums construct place-bound know-ledge which is actively used in identity formation. This use, they argue, often denies the validity of presented academic knowledge, relying instead on a Romantic gaze (cf. Urry, 1990) which, in fact, places a sense of authenticity, through a celebration of the surface of the object, at the centre of their understanding of historical reality (Fyfe and Ross, 1996: 146 ff.), which in turn ties in with Baudrillard's theorizing of simulacra (1983). Baudrillard delineates the twentieth century's particular emphasis on image as 'more real' than reality, where representation takes precedence over being. Yet what is at stake is perhaps not, as Baudrillard argues, the preceding of the real by the simulacrum, but the contemporary valuing of representations of things on a par with the 'authentic'.

Although Bagnall notes that visitors desire the verification of the authentic (1996: 229), many comfortably and often self-consciously enjoy

the overtly fictional. Children run through the houses of the Celtic Village at the Museum of Welsh Life shouting about Indians, guns and teepees, whilst adults appear to understand reconstruction as both construction and as 'reality'. One senior citizen at Castell Henllys was certain that 'we've got a lot to learn from these people', that 'there's a lot to learn with sloping roofs and these sorts of things' (man, 60+) even though he was clear that the houses were built in the twentieth, not the first, century.

My own interview work took place over the summer of 1996 as part of a project for the Board of Celtic Studies, 'The Social Construction of Heritage and Its Meanings in Modern Wales'. My aim was to set up in-depth interviews with visitors to the Celtic village at the Museum of Welsh Life, to Castell Henllys and to the non-open-air reconstruction at Celtica, one of Wales' most recent representations of 'Celtic culture' past and present. At the Museum of Welsh Life I was permitted only to observe visitors to the Celtic village as the museum administration discourages any outside 'interference' with the visitor experience. Castell Henllys, however, allowed me to conduct loosely structured in-depth interviews (lasting anywhere from five minutes to an hour, depending on the interviewees' willingness to participate) within the reconstructed roundhouse enclosure. These were audio-taped and transcribed.

In all, at Castell Henllys I spoke with twenty-seven groups consisting of between one and seven individuals. Because most museum and heritage centre visitors experience sites in a group (but see Bagnall, 1996: 231), I did not wish to draw conclusions on the basis of individual numbers. I therefore do not make any claims about the percentages in particular professions or age groups. Nonetheless, visitors to Castell Henllys broadly correspond with demographic trends in museum visiting noted by Heinich (1988), Merriman (1989, 1991) and, more recently, Bagnall (1996). In sharp contrast to Bagnall's work, however, most visitors to the site were not local, that is they lived further than thirty miles away from Castell Henllys. In fact, the vast majority of visitors I spoke with at Castell Henllys were not from Wales at all, but visited the site as part of a holiday break from England and Scotland. All had a broad appreciation of an unspecified heritage and fluently participated in various forms of academ- ically structured historical discourse which point to either engagement in some form of higher education (sixth form or above) or the activation of cultural capital implicit in such an education. Significantly, there was little ethnic diversity among visitors. Over the few weeks I spent at Castell Henllys only one Afro-British family (from London) visited. The father resisted questions about identity (perhaps he thought I was asking simply because he was 'black' and therefore of interest to academic researchers?), telling me they visited just because they were interested in museums.

I asked people about their specific reasons for visiting the site and why

they engaged in the heritage industry generally; what understanding they had of the Iron Age and of 'Celtic' culture; what outside activities they engaged in (watching documentary television, buying souvenirs, etc.); and how they felt visiting heritage centres and museums played into the wider picture of their everyday lives. For this chapter, however, I wish to ask how the non-everyday of heritage places become spatialized through what I will argue is the performance of everyday identities. Although the qualitative information from Castell Henllys cannot be used to generalize the consumption of all open-air reconstructions of a Celtic Iron Age, it allows us to look specifically at the relations between heritage consumption, habitus and identity.

Heterotopia and physical theatre

Habitus and cultural capital are activated through open-air reconstructions as heterotopia. Heterotopia can be defined as 'sites of incongruous spatial relations that challenge the dominant space of representation within a society' whose 'meaning is derived from a process of similitude which produces, in an almost magical, uncertain space, monstrous anomalies that unsettle the flow of discourse' (Hetherington, 1996: 157–9). In other words, heterotopia are defined as those areas spatialized outside of the everyday, areas which frame possible dislocations of the social relations of the everyday through unusual juxtapositions of past and present, domestic and institutional, private and public.

Although Hetherington uses the utopics of Foucault's social ordering to make sense of Stonehenge as a museum without walls, I argue that the specific implications of a focus on the ritualized entry ways into heterotopia can begin to contextualize open-air reconstructions as spaces within which we perform and reproduce myriad, often conflicting, identities (cf. Urry, 1996). Of particular interest is the way in which visitors enter heterotopia only by special permission and after they have made a certain number of gestures; 'they enter on alien space, akin to someone else's home' (Hooper-Greenhill, 1992: 211; cf. Delaney, 1992). The three open-air reconstructions discussed revolve around the contradiction implicit in their being reconstructed domestic spaces, the most familiar domain of social relations, and in their remaining strange because they are meant to represent someone else's home, the added irony being of course that they are 'home' to no one.

At the open-air sites of Saveoc Mill, Castell Henllys Iron Age Hillfort and the Celtic village at the Museum of Welsh Life at St Fagans, the entrances into heterotopia are clearly different. To enter Saveoc Mill the visitor must possess knowledge of the site to begin with, in addition to a map, directions or local knowledge of the area, as the site is not marked

from the road. For schoolchildren the transformative process of entering the site is explicit: they have to exchange their twentieth-century clothing for Iron Age tunics. Even though these clothes may have tenuous links with textiles of the past, they are not the everyday costumes of school-children and thus function to effectively signal difference. All visitors move from the collective space of the road onto a private trackway which brings them to the private mill site, past the modern house and down the hill to the final small-scale communal site of the roundhouse grouping. Only through successive movements into increasingly private spaces can we then gather in a constructed community.

At the Museum of Welsh Life, the Celtic village is situated in one of the more overgrown areas of the site, on the margins of a wood, separated from the sixteenth-century mills and modern South Walian terraces, all of which creates an image of 'natural' wildness, a seemingly appropriate environment in which to stage the distant past (Figure 8.1). Before entering the village, visitors are confronted with an interpretive panel:

> This reconstruction of a Celtic settlement is intended to illustrate how people would have lived some 2,000 years ago. The structures depicted here are all based on excavated archaeological evidence from different parts of Wales and the Marches.

> The houses contain appropriate reproductions of Celtic furniture, household implements, agricultural tools and hunting equipment, together with weaving looms, fire dogs, querns (for grinding corn), skins, fleeces and textiles.

> The settlement is surrounded by a ditch and earthen bank topped by a wattled palisade fence. It is thought that the purpose of this kind of fence was to keep livestock away from the buildings.

Engagement with the Celtic village is first framed, then, by the textual assertion that this is how people *would* have lived, a statement supported by the fact that the houses are based on archaeological *evidence*, even though that evidence comes from various settlements spread over a vast geographical area.

The preliminary textual focus on function, however, is disrupted by the physicality of the village, by the way in which the liminal point of entry is foregrounded as having to do with the ritual or spiritual world. A rubber skull impaled on the gate-post marks the way into the site and ties that entry movement to its role as a visually simple but thematically rich symbol of everything the site contains. The grouping thus encloses a space in which to engage with many aspects of different Iron Ages, yet at the same time reproduces constructions of non-specific Celtic culture.

Embodying and signalling our first encounter with the past at Castell

Henllys is a life-size plastic mammoth erected by the original site owner Hugh Foster (of London Dungeon fame). This sign of the very distant past in the form of a familiar elephant made strange can leave visitors in no doubt that they are about to consume something Other. The space of Castell Henllys is complex, however. Although the mammoth marks our first point of entry, the visitor has to complete a number of different gestures at each stage of moving into the site. Once past the car park, visitors must check into the shop where they purchase their entry tickets. Beyond this lies the wood into which visitors must progress before they can reach the central space of the 'lived' Celtic of the reconstructed roundhouse grouping.

In discussions with professional interpreters of the past (the site interpreter and two professional archaeologists I spoke with who visited the site while on holiday in Wales), gateways and entrances were focal in their articulating the significance of the reconstruction. The site interpreter argued that Castell Henllys might become an even 'bigger' site than a reconstructed village in Wexford (Republic of Ireland):

> because they have a gateway on the other side and when that's reconstructed it'll be very impressive. Attracts a lot more people. You know on the far side, where the main gateway was, it's the most impressive part of the whole site ... it must have been done on purpose, designed to impress anybody who came up.

An adult educator in archaeology, however, identified gateways and door hangings as a problematic area of reconstruction in that she has 'never been convinced that we've really got to grips with the business of how doors were hung'. Her male partner continued: 'these silly little bits they've got sticking on the inside there, that have been tacked on almost as if they thought, how are we going to fit the door'. This archaeological artistic licence is at the root of their overall questioning of the value of the site:

> I'm much happier with these sorts of structures and adult students. If you're teaching adults you've got a chance of throwing in the 'what ifs'. You're obviously aware of the fixation problem whereby you see something that's a reconstruction and you think, ah yes, that's it. But it's a bit like seeing something on television, you know? That is then stuck in their minds that this is what things were like in the past without the questioning. (Adult educator)

Non-expert visitors reproduced the site as heterotopic through their keen awareness of the site as special and different in physical terms. Although generally 'an Iron Age hillfort ... sounds old and interesting enough to justify a trip' (man, 41–50), difference is also objectified in the structure of

the roundhouses within the enclosure. The enclosure gives 'you ... an idea of how they used to live then' (woman, 21–30), that 'it's quite interesting, isn't it, how they used to live in the old days' (man, 51–60). This past living is conceived of in both positive and negative terms, often expressed concomitantly. Although the site 'shows you how we all started living, how basic it was and what you could do with what you've got', people are seen to have lived longer 'because it was fresh air, it was natural' (woman, 41–50).

Perhaps the clearest marker of visitors participating in the reproduction of heterotopia is their interest in the roundhouse fires. Once through the doorways visitors noted that it is 'absolutely dry, and the fire burning in there gave it a feeling of warmth ... it was very cosy in there wasn't it?' (man, 60+); 'you can visualize it all can't you? It's cosy isn't it?' (woman, 41–50). Moreover, there is a definite sense that it is through physical engagement (cf. Bagnall, 1996: 234–5) that we come to experience the past:

> I think anywhere you can use your imagination and obviously here is particularly good in that respect because you can read and see pictures of these huts in books but to actually go inside and smell 'em and see how dark they were and see what effects of having a fire in there and light and see how they were robust, ha! surprisingly robust. (man, 51–60)

The element of surprise plays a significant role in the articulation of heterotopia. One couple visiting with their young child remarked that 'it was the size that amazed us, really impressive' (woman, 31–40) and were 'quite surprised by the technology in those days, that those small mud huts, you don't appreciate the technology it takes to put one of those things up and the fortresses and the planning and how they laid them out' (man, 31–40). The 'expert' adult educator confirmed this aspect of visits to open-air reconstructions by arguing that:

> the commodiousness of these structures is one of the best principles to be demonstrated ... People just do not realise with a circular structure just how much room there is, so it's of very great value.

Consumption and performance

In the previous section what emerges is a sense of the 'doing' of the past, of participating in the materiality that marks out Castell Henllys as heterotopic. However, this physicality also ties in with a certain desire to be involved in the production of everyday life. What evidence is there for the material of the site being used as 'props' in social relations? When I asked a family of four how visits to heritage sites such as Castell Henllys create a sense of 'family memories' they replied:

| *Woman:* | I think that sometimes you do, that sometimes things stick in the children's memories. |
| *Man:* | I think the fact that there's a practical demonstration here today will make it a memorable experience. |

Specific relationships between concepts of identity and pastness are given shape through the site as a structure which would have enclosed activities of the everyday:

Woman:	This is our roots, isn't it?
Man:	The man who invented the wheel lived in something like this. At the end of the day and without the wheel you've not got your shopping trolley. You can't go around Tesco's if you haven't got your car.
Woman:	If you haven't got your flints, you can't chop the wood and you can't have your fire. It's all about learning how it started. It's going back.
Man:	But at the end of the day, the mother of invention is here.
Woman:	This is our roots.

Explicit in another interview is the link between:

... how they lived, the society aspects of it, how they had to have skills. How they had to have someone who could dye and someone who could cook and tend fields whereas nowadays there are about two things we can do and we rely on everybody else to do the rest of it.

Visitors frequently asked how the smoke from the hearth fires escapes (or not) through the hole-less thatched roof; questions about the cost and method of the thatching itself (perhaps signalling that habituses which include museum and heritage centre visiting also involve a particularly National Trust aesthetic of the thatched roof[4]); and questions about how archaeologists know the houses were built in this way. As one visitor concluded, in the context of discussing the relative merits of life today and life in an Iron Age village, 'It is technological, isn't it?' After one mother questioned the authenticity of the presentation her son reasoned:

Basically the historians and archaeologists probably found out that the hearth or house they lived in was circular but how do they know there was a fire in the middle of it? Because it was the most sensible place for it to be.

This functionalism is mirrored in concerns with hygiene evidenced by this exchange:

| *Woman* (2): | It is technological, isn't it? |
| *Man:* | Yes, if you don't have central heating. |

Woman (2): Well, they did have central heating in a way.
Woman (1): It's just the indoor plumbing I'd miss.
Man: But some of our plumbing is appalling, isn't it?
Woman (1): But at least it's inside.
Man: That's one thing they hadn't learnt, but perhaps it was more hygienic anyway.

Seemingly banal, these exchanges point to a continuing mechanistic understanding of what it means to be a successful human being in both the past and present. Certainly the obvious visual focus of Castell Henllys, in common with the other open-air reconstructions discussed, is on things, but visitors incorporate and extend questions of functionality to their own concerns. This may also articulate perceptions of greater individual control over one's surroundings in the past, constructed in response to general currents of modern disenfranchisement in our 'postmodern condition', that 'a lot of people look to the past more because the present is not very wonderful'.

Visitors seamlessly weave the archaeo-historic narratives of the site into their own narratives by using the site and roundhouses to make statements about their participation in heritage and historical discourse generally. Unprompted, visitors brought into conversation visits to castles and abbeys and canals, to heritage centres such as Jorvik in York, to other open-air reconstructions at Wexford and Flag Fen and even to other archaeologically focused sites such as Stonehenge (specifically connected to Pembrokeshire and Castell Henllys through the Preseli Hills provenance of the bluestones), Pentre Ifan, Avebury and various hillfort sites throughout Britain. The site interpreter informed me that people make connections between the Castell Henllys roundhouses and houses they have seen in Spain and among the Sami of Finland. Visitors themselves remarked that 'it wouldn't have surprised me to see something similar to this in Scotland or Cornwall or anywhere else the Celts might have been' and 'I should think it would be like the sort of village at that sort of stage that you'd have anywhere in a more primitive setting'. More specifically, one woman thought that the central roundhouse was 'much like a teepee', while one man in a group consisting of two middle-aged couples explained, 'I mean I've been in African houses and certainly nothing quite as grand as this. They're much more, even in a permanent village, they're much more temporary in appearance.'

The meanings of things

Before we make the intellectual connections which make these sites *meaningful* it is our actual presence in, and movements within, these spaces, our primary awareness of 'being there' in the specific sense of

Dasein (as opposed to what I outline above as Bourdieu's interrogation of the networks of 'social being' in the world) which embodies and shapes our identities to allow us to make 'sense' of what we see (Dilman, 1993: 20–7; Heidegger, 1996: 274-308). The 'fact' of presence underpins (and precedes) Bourdieu's quest to illuminate meaningful presence within and through habitus. The physicality of these reconstructions becomes the stage upon which we begin to perform an understanding of ourselves and others. They form spaces distilled out from the everyday, special spaces to which we come to create and negotiate certain social roles in the presence of others.

If we think of Proust's remembrance of things past initiated by the sight, smell and touch of the *madeleine*, it is clear that objects and spaces excite not only our gaze (Merriman, 1991: 110–11; Urry, 1990) but all of the senses as part of a process through which we conceive of ourselves. Connerton (1989) writes of this in terms of the incorporating practices involved in the ways in which societies remember whilst Urry (1996: 54) specifically foregrounds the role of performance in reminiscence. In fact, concepts of narrative, intelligibility and accountability 'presuppose the applicability of the concept of personal identity, just as it presupposes their applicability and just as indeed each of these three presupposes the applicability of the two others' (MacIntyre, 1996: 549). Put another way, embedded in the very concept of personal identity are elements of performance. The ways in which open-air reconstructions are structured around historical narratives, intelligibility and accountability presuppose formulations of performed identities within the heritage space.

Clearly, physical presence in and engagement with the built environment are central to the narratives of these visitors' lives, narratives which give form to the spatializing of place (cf. Duncan and Ley, 1993; Lefebvre, 1991). Castell Henllys physically encloses visitors and provides them with the material with which to develop their own relationships with ideas of pastness, the domestic sphere and wider identity formations. In terms of the social relations within the group and between the group and myself, it appears from the above excerpts that there is a concern among visitors to perform for me their participation in, and display the extent of their knowledge about, heritage and the past, generally. Although I am an outsider to their experience, I am also an 'expert' and yet I am showing visitors that I am interested in what sense they make of the site. The foregrounding of exterior knowledge in these interviews is a particularly clear display of the use of cultural capital in order to position oneself reliably within familiar sets of social relations.

The components which make up the site structures – mud, wood, straw and more tangible items such as reproduction shields, swords, hearths and beds – also figure as props used in visitor narratives. To some,

the roundhouse furnishings are used to articulate attitudes that it is better to live in the present than in the past. When I asked the daughter within a family group of three whether she would like to live in a house 'like this', she answered 'no', saying that it 'looks cold … the beds …' at which her mother interrupted with 'I think your first thought is that it didn't look clean'. Another woman attempted to demonstrate (to other visitors? to her children? to the site interpreter?) her knowledge of the Iron Age in a defensive exchange with the interpreter:

Woman:	So why have they got the tripod here, because they didn't cook over fire?
Interpreter:	They sometimes had tripods like this when they were on campaign.
Woman:	But they didn't have metalwork.
Interpreter:	Well, we're into the Iron Age now.
Woman:	Oh, the Iron Age.
Interpreter:	So they'd gone through the Bronze Age.
Woman:	So they *did* have cauldrons and things?
Interpreter:	That's actually of a later date.
Woman:	Yes, I'd forgotten that they'd started and been used all the way through.

The most explicit example of the incorporation of the site into visitor habitūs arose during an interview with a couple from Liverpool. After the male partner's exclamation of surprise at the heat of the fire he told me:

Man:	We've just got a coal fire in.
Woman:	I think we're going back in our time, aren't we?
Man:	We've got central heating, but …
Woman:	We just fancied a real fire.

This specific relationship between heritage visiting and shopping is unsurprising (Samuel, 1994), but visitors masterfully relate contradictory themes of authenticity ('real fire') and frivolity ('we've got central heating, but …') and telescoping uses of time (Iron Age hearth conjures up coal fires of the Victorian period, both of which mean 'going back').

The structural components of Castell Henllys are actively used in the reproduction of visitor habitūs as they provide concrete 'proof' of the way in which their worlds operate in the present. The self-consciously archaeological argument that:

Man:	The archaeological evidence, you know the construction of these places. They find in the earth, like postholes and ramparts, it portrays a divided and warlike society because there were so many forts. But I mean, if they didn't use stone, then

the most natural building material is obviously wattle and daub, but I don't really know if they were that shape of roof ... To keep the water out they'd have to be pitched and you couldn't use daub on the roof as that would get water soaked and come through. Had to be thatched.

and the architectural understanding of the past here:

Man: You know, for each generation there's something added for some reason and when you look at these things, I think a number of our architects should come along and look at this ... you know they build these flat buildings that leak like mad ... well, I must admit I have a low opinion of architects.

again highlights the importance of the 'bare bones' of the site in the reproduction of the role of heritage within varied habitūs through the activation of cultural capital. Whether speaking in archaeological terms, or conversationally, visitors used the concrete to make complex statements about their relationships in and towards the world and each other.

Conclusion

Arguably heritage is about things (Bagnall, 1996: 244). However, beyond their 'intended' use in making sense of the open-air reconstruction itself, I suggest that the objects contextualized within a simulacrum of a past domestic enclosure are in fact used by visitors to articulate very present-day concerns, both to one another and to me, the interviewer interested in their heritage-consuming practices.

The physicality of heritage appears central to the reproduction of group identities through relationships of performed memories. As heterotopia, open-air reconstructions such as Castell Henllys do make familiar domestic relations strange. Yet the specific materiality of open-air recon-structions in the context of habitūs which incorporate heritage visiting also plays a vital role in the 'everyday' social relations of the outside. These special places are, indeed, spatialized through the performance of habitus:

My parents used to take us when we were small, around the churches and the cathedrals, anything of historical interest we were sort of dragged around. I can understand now but didn't enjoy it so much at the time ... Now I can see why they did it, because I'm doing the same with mine. I think as you grow older you appreciate it more. You don't always when you're younger, do you? (woman, 41–50)

However, from this active world of performing identity, through rela-tionships of material culture and memory, arises the problem that the object world of the open-air reconstruction is static and designed to

correspond with a specifically 'Celtic' Iron Age. This entails a textual narrative of druids, warriors, chieftains and spirits and a physical narrative of hillforts, roundhouses, shields and fire. The physical structures of the three open-air reconstructions at Saveoc Mill, the Celtic village at the Museum of Welsh Life and Castell Henllys affirm a general picture of the Iron Age, based on an amalgam of reconstructed archaeological evidence centred largely on the South-east.

Although site managers have been at pains to problematize representation through the introduction of 'may have beens' and 'what ifs' into the narrative, as the visitors to Castell Henllys have shown, the objects and structures of the enclosure were quickly subsumed within particularly functional ways of viewing the world outside the heritage industry. This is, perhaps, an unexpected twist to arguments about the resistant readings visitors make. While it is clear that open-air reconstructions are good to think, I suggest that reconstructions of a Celtic Iron Age (and through relation, many other open-air reconstructions to which it was compared by visitors) do in fact play into restrictively functional understandings of society both past and present which legitimates causality with respect to social change and the positioning of heritage visitors within socially 'privileged' (and ethnically homogeneous) habituses.

Notes

1. Nelwyn East/Bodmin Moor County Primary, St Erth Primary, Gulval Primary, Gwinear Primary and Nancledra Junior School have all been active participants in the Early Technology Project (Butts, personal communication). As Andy Christophers, Head at Nancledra, informed me, in Key Stage 1 the Iron Age is viewed as a technology, rather than a history subject as the National Curriculum for England (under which Cornwall operates) does not allow for specific study of the Iron Age.

2. The use of Celtic culture to symbolize folk culture in France and the centrality of the 'folk' in France (cf. Dietler, 1994; and Orton and Pollock, 1980) has resulted in a massive influx of French students to British sites which represent the Iron Age and folk culture generally, with French school visits often outnumbering the British visits by up to four times (Nash, pers. comm.). In Wales it is worth noting the similarities between the French focus on folk culture and the role of the *gwerin* (loosely translated as 'folk') in defining Welsh culture (cf. Lord, 1994).

3. Ken Brassil, now head of Archaeological Interpretation in Education at St Fagans, has recently discussed with me the difficulties the museum has in trying to open up the past for teachers, as well as children. He has attempted to problematize the specifically Celtic construction of the Iron Age and to encourage teachers to think of the past as contingent and thus

make, from what is clearly a limited site, a useful construction through which to discuss the making of histories.

4. In fact, all interviewees told me that their heritage practices involve visiting National Trust houses and English Heritage properties.

Bibliography

Bagnall, G. (1996) 'Consuming the past', in Edgell, S., Hetherington, K. and Warde, A. (eds), *Consumption Matters: The Production and Experience of Consumption*. Oxford: Blackwell, 227–47.

Baudrillard, J. (1983) *Simulations*. New York: Semiotext(e).

Bennett, T. (1995) *The Birth of the Museum: History, Theory, Politics*. London: Routledge.

Bourdieu, P. (1990) *In Other Words: Essays Towards a Reflexive Sociology*. Oxford: Polity Press.

Bourdieu, P. and Eagleton, T. (1991) 'Doxa and common life', *New Left Review*, 191, 111–21.

Bourdieu, P. and Loïc, J.D.W. (1992) *An Invitation to Reflexive Sociology*. Oxford: Polity Press.

Connerton, P. (1989) *How Societies Remember*. Cambridge: Cambridge University Press.

Corner, J. and Harvey, S. (1991) 'Mediating tradition and modernity: the heritage/enterprise couplet', in Corner, J. and Harvey, S. (eds), *Enterprise and Heritage: Crosscurrents of National Culture*. London: Routledge, 45–75.

Delaney, J. (1992) 'Ritual space in the Canadian Museum of Civilization', in Shields, R. (ed.), *Lifestyle Shopping: The Subject of Consumption*. London: Routledge, 136–48.

Dietler, M. (1994) ' "Our ancestors the Gauls": archaeology, ethnic nationalism and the manipulation of Celtic identity in modern Europe', *American Anthropologist*, 96 (3), 584–605.

Dilman, I. (1993) *Existentialist Critiques of Cartesianism*. Lanham: Barnes and Noble.

Drotner, K. (1994) 'Ethnographic enigmas: the everyday in recent media studies', *Cultural Studies*, 8, 341–57.

Duncan, J. and Ley, D. (eds) (1993) *Place/Culture/Representation*. London: Routledge.

Fyfe, G. and Ross, M. (1996) 'Decoding the visitor's gaze: rethinking museum visiting', in Macdonald, S. and Fyfe, G. (eds), *Theorizing Museums: Representing Identity and Diversity in a Changing World*. Oxford: Blackwell, 130–54.

Gillespie, M. (1995) *Television, Ethnicity and Cultural Change*. London: Routledge.

Gosden, C. (1994) *Social Being and Time*. London: Routledge.

Hammersley, M. (1992) *What's Wrong with Ethnography? Methodological Operations*. London: Routledge.

Heidegger, M. (1996) 'Letter on humanism', in Cahoone, L. (ed.), *From Modernism to Postmodernism: An Anthology.* Oxford: Blackwell, 274–308.

Heinich, N. (1988) 'The Pompidou Centre and its public: the limits of a Utopian site', in Lumley, R. (ed.), *The Museum Time Machine: Putting Culture on Display.* London: Routledge, 199–212.

Hetherington, K. (1996) 'The utopics of social ordering: Stonehenge as a museum without walls', in Macdonald, S. and Fyfe, G. (eds), *Theorizing Museums: Representing Identity and Diversity in a Changing World.* Oxford: Blackwell, 155–72.

Hooper-Greenhill, E. (1992) *Museums and the Shaping of Knowledge.* London: Routledge.

Lefebvre, H. (1991) *The Production of Space.* Oxford: Blackwell.

Lord, P. (1994) *Gwenllian.* Llandysul: Gomer.

Macdonald, S. and Fyfe, G. (eds) (1996) *Theorizing Museums: Representing Identity and Diversity in a Changing World* Oxford: Blackwell.

MacIntyre, A. (1996) [1984] 'The virtues, the unity of a human life and the concept of a tradition', in Cahoone, L. (ed.), *From Modernism to Postmodernism: An Anthology.* Oxford: Blackwell, 534–55.

Merriman, N. (1989) 'Museum visiting as a cultural phenomenon', in Vergo, P. (ed.), *The New Museology.* London: Reaktion Books, 149–71.

Merriman, N. (1991) *Beyond The Glass Case: The Past, the Heritage and the Public in Britain.* Leicester: Leicester University Press.

Miller, D. (ed.) (1995) *Acknowledging Consumption.* London: Routledge.

Orton, F. and Pollock, G. (1980) 'Les données bretonnantes: la prairie de représentation', *Art History,* 3 (3), 314–44.

Piccini, A. (1999) Celtic constructs: heritage, media, archaeological knowledge and the politics of consumption in 1990s Britain. Unpublished PhD dissertation, University of Sheffield.

Samuel, R (1994) *Theatres of Memory. Volume 1: Past and Present in Contemporary Culture.* London: Verso.

Shields, R. (1991) *Places on the Margin: Alternative Geographies of Modernity.* London: Routledge.

Silverstone, R. (1989) 'Heritage as media: some implications for research', in Uzzell, D.L. (ed.), *Heritage Interpretation,* vol. 2, *The Visitor Experience.* London: Belhaven Press, 138-48.

Urry, J. (1990) *The Tourist Gaze: Leisure and Travel in Contemporary Societies.* London: Sage.

Urry, J. (1996) 'How societies remember the past', in Macdonald, S. and Fyfe, G. (eds), *Theorizing Museums: Representing Identity and Diversity in a Changing World.* Oxford: Blackwell, 45–65.

Wellman, D. (1994) 'Constituting ethnographic authority: the work process of field research, an ethnographic account', *Cultural Studies,* 8, 569–83.

9

Interaction or Tokenism?
The Role of 'Hands-on Activities'
in Museum Archaeology Displays

Janet Owen

'Hey, Mum, they decorated these pots like we make pies . . . the bloke who made it had bigger hands than me though.'
(Overheard comment of a 10-year-old child at a medieval pottery activity day, City & County Museum, Lincoln, 1993)

Archaeologists have a long tradition of encouraging people to handle archaeological material at museum open days, site events and other outreach activities. However, it is only really in the last decade that archaeologists have begun experimenting with the use of hands-on activities in archaeology displays as part of a more general trend to involve the visitor in a personal process of discovery. Though it is recognized that there are many practical issues involved in developing this medium, the chapter will focus on the philosophical aspect of using these activities. As a result perhaps of the obvious physical and social interaction which they inspire, hands-on activities are often termed *interactives* and are assumed to be more 'interactive' than any other form of exhibition medium. However, what is the nature of any intellectual interaction which takes place? Do these hands-on activities inspire the visitor to think creatively about the ideas presented in the narrative? How do the authors of a narrative perceive and influence this intellectual interaction between visitor and activity? Are museums using hands-on activities to involve the visitor in a personal process of discovery or are they just a token gesture towards providing greater intellectual and physical access to our collections and the work of the museum?

This chapter will focus on the last two questions: the museum agenda. A study of the visitor agenda is outside the scope of this work though ultimately both museum and visitor agendas work together to define the nature of any intellectual interaction taking place between visitor and activity. However, the complexity of this interaction will be examined briefly to provide a framework for discussion of the display authors'

intended learning role for hands-on activities in a selection of archaeological displays in the UK. This chapter does not attempt a comprehensive survey of current practice, but is rather a commentary on experiments to date using hands-on media.

What do we mean by 'interaction' and 'hands-on activities'?

'Interaction' is defined as 'acting on each other'. Fundamentally, all exhibition media have this property: text is designed to be read, photographs and illustrations to be viewed, objects in cases to be scrutinized, hands-on activities to be handled – all with the intention of having some kind of impact upon the visitor who in turn 'brings [his or her] unique experience, knowledge and perception into play' (Kaplan, 1995: 41). Various exhibition media and the visitor therefore *act on each other* in any individual's interpretation of an exhibition; some form of interaction takes place. The nature of this interaction can vary considerably: it can be physical, emotional, social, intellectual, or a combination of any or all of these. It is determined to a great extent by the objectives and design of individual media and the exhibition within which these sit, as well as by the agenda of the individual visitor. A *hands-on activity*, for the purposes of this chapter, is one requiring, or expecting, at the least a *physical* interaction between the person and the activity.

Using this definition, hands-on activities can take many forms; these can be divided into three main categories. Activities can involve people touching the material evidence of the past, the 'genuine article' (handling a real medieval pot, for example); the use of replicas, models or physical displays of the type seen in science centres; and computer interactives where the physical interaction involves pressing a touch screen or moving a joystick.

Inspiring creative thought?

A good deal of evidence exists to suggest that hands-on activities help to create an atmosphere conducive to learning and development by encouraging people to relax in the museum environment, enjoy themselves and to interact socially with friends and strangers (Coles, 1984; Cox, 1996; Freeman, 1989; Gunther, 1994; Peirson Jones, 1995). Authors of museum narratives regard this emotive and social interaction as an opportunity which can be built on to inspire visitors to think more closely about the objects and ideas presented. Recent work in the field of learning theory suggests that a large proportion of people learn more from doing things than from reading about them. Through the use of hands-on activities visitors can be encouraged to use their senses of

touch, sight, sound and smell to analyse objects and ideas within the context of the exhibition and within the context of their own experiences and perceptions of the world around them (Hooper-Greenhill, 1991). Research by Piaget amongst others suggests that this opportunity is particularly valuable for young children (Jensen, 1994), but older children and adults can also benefit from *learning by doing* (Gunther, 1994).

The three categories of hands-on activity will each influence the visitor's learning experience in its own unique way. Those activities which emphasize 'the genuine article' will perhaps inspire a stronger emotive and social response than those centred on the use of replicas. Computer interactives will contain an element of fun for some visitors, but might frighten the computer-illiterate museum visitor (Johansson, 1996; Tyler, 1990). However, the intention of all these varied activities is to use a basic element of physical interaction as a starting point to encourage further intellectual interaction between visitor and museum narrative.

The nature of the intellectual interaction can vary across a broad spectrum from a *closed, passive interaction* at one extreme to an *open, active interaction* at the other. The author of the narrative may choose to pre-determine the outcome of the interaction taking place, or may design the hands-on activity in a way that encourages interaction between visitor and narrative but does not fully direct its form. The potential of hands-on activities to encourage visitors to think for themselves and to become actively involved in creating the narrative is perhaps their most exciting aspect. Interpretation in museums is currently focusing on providing greater access to collections and ideas, and is also keen to provide the visitor with enhanced freedom and choice about what they experience during a visit. Now aware that facts are relative, that all narratives are subjective and that every individual interprets any narrative in their own unique way, museums are increasingly concerned with empowering the visitor; with facilitating learning development rather than dictating any particular direction which that learning experience should take (Freeman, 1989; Peirson Jones, 1995).

In 1986 Birmingham City Museums and Art Gallery began a project to re-display its ethnographic collections. The 'Gallery 33' project had two primary objectives: to encourage visitors to address the issue of cultural relativism, and to think about the issue of cultural representation in museums (Peirson Jones, 1995). Hands-on activities are used as a means to actively involve the visitor. An interactive video supports a diorama entitled the 'Collector's House', both exhibits focusing on the issue of cultural representation in museums. The video provides the visitor with a number of perspectives on the subject of the return of cultural property, and encourages people to make up their own minds regarding this issue. Formal evaluation carried out for the Museum suggests that a

third of visitors found the programme had influenced their views on
the repatriation of artefacts to countries of origin.

The people behind the Discovery Gallery at the Royal Ontario
Museum in Toronto, Canada (ROM), have analysed the nature of intel-
lectual interaction taking place between the visitor and activities in detail.
The gallery is based on Mosston's discovery learning concept (Freeman,
1989) which recognized that various types of intellectual interaction could
take place within the learning environment and arbitrarily classified them
into three categories (Figure 9.1). Freeman argues that a truly open, indi-
vidual, learner-designed programme is not possible in the museum
environment where inevitably through selecting and designing the
activity the museum keeps a certain degree of control over the learning
experience. However, experience at the ROM suggests that a mixed
approach of problem-solving and guided discovery works best. Those
who wish to explore issues in their own way are able to do so, but those
who feel less comfortable working to their own agenda still feel able to
participate.

The ROM's evaluation findings and the resulting approach adopted
suggests that some people do find having to think completely for them-
selves a little daunting, a conclusion echoed by experiments elsewhere
(Fisher and Lalvani, 1996; Gunther, 1994). Therefore, hands-on activities
should perhaps be used in ways which provide opportunities for both
open and closed intellectual interaction.

Guided Discovery	Problem-solving	Designed Programme
• instructor-led	• instructor poses problems	• learner poses problem
• convergent thinking	• divergent thinking	
• discoveries lead to predetermined conclusion	• alternative solutions	• solution pursued independently

Closed, passive interaction <———————> **Open, active interaction**

Figure 9.1 Muska Mosston's concept of discovery learning (after Iles, 1991: 16),
annotated with the 'open-closed interaction' scale proposed in this
text.

The role of hands-on activities in the making of archaeological histories in UK museums: the museum agenda

Archaeologists are currently very keen to develop narratives which are more meaningful to the wider community and more relevant to people's everyday lives (Merriman, 1990; Owen, 1996). Encouraging an active physical and intellectual interaction with archaeological material is one way of enabling a more personal encounter between the visitor and artefacts or narratives regarding the distant past. Archaeology is an ideal subject for exploiting hands-on media and for encouraging active intellectual interaction. It fascinates and captures the imagination and, as a discipline, places great emphasis on active problem-solving. Archaeologists draw on evidence from a variety of sources to create a narrative, and with the influence of postmodernism on archaeological theory the place and value of alternative narratives is gradually being recognized by those responsible for creating archaeological histories (for example, Bender, 1993; Cotton, 1997; Merriman, 1990; Owen, 1996; Shanks and Tilley, 1992; Stone, 1994).

Do the authors of archaeological histories in museums use hands-on media to provide opportunities for both open and closed intellectual interaction between visitor and narrative? This chapter will look at two sources of evidence to discuss this question: the nature of a sample of exhibits themselves, and the display authors' intended objectives for these exhibits. Information has been gathered from the literature published on the subject, the responses to an informal questionnaire sent to colleagues in nineteen museums known to be working in this area and various site visits made since 1995 (Figure 9.2).

The nature of the exhibits

A number of museums have recently re-displayed their archaeological collections, or are in the process of doing so. The majority of these re-displays will undoubtedly incorporate some element of hands-on interaction. Hands-on activities are an integral aspect of the galleries at the Verulamium Museum in St Albans, the Roman Gallery at Colchester Castle Museum, and the Early Ireland Gallery at the Ulster Museum, for example. Various museum and archaeological organizations have established, or are planning, hands-on activity centres physically separate from narrative displays but intended to complement the latter's communicative role. York Archaeological Trust established the Archaeological Resource Centre (ARC) in 1990, Hampshire Museums Service opened SEARCH, their Hands-on Centre for History and Natural History in 1995 and the British Museum, the National Museums and Galleries on Merseyside (NMGM) and Reading Museums are working on projects still in the

Museums/ Organizations Sent Questionnaires	Museums/Organizations Visited
Archaeological Resource Centre	Archaeological Resource Centre
British Museum	Colchester Castle Museum
Colchester Castle Museum	Lawn Archaeology Centre, Lincoln
Doncaster Museum & Art Gallery	Leicestershire Museums
Glasgow Museums	Manchester University Museum
Hampshire Museums Service	Museum of London
Jorvik Viking Centre	Reading Museums
Lawn Archaeology Centre, Lincoln	Stoke-on-Trent Museum & Art
Manx National Heritage	Gallery
Museum of London	Verulamium Museum
National Museums & Galleries on Merseyside	
National Museums of Ireland	
National Museum of Scotland	
Plymouth Museums	
Reading Museums	
Royal Cornwall Museum	
Ulster Museum	
Verulamium Museum	
Winchester Museums Service	

Figure 9.2 A list of museums sent informal survey questionnaires and a list of museums visited

planning stages. A number of museums intending to use hands-on activities in permanent gallery re-displays have explored visitor reaction to the medium through a series of evaluated temporary exhibitions. NMGM have held a number of 'Have a Go at Archaeology' exhibitions since 1991, and will use their experiences and evaluation findings to shape exhibits proposed for the new NMGM Discovery Centre (Southworth, 1994).

A range of activities has been devised by museums to engage the visitor in the various processes used by archaeologists in their work. An activity which encourages the visitor to sort artefacts by their material type is popular and has been used by the NMGM, the ARC in York, Winchester City Museums, and the Lawn Archaeology Centre in Lincoln. Text- and image-based aids provide the visitor with all the information necessary to sort a mixed tray of stone, pottery, animal bone and tile fragments and place them in the stone, pottery, bone and tile trays. This activity requires the visitor to think about the characteristics of the dif-

ferent materials in order to solve the problem. However, there is a correct solution, and the outcome of the activity is to a great extent pre-determined. Other similar activities encourage the visitor to identify bones from different parts of an animal's skeleton and identify different pottery types.

Museums experimenting with these activities do employ a number of aids to enhance the interactive problem-solving value. At the ARC and in the NMGM staff are on hand to discuss the task further with the visitor and potentially a more visitor-led exploration of the activity could be facilitated. However, the staff must be tightly briefed to ensure that as far as possible they provide a balance between assisting visitors and giving them space to develop their own ideas. At the ARC extra reference material is also provided for the staff to access if relevant to their discussions with visitors. In some instances, the text complementing a particular activity will contain questions to encourage visitors to look at artefacts closely and to develop their own ideas about what they observe. In 1994, NMGM intro-duced this approach into their experimental temporary exhibition pro-gramme. The label extract below is taken from an activity which encouraged visitors to think about how archaeologists date pottery.

Match up the pieces with the pots in the case and put them into trays.

Hint: Is it rough or smooth?
 Is it plain or decorated?
 Was it made by hand, on a potter's wheel or in a mould?

(From 'How do archaeologists know how old their finds are?' 'Have a Go at Archaeology' display 1994, National Museums & Galleries on Merseyside.)

Formal evaluation of the display (Pennington, 1994) suggests that its intentions were achieved and that some visitors began to consider further the differences in the pottery shards available,

some in relation to improvement in manufacturing techniques over the years and others that they look similar but have different textures and qualities. (Pennington, 1994)

Visitors to the ARC and Hampshire Museums Service's SEARCH Hands-on Centre for History and Natural History are invited to assist the archaeologists in their sorting of soil samples. A microscope is provided and individual visitors are able to search the sample for any interesting faunal remains. Using tweezers they remove the remains from the sample for researchers to analyse at a later date. This type of activity does give visitors the impression that they are contributing to the archaeological process, and does give them space to interpret what they say or do in their

own way: 'What material is important and therefore should I be selecting?' Though again the learning experience is stage-managed and pre-determined, the activity is more open-ended than the sorting of various types of material.

Both NMGM and Stoke-on-Trent City Museum & Art Gallery have experimented with an activity which encourages the visitor to think about how a complete ceramic can be reconstructed from a heap of shards. At NMGM visitors were provided with moulds of a complete post-medieval vessel to act as a guide. Visitors placed shards of a replica pot (made specifically for this purpose) inside in order to reconstruct it. A complete original of the ceramic was displayed in a case nearby. The problem posed does require the visitor to think hard about the solution and to look closely at the material. However, again the solution is pre-determined: the mould firmly guides the visitor as to the relationship between each of the shards on the table and the form of the complete vessel (Longworth, 1994).

A number of museums provide opportunities for visitors to handle archaeological material as part of a chronological or themed interpretive narrative, with the intention of adding a personal and interactive dimension. Visitors to the 'Early Ireland' display at the Ulster Museum can touch various prehistoric artefacts on open display, including two Palaeolithic hand-axes, a 'Bann' flake and a bronze flat axe. The Prehistoric and Roman Galleries at the Museum of London provide opportunities for visitors to touch replica pottery, hand-axes and Roman tiles. Boxes of pottery are laid out in a 'mock-museum' storage area at Stoke, and visitors are encouraged to open the lids and have a look at the material inside. At Colchester, visitors are invited to touch a replica of a decorated Samian bowl to feel the quality of the fabric and the relief of the decoration. A replica of a suit of armour is available and visitors are able to try it on, to feel how heavy it is, and to sympathize with the soldiers who had to wear the originals! In 1993 Glasgow Museums prepared a travelling exhibition, 'In Touch With the Past', which aimed to introduce various aspects of prehistoric technology to visually impaired and sighted people. It incorporated approximately fifty objects from the reserve collections which visitors were able to handle and examine closely, including flint waste, polished axes and ceramics (Batey, 1996).

Whether an opportunity to touch and handle an artefact provides a closed or open intellectual interactive experience depends very much on the design of the activity of which it is a part. The museums visited in preparation for this chapter predominantly used handling material to reinforce issues and concepts discussed in the text. In the 'Technology Before Fire' section of the Prehistoric Gallery at the Museum of London various raw materials are available for visitors to feel and interpret in the

context of what is described on the panels. Any interaction is of a relatively passive nature: visitors are expected to look at the objects with a predetermined conclusion in mind; there is no active encouragement to think further about the objects and what they might mean. This is a point perhaps borne out by the findings of a summative evaluation on the gallery by Susie Fisher (1995) which suggests that hands-on media could be used more effectively. Interestingly, hands-on activities are not used to explore one of the key objectives of the exhibition – to demystify the archaeological and museological process behind the gallery (Museum of London, undated a) – an objective which focuses on the active role of the individual in any narrative. Fisher's survey (1995) suggests that the current focus on using text as the key medium to communicate these philosophical ideas is not working effectively; perhaps hands-on has a role to play.

In the Ancient Egypt Gallery at New Walk Museum in Leicester, visitors are able to open drawers under the display cases containing shabtis to reveal more of the same from the reserve collections of the Museum. This is an activity which has a long history of museum use, and is increasingly exploited in archaeology displays. In the Early Ireland Gallery at the Ulster Museum drawers below the tool case in the hunter-gatherer section contain additional specimens to those on display and also exhibit their suggested modern equivalents: a Mesolithic borer is displayed alongside a Black & Decker drill, for example.

These drawers do provide greater access to elements of the museum collection which are too fragile to be made available for handling or touching. They incorporate an element of discovery in the process of opening the drawer and seeing what is inside (Longworth, 1991). To many visitors that may be the extent of their fascination; to others it may bring home the fact that museums have material which is not always put on show, and may help them to appreciate the great diversity of material found by archaeologists and housed in museum collections. To a small few, metal detectorists for example, it may be a facility which helps them to identify material of their own. These visitors will interact with the exhibit, but for many, unless they are encouraged to work with the material in the drawers, any intellectual interaction will be of a passive nature.

Museums are experimenting with activities which encourage visitors to have a go at making replica artefacts. At the ARC staff are on hand to help visitors make a Roman shoe and weave using a replica Viking Age 'upright warp-weighted loom'. The visitor is faced with a problem, for example, how to make a shoe from stiffened leather or how to work the loom, and has to come up with a solution. Again there is a definitive finished product, as suggested by the archaeological evidence, but there is scope for visitors to devise their own solution to the task in hand, with or without the assistance of staff.

Hands-on activities are also used to explain broader archaeological concepts, as well as inspiring visitors to think about the objects on display. These activities vary greatly in design and approach, and provide ample opportunity for stimulating open interaction between the visitor and the narrative. However, many identify a problem which needs to be solved and the visitor works towards a predetermined conclusion: in the Ancient Egypt Gallery at New Walk Museum, Leicester, for example, the visitor is asked to consider 'How Egyptian Writing Works'. The text panel explains how the hieroglyphic language uses pictures rather than letters to represent particular sounds, and the interactive encourages visitors to investigate this principle further. The activity is a good example of where 'having a go' helps the visitor to understand quite a complex concept. However, the solutions to the problem are fixed: the visitor needs to match up the correct pictures which create a given word in order for the activity to be successfully concluded.

Museums are beginning to explore the potential of computer interactives as an element of archaeology displays. These enable the author of a narrative to provide visitors with further information as and when they wish to view it. At the Manchester University Museum, visitors can use a terminal located in the archaeology gallery to interrogate a computerized database containing further information about items on display. Visitors can select the particular artefact to be investigated further, and the type of information to be retrieved. This activity does have the potential to stimulate active interaction particularly if the visitor has a 'problem' in mind which they wish to explore further. However, if this is not the case, the activity may be less effective because of the lack of any clear problem-solving structure. Visitors may meander through the information concerned to have a go at the technology rather than to review the information.

At Verulamium Museum a touch-screen computer interactive allows the visitor to access further information about Roman food, and the use of rooms in a Romano-British villa. At the ARC visitors can examine a laser disk containing an archive of photographs and other information from the excavations at Coppergate in York. They can select the historic period to be viewed and individual photographs of interest. The new 'House of Manannan' exhibition at the Peel Heritage Centre on the Isle of Man incorporates a number of computer interactive facilities which enable further exploration of aspects of Iron Age life on the island. Visitors are able to choose the type and level of information they wish to access according to their own particular agendas. However, the information content of many of these interactives is still predominantly didactic: visitors may choose the line of enquiry but the results are still presented as fact.

The majority of the activities outlined above draw on the problem-solving nature of archaeological work and interpreting the past, but do so in a way which emphasizes the closed intellectual end of the interactive spectrum. Visitors undoubtedly develop invaluable observational and problem-solving awareness as a result of these activities (Robertson, 1991) and understand more about the work of archaeologists (Davis, 1991; Pennington, 1994). These activities do perhaps satisfy many of the learning needs of those visitors who do like museums to provide them with a didactic experience. However, because they focus almost completely on closed interaction, these activities ignore the uncertainty, subjectivity and diverse nature of the archaeological process. Visitors are not set a more open-ended problem and encouraged to work towards alternative solutions, to develop greater confidence in their own ideas.

The display authors' intended objectives

A study of formalized aims and objectives for some of the activities discussed above suggests that most authors had clear learning experiences in mind for visitors who used those activities. In most cases, there is an emphasis on providing an enjoyable learning environment and there is obvious intent to actively engage visitors in the exhibition narrative:

> [The SEARCH Hands-on Centre for History and Natural History] encourages children to investigate with help from specially trained demonstrators or interpreters. (Hampshire County Council, undated)

> To introduce visitors to the work of archaeologists and the range of skills and techniques employed … To provoke interest in, and enjoyment of archaeology by breaking down the barriers that surround it and making it approachable to non-specialists. (Iles, 1991: 26)

> The aim of the Centre is to explain the work of Archaeologists in the context of the Roman, Viking and Norman periods of Lincoln. This is done through a series of 'hands on' tasks which require Information Recording, Planning, Drawing and Sorting. (City of Lincoln Archaeology Unit, undated, pages unnumbered)

Hands-on activities are also regarded as a means of providing greater access to material in collections, and to information about those collections, in a way which enables visitors to choose the level of information they wish to access:

> to … improve physical and intellectual access to the collections. (Longworth & Philpott, 1993, pages unnumbered)

> to make use of parts of the reserve collection … to introduce various

aspects of prehistoric technology to both visually impaired and sighted people. (Batey, 1996: 19)

Only one of the objectives documents analysed includes any explicit intention of using hands-on activities to explore the subjective nature of archaeology and archaeological interpretation. As a result the objectives identified for individual activities are primarily didactic in nature:

The purpose of this section was to explain what archaeologists find out from pottery. (Longworth, 1994)

1. To demonstrate the finds recording system operated by the York Archaeological Trust.
2. To allow visitors to handle small finds. (Iles, 1991: 78)

The objectives outlined for the Time Machine element of the proposed Rotunda History Centre at the Museum of London were the exception:

[the visitor will be given] the chance to explore both the known parts of an object and the deduced, interpreted aspects of its past use and importance in society... [and will be encouraged] to appreciate the difference between known fact and essentially subjective, and therefore debatable, interpretation.' (Museum of London, undated b)

This innovative approach to museum interpretation, whereby visitors would be encouraged to select an object and investigate it at a series of work stations to answer key questions about the object, has unfortunately failed to secure the necessary financial backing required for its development.

The picture evolving from this brief analysis is primarily one of emphasis on developing a closed intellectual interaction between visitor and narrative. A similar picture also emerges at a more informal level: the questionnaire sent to a small sample of museum archaeologists in the UK asked respondents to consider why hands-on activities had been incorporated into archaeology displays in their museums.

The replies placed a great deal of emphasis on the benefits of *doing* as a means to learning; and the feeling that there is value in providing direct access to real collections and artefacts in an entertaining way came through strongly:

Transfer of knowledge would be better served by displays encouraging activity rather than passivity. (Isle of Man)

There is nothing better than being able to touch real objects. (Glasgow Museums)

Hands-on activities involve participation which can be fun. An enjoyable experience is also potentially the best form of communication. (Plymouth Museums)

A number of respondents mentioned the role of hands-on activities in stimulating an intellectual interaction between visitors and the themes of the exhibition.

> Computer interactives also enable the creation of a hierarchy of information which enables the visitor to choose the level at which he/she wants to investigate a subject. (Isle of Man)

> The hands-on elements were designed with the [National] Curriculum in mind where children have to discover and work things out for themselves. (Verulamium Museum)

> It is generally proven that they allow an additional way of interpreting the past which due to their interactive nature allows people to discover the past for themselves, and provides a physical link to the past. (Winchester Museums)

However, in answering the question posed no one explicitly mentioned the potential for using hands-on activities to encourage people to explore the uncertainties of archaeological evidence and to inspire visitors to think in more active and creative ways about their past.

How can we develop hands-on activities which inspire a more active participation by the visitor in the creation of an archaeological narrative?

A brief analysis of the nature of the exhibit and the intentions of the authors using hands-on activities in archaeology displays suggests that museums might benefit from experimenting further with problem-solving activities which encourage visitors to think actively about alternative solutions. What form could such activities take? Anne Fahy's point that all interactive media used in museums are ultimately shaped by curatorial action is taken (Fahy, 1995), but it should be possible to 'stage manage' a hands-on activity which encourages people to consider alternative solutions to a problem and to input their own ideas.

The desktop assessment aspect of the archaeological process perhaps has potential: visitors could be supplied with relevant information about a non-confidential, past planning application in the local area and also with the known archaeology of the proposed development site and asked if they would recommend archaeological intervention or not as a result of analysing the information available to them. The museum could then identify and explain the archaeologist's decision in this case.

Another form of activity might focus the visitor's mind on what an item could have been used for, an inevitable unknown for a great number of archaeological artefacts. The visitor could be encouraged to look at the

object for clues of use – its size, form, material of manufacture, surface treatment, weight, decoration, etc. and from these observations suggest possible uses for the artefact. Their thoughts and ideas about the object could then be compared with an archaeologist's interpretation. This is the type of approach that the Museum of London proposed developing in the 'Time Machine' element of its Rotunda History Centre. The museum commissioned front-end evaluation for the project incorporating focus group work with both museum visitors and non-visitors (Fisher and Lalvani, 1996). The results suggest that the attraction would have been eagerly awaited by participants, and interestingly that:

> they [the interviewees] have difficulty grasping the concept of objects as a means of exploring and understanding history. This is because they believe history to be known already – a given, not a mystery. To be related to them, not worked out. (Fisher and Lalvani, 1996)

It is, therefore, much to be regretted that this dynamic and innovative project has not so far attracted the backing of the Heritage Lottery Fund. The findings of Fisher and Lalvani (1996) suggest that the Centre would certainly have challenged people's perceptions of archaeology and the past.

Computer interactive technologies provide museums with the opportunity to encourage visitors to think about alternative interpretations of archaeological material culture by, for example, providing various interpretations of particular material culture evidence. Visitors could select various interpretations to consider, and be encouraged to develop personal opinions about the alternatives proposed. In a paper presented at the Society of Museum Archaeologists Conference at the Museum of London in 1995, Ian Hodder discussed plans to use virtual reality technology to interpret the archaeological site of Çatal Hüyük in Turkey in such a way that a visitor could explore alternative reconstructions of the site and alternative interpretations of the material culture evidence discovered.

Conclusion

It has been mentioned from the outset that this chapter is a commentary on, rather than a comprehensive survey of, the issue under debate. However, the evidence to hand suggests that a number of museums are successfully using hands-on activities in archaeology displays to stimulate problem-solving learning experiences. It also suggests that the intended nature of this learning experience is predominantly didactic, involving a passive intellectual interaction on the part of the visitor. Museums now need to explore further the potential of hands-on media to stimulate a more open and active engagement between the visitor and the narrative

of a display, and to seek ways of evaluating the learning experiences taking place as a result. Undoubtedly the planned discovery centres springing up around the UK will provide an ideal opportunity (with their emphasis on providing adequate space and resources for hands-on activities) to explore these open interaction possibilities further. However, there is no reason why the hands-on media used to complement archaeology display narratives could not reflect a greater balance between open and closed intellectual interaction. Only then will the interactive role of hands-on activities be developed to its full potential and visitors recognized as contributing authors in the making of early archaeological histories.

Acknowledgements

Thanks go to all who assisted in the preparation of this chapter, particularly to Christine Longworth (National Museums & Galleries on Merseyside) and Ian George (the Lawn Archaeology Centre) who discussed their work extensively with me, and to all who completed the questionnaire:

Dr Andrew Jones (ARC)
John Reeve (British Museum)
Colleen Batey (Glasgow Museums)
David Allen (Hampshire Museums)
Hazel Simons (Manx National
 Heritage)
Dr Nick Merriman (Museum of
 London)
Eamonn Kelly (National Museums
 of Ireland)
Alan Saville (National Museum of
 Scotland)

Mark Tosdevin (Plymouth
 Museums)
David Pearson (Reading Museums)
Anna Tyacke (Royal Cornwall
 Museum)
Sinead McCartan (Ulster Museum)
Vivienne Holgate (Verulamium
 Museum)
Robin Iles (Winchester Museums
 Service)

Bibliography

Batey, C. (1996) 'In touch with the past at Glasgow museums', in Denford, G.T. (ed.), *Museum Archaeology: What's New? The Museum Archaeologist* 21. Winchester: Society of Museum Archaeologists, 19–23.

Bender, B. (1993) 'Stonehenge-contested landscapes (medieval to present-day)', in Bender, B. (ed.), *Landscapes: Politics and Perspectives*. Providence, RI: Berg.

City of Lincoln Archaeology Unit (undated) Lincoln Archaeology Centre Booking Form. City of Lincoln Archaeology Unit, unpublished.

Coles, P. (1984) *Please Touch: An Evaluation of the 'Please Touch' Exhibition at the British Museum 31 March to 8 May 1983*. London: Committee of Inquiry into the Arts and Disabled People/Carnegie Trust.

Cotton, J. (1997) 'Illuminating the twilight zone? The new prehistoric gallery at the Museum of London', in Denford, G. (ed.), *Representing Archaeology in Museums. The Museum Archaeologist* 22. Winchester: Society of Museum Archaeologists, 6–12.

Cox, M. (1996) *Just Like Drawing in Your Dinner...: Start, the First Interactive Art Gallery Experience Designed for Three to Five Year Olds*. Walsall: Walsall Museum and Art Gallery.

Davis, W. (1991) 'The archaeological resource centre: an educational evaluation'. Unpublished MA dissertation, Department of Archaeology, University of York.

Fahy, A. (1995) 'New technologies for museum communication', in Hooper-Greenhill, E. (ed.), *Museum, Media, Message*. Routledge: London, 82–96.

Fisher, S. (1995) 'How do visitors experience the new prehistoric gallery? Qualitative research'. Unpublished report for the Museum of London. London: Susie Fisher Group.

Fisher, S. and Lalvani, S. (1996) 'A qualitative evaluation of visitor reactions to the London Slice and Time Machine'. Unpublished report for the Museum of London. London: Susie Fisher Group.

Freeman, R. (1989) *The Discovery Gallery: Discovery Learning in the Museum*. Toronto: Royal Ontario Museum.

Gunther, C.F. (1994) 'Museumgoers: life-styles and learning characteristics', in Hooper-Greenhill, E. (ed.), *The Educational Role of Museums*. London: Routledge, 86–97.

Hampshire County Council (undated) 'What is SEARCH?' information leaflet, in *SEARCH Information Pack*, Hampshire County Council.

Hooper-Greenhill, E. (1991) *Museum and Gallery Education*. Leicester: Leicester University Press.

Iles, R. (1991) 'Interactive communication and evaluation at the ARC'. Unpublished MA dissertation, Department of Museum Studies, University of Leicester.

Jensen, N. (1994) 'Children, teenagers and adults in museums: a developmental perspective', in Hooper-Greenhill, E. (ed.), *The Educational Role of the Museum*. London: Routledge, 268–74.

Johansson, L. (1996) 'The electronic family album: a case study'. Unpublished MA dissertation, Department of Museum Studies, University of Leicester.

Kaplan, F.E.S. (1995) 'Exhibitions as communicative media', in Hooper-Greenhill, E. (ed.), *Museum, Media, Message*. London: Routledge, 37–58.

Longworth, C. (1991) 'My interpretation of the Discovery Centre'. National Museums & Galleries on Merseyside internal document, unpublished.

Longworth, C. (1994) 'Discovery Centre: evaluation report 28 May–5 June 1994.

Have a Go at Archaeology'. National Museums & Galleries on Merseyside internal document, unpublished.

Longworth, C. and Philpott, F. (1993) 'The Discovery Centre'. National Museums & Galleries on Merseyside internal document, unpublished.

Merriman, N. (1990) 'Dealing with present issues in the long term: "The Peopling of London Project"', in Southworth, E. (ed.), *Ready for the New Millennium? Futures for Museum Archaeology. The Museum Archaeologist* 17. Liverpool: Society of Museum Archaeologists, 37–43.

Museum of London (undated a) 'Museum of London Prehistoric Gallery: Objectives'. Museum of London internal document, unpublished.

Museum of London (undated b) 'The Rotunda History Centre'. Museum of London internal document, unpublished.

Owen, J. (1996) 'Making archaeological histories in museums', in Kavanagh, G. (ed.), *Making Histories in Museums*. Leicester: Leicester University Press, 200–15.

Peirson Jones, J. (1995) 'Communicating and learning in Gallery 33: evidence from a visitor study', in Hooper-Greenhill, E. (ed.), *Museum, Media, Message*. London: Routledge, 260–75.

Pennington, A. (1994) 'Report of formative evaluation of two elements of the Have a Go at Archaeology display'. National Museums & Galleries on Merseyside internal document, unpublished.

Robertson, J. (1991) 'A case study of the ARC, focusing on object orientated learning'. Unpublished BA dissertation, University of York.

Shanks, M. and Tilley, C. (1992) *Re-Constructing Archaeology: Theory and Practice* (2nd edn.). London: Routledge.

Southworth, E. (1994) 'Archaeology and Ethnology, "The Discovery Centre". A Development Plan'. National Museums & Galleries on Merseyside internal document, unpublished.

Stone, P. (1994) 'The re-display of the Alexander Keiller Museum, Avebury, and the National Curriculum in England', in Stone, P. and Molyneaux, B. L. (eds), *The Presented Past: Heritage, Museums and Education*. London: Routledge, 190–205.

Tyler, J. (1990) 'Interactive Videos in Museums'. Unpublished MA dissertation, University of Leicester.

10

Thinking *Things* Over: Aspects of Contemporary Attitudes Towards Archaeology, Museums and Material Culture

Alan Saville

Introduction[1]

Archaeological curators experience an increasing physical and ideological alienation from the objects in their care, in part simply because of other, more pressing, demands on their time, but also because of changing curatorial perceptions and agendas. Once past their initial training, they may never do any further concentrated work with objects. Most of the basic curatorial documentation work on collections in museums in Britain seems to be done by volunteers or short-term contract workers, not by curators (this may overstate the case, but only just?)

The in-house archaeological curator, as the authority on objects – that is as scholar, connoisseur, or expert – is a threatened species, already extinct in many museums. The expansion of museum collections and of the calls upon museum services has not been matched by an increase in curatorial resources, at either local or national level. As in many other public service professions – education and healthcare offer rich parallels – the museum curator's status and function have been devalued by free-market economics and the Thatcherite legacy of privileging all-pervasive management at the expense of professional specialization. The experts are now in the antiquities trade or on *The Antiques Road Show*, to which even museum curators have reportedly been seen taking objects to obtain an opinion.

This estrangement of curator from objects has taken place against a background of growth in museum studies and rapidly increasing interest in museums and galleries from many branches of academia (less so from traditional subject areas, such as archaeology or classics, than from the interdisciplinary arts and social sciences, particularly cultural studies). This concern for museums by university academics is wholeheartedly welcome,

but there is a paradox in that the proliferation of museum studies courses and their students at universities is depressingly in inverse proportion to the decrease in subject-specific curatorial posts in museums.

The ethos abroad in some universities (which of course have their own major problems of funding and so on) makes museums and galleries convenient and cheap quarries for aggressive 'research' (Hetherington, 1997) to fulfil ever-demanding product quotas. It is much easier for students and academics to deconstruct existing displays (and suggest the inadequacies and delusions of curators) than to undertake original research on the collections; much easier for academics to make dilettante pick-and-mix shopping expeditions into museum stores as 'guest curators' than to face the stark realities of collections management. Rarely is the curator, thus further undermined, empowered to 'bite back'.

As for 'real' research on museum objects, I cannot cite any hard statistics for university archaeological staff, postgraduates, or students undertaking work on museum collections, but anecdotal evidence and the scanning of current publications would suggest a continuing decrease. Such a decline would, in contrast, be matched by an undoubted boom in the study of the history of collections and the (mainly theoretical) study of material culture, as part of the new academic interest. The trickle of publications on collections and material culture especially has become a flood (Pearce, 1989a); keeping up with publications in this field would be difficult for most museum archaeologists, even supposing they thought the publications to be of any relevance.

While interest in 'things' has undergone a renaissance at academic level (e.g. Lubar and Kingery, 1993; Stocking, 1985), and to a certain extent at a popular level (e.g. Durbin et al., 1990; Roland, 1995), this concern with material culture is often at least one stage removed from objects themselves. Thus one of the most influential (to judge by citations) works in this area, Appadurai's *The Social Life of Things* (1986), does not actually include any illustrations of objects. This may be regarded as an oversimplistic observation – after all this chapter has no illustrations – but in my view it does in this case reflect a real divide in terms of perception and practice between those who work directly with objects and those who, at one stage removed, treat material culture as text.

Curators are understandably confused by some of the outpourings by proponents of the new museologies and the inapplicability of much academic writing on museum archaeology to their day-to-day dealings with field archaeologists and with those members of the public who actually find *things* and want to see *things* in the collections. The contradictions raised by the new ways of looking at material culture are multifarious but their direct implications for the museum professional have perhaps been overestimated. To be told that 'material culture is polysemous, located

along open systems of signified-signifiers or metacritical signs' (Shanks and Tilley, 1987a: 117) invites incomprehension and thus hostility, but any effects of such writing may be very partial and transient. There is an analogy to be drawn here with the way in which most of mainstream archaeology in Britain (especially field archaeology) was essentially un-affected by the 'new archaeology' of the late 1960s/early 1970s (Courbin, 1988), despite all the publicity and (self)importance of 'new archaeology' at the time. Possibly the effects of post-processual archaeology (Hodder, 1992: 171) and the application of structuralist linguistic theory to material culture in museum collections (Pearce, 1989b) will prove equally evanescent.

Certainly the museum curator concerned with objects and collections management should not feel intimidated by criticism from academics who hide the shallowness of their rhetoric behind obscurantist prose (see Campbell, 1996 for an anthropologist's rebuttal on this issue).

I shall return to some of these more academic concerns at the end of this chapter, but I wish to explore in the following sections five inter-related aspects of 'objectology' — the study and use of material culture in museums. In so doing I am perfectly content to be labelled an 'object fetishist' in the terminology of those who deliberately devalue curatorial concerns for collections management in pursuit of misguided short-term political goals. If some museum directors sincerely believe that 'in hold-ing so fast to ancient and regressive views of museums as repositories of relics ... we spurn a brighter, better-funded and more worthwhile future' (Fleming, 1997), then the way forward must be to foster museum centres of excellence in material culture, where the unwanted 'relics' can be rehoused in the care of those who can appreciate their value and potential.

Bias in the interpretation and presentation of objects

One of the widespread intellectual achievements of the twentieth century has been the recognition of bias in the conduct of all human affairs including scholarship, so much so that, generally speaking, bias is now accepted as a given constraint in all areas of archaeological endeavour. Living with the recognition of this pervasive bias can be difficult. Museum curators are not immune to that 'loss of nerve' (Bradley, 1993) or 'endemic doubt' (Gosden, 1992), which the post-processualists, or more properly anti-processualists (Renfrew, 1994), have fostered by their rejec-tion of accepted values concerning much of the archaeological record (including objects) and its interpretation.

What seems to have changed more recently, perhaps simply as part of the crescendo of cultural uncertainty engendered by the approaching end of the millennium, is that self-doubt has reached such a pitch that it threatens to undermine professional conduct in archaeology. If nothing is

'real', if there can be no 'correct' interpretation, if everything is dependent upon personal and cultural bias, then the concepts of expertise and of standards of practice are called into question, as is the conduct of archaeology in general (Chippindale, 1993: 32; Hodder, 1992: 164).

One of the problems the archaeological curator faces in this situation is that, if postmodernist relativism and post-processual deconstructionist tendencies in archaeology are adopted wholesale, then various unsavoury cans of worms may be opened. Barbara Bender (1997) has analysed the acceptable face of multivocal/cultural, pluralist hypotheses about Stonehenge being contained within a temporary travelling exhibition, but it would be quite another matter to apply the extreme relativism or nihilism of some post-processual positions to 'permanent' displays or to artefact collections themselves. This would offer a platform to all kinds of alternative fantastic and cult 'archaeologies' (Harrold and Eve, 1995), which might easily promulgate the view that, if 'there is no original meaning to be discovered' in material culture (Shanks and Tilley, 1987a: 211), then it can be dispensed with.

A dilemma for post-processual archaeologists is that their relativist intellectual position does not allow them to either identify or condemn crackpot interpretations for what they are. If archaeologists are not prepared to draw a line (or even to admit there is a line to be drawn), if they are not prepared to implement their expertise and to stand up for their expert opinions in the face of fantasy, then they must be prepared to accept the von Dänikens of the world as professors of archaeology. This dilemma stems from confusion as to what archaeology is actually about. Advocating that archaeology should embrace 'New Age' concerns of whatever kind is specious; archaeology must by definition be based upon the documentation and interpretation of the archaeological record, an important part of which is material culture. In archaeology this material culture must always have a concrete existence; archaeology cannot directly encompass the fantastic, and cultural studies which do so are not archaeology.

The desire to minimize supposed bias can lead to the kind of extreme position instanced by those who suggest that not only do we need to declare our cultural and socio-economic baggage, but that we need to reveal our innermost psychological selves so that our neuroses and fantasies can be given due significance as well. This view, that archaeologists should undergo self-criticism and group therapy to expose their psychological imperfections and thereby become better archaeologists (James, 1993), would be easy to satirize and dismiss were it not easy to foresee how it could be accepted into management courses for museum staff. This is especially so when curators themselves chose to reflect the current academic fashion for foregrounding the role of the individual in all areas of

activity involving the past and its interpretation by personalizing their role in 'permanent' displays, as in the case of the Prehistory Gallery at the Museum of London (Cotton and Wood, 1996: 63), where the curators attempt to speak directly to the visitor (Wood, 1996: 61). When lecturing on the rationale of this gallery, Jon Cotton has, to demonstrate the potential biases in his presentation of London's prehistory, given his own personal profile, including which local football team he supports.

This link between bias and the individual biographies of curators is a manifestation of a rather distasteful modern fad of over-personalization. An epitome of this in current archaeological literature is *Fairweather Eden* (Pitts and Roberts, 1997), where the account of the excavations at the Boxgrove Palaeolithic site is interspersed with 'fanzine' trivia. Such journalistic dumbing-down, in a style imported from the USA, is intended to make what are considered to be the otherwise unpalatable hard data more accessible. This approach capitulates to the lowest common denominator, in the belief that the subculture of breakfast television provides a good model for popularization.

My own feeling is that this fad will have a shorter lifetime than most 'permanent' displays in museums and that it is ill-advised to ape the mass-market commercial media in this way. There are perhaps some encouraging signs of backlash, as in the following comments on displays in the Natural History Museum in London.

> But more lip-pursingly annoying still are the headings on the explanatory notes at each exhibit. Over the praying mantis is a sign saying 'Getting to Grips' and over some other arthropod is another reading 'Up for Grabs'.
>
> I spent a minute trying to work out what the resonances were until it occurred to me that these weren't museum labels: they were tabloid newspaper headlines. Yes: even our noblest museums have fallen foul of that most insidious late-20th-century scourge – the newspaperization of everything. (Diamond, 1997)

Curators need to be aware of both overt and subtle pressures upon them to succumb to such trends espoused by the mass media, as indeed they need constructively to resist moves to divert limited museum resources away from their traditional core activities.

There are certainly many biases the archaeological curator needs to confront before worrying too much about the influence of personal profiles. One of the most pressing in terms of British archaeology is the relative unavailability of information on the material culture excavated or found over the last twenty-five years. Most museum displays are dominated by artefacts recovered before then, when, generally speaking, there existed the time, expertise and resources to enable objects to be properly documented, studied and published. (In the 'good old days', some

museums were actually able to issue illustrated catalogues of their collections. The CD-ROM revolution theoretically offers a new way forward in making the same kind of information available, but does the curatorial infrastructure to research and collate the information still exist?)

It is far easier, when creating a new display, to recycle the same objects as were always displayed, rather than to tackle the problems associated with selecting new objects from among all those hundreds of cardboard boxes of finds which have accumulated so rapidly in recent decades. This is not to say that the 'oldies but goodies' do not deserve re-display, but to observe that there is a danger of an inherent bias against recently excavated material. Yet the recently excavated finds generally have greater integrity as far as context is concerned and, because of better recording and recovery techniques, have the potential to tell much more and in much greater depth than the isolated 'goodies' found previously.

The anti-collecting critique

At most conferences on museological themes, at least one speaker will use pejoratively the term 'stamp-collecting' to describe the activities of those supposedly unreconstructed curators who do not fit with the particular approach being advocated. I have never fully understood the use of 'stamp-collector' as a jibe, since it has always seemed to me that stamp-collecting as a pursuit has many desirable attributes in common with curatorial work. The hobby can arguably include aspects of identification, classification, documentation, connoisseurship, detection (e.g. of fakes), conservation and collecting policy, which are all important elements of museum work. Indeed, it is very hard to see just what makes numismatics, an established museum activity, so intellectually superior to philately. Over time this contradiction will no doubt be resolved by the gradual integration of philately into mainstream museum collection and display. The sub-genre of historical and archaeological representation on postage stamps already cries out for museum treatment.

Collecting, whatever the type of object, is indisputably part and parcel of what museums are all about, and to condemn any one area or aspect of collecting out of hand is rather arrogant. This is not to ignore the problems of distinguishing between collecting and accumulating (Pearce, 1992: 49), which are actually quite acute in archaeology, where 'selection' is a very real issue with which the Society of Museum Archaeologists has recently grappled but by no means resolved (SMA, 1993). Perhaps the vehemence with which collecting and exhibiting objects is sometimes disparaged — 'I will say no more of these postage stamp archaeologists than that it grieves me as a taxpayer to have a share in paying their salaries' (Clark, 1972: 4) — stems from an ill-conceived position of

intellectual superiority which assumes that the 'real' archaeologist is only concerned with some higher plane of interpretation. Thus the 'postage-stamp archaeologist' in this context is condemned as merely a collector.

What future for the study of the material culture of the past if there are no 'collectors' in museums? I recently attended a meeting at which one speaker explained how fragments of stalagmite preserved in a museum collection from excavations of some fifty years ago are now making a significant contribution to the dating of the Palaeolithic activity at the site. These fragments were preserved in the museum during this period because they were part of the original excavation assemblage, not because the curators necessarily appreciated that the material had any relevance or significance; fortunately the curators were in this case acting profession-ally as 'mere collectors'. A relatively minor success maybe, but here the archive function of a museum collection was vindicated, and archaeo-logical curators have probably not made enough of the analogy between museums and record offices, where the crucial function is to preserve rather than display. There will always be hard-core material culture, intended only for adult archaeologists, to be kept in the museum vaults (though the vaults themselves could well be items of display – see below).

Empowering the silent object

There is a conundrum in the undeniable power of objects on the one hand (Schultz, 1993), and on the other the realization that objects do not 'speak for themselves' (Vogel, 1991: 201).[2] Certainly, few curators nowadays would risk putting archaeological objects on display, at least in their 'permanent' exhibitions, without some explanation or interpretation, and without at the very least a nod towards all the problems of bias (see above).

Some curators might prefer to privilege the explanation at the expense of the object, even to the extent of not needing the actual object (with all its obligations for conservation, security, insurance, etc.). This latter viewpoint, which makes a virtue out of the heritage-centre use of replicas, rides roughshod over the reality of the frisson to be obtained by engagement with the actual thing. It may be a cliché, but nevertheless true, that a museum's trump cards are the actual objects (Hull, 1997), and it must play to its strength by displaying them.

It also underestimates and patronizes the museum visitor to suggest that objects do not communicate at all; artefacts are by definition the product of human modification and/or use and can be engaged with to a lesser or greater extent by anyone attuned to the cased presentation of objects and with some grounding in the protocol of museum visiting. The way in which this protocol operates as a barrier with a social dimension (Bourdieu and Darbel, 1991; Merriman, 1989: 162) is arguably more of an

educational training problem for parents, schools and universities rather than for museums themselves. This may sound complacent, and of course museums ideally should be integrated far more closely into educational systems, but museums are not schools and curators are not primarily teachers.

In those instances where museum display fashions have not moved so rapidly or become high-tech, it is still possible to experience enviably high visitor numbers to displays of serried ranks of specimens in cases with only the most minimal of labels or other supporting information. Recent personal observation of this apparently universal (albeit 'Westernized'?) human activity in process in museums in France, Japan and Poland, and at the British Museum in London, suggests that, though there may be an element of 'going through the motions', of expectations being fulfilled, there is also some validity in the experience.

The experience can undoubtedly be enhanced by the presence of a live interpreter, whether this is a teacher with a party of schoolchildren, a curator with a visiting group, or a gallery host. Having an experienced, knowledgeable and enthusiastic intermediary between the objects and the visitor – explaining object histories, contexts, compositions, uses, or simply answering questions – is a huge plus. Anyone who doubts this should attend one of those lunchtime lectures in their local art gallery where a curator simply stands in front of a particular work of art and talks about it for twenty minutes; given the right circumstances the experience can be both electric and revelatory.

To believe that a machine, however interactive, can replace or even begin to approach the same level of effectiveness in educational communication is bizarre. Yet the amount of scarce museum finance being invested in multimedia rather than human resources is extraordinary. This is not an entirely Luddite view (though it does relate to the original sense of workers reacting against loss of their livelihoods because of machines); I principally mean to recognize the common experience of both archaeologists and educationalists who repeatedly stress the value of engagement with the actual object and the knowledgeable individual (Bonham, 1997). To this extent a *rapprochement* is required between the living-history people (Price, 1996), the heritage-centre exponents and museum archaeologists to bring the interpreters back to the museums and to the real objects.

It is now generally acknowledged that the ability to handle objects can dramatically increase the quality of the museum experience for all types of visitor (Batey, 1995; Hooper-Greenhill, 1994), just as object handling enhances the curator's engagement with material culture (see below). The problems and contradictions involved in making objects available for public handling are considerable, however, and there is yet to be a consensus on strategy for 'permanent' displays. The experiment tried in the

new Museum of London Prehistory Gallery, using some real antiquities but securing them very tightly, so that they could only be touched rather than handled, has been felt to be only a partial success (J. Cotton, pers. comm.). Expendable replicas are not the answer, though with certain categories of object it is difficult to envisage how the real thing could ever be made available for handling. Nevertheless, it can be predicted that demand will lead, quite properly, to much curatorial energy being expended on finding solutions so that much more hands-on experience is achieved. Even here, however, a sense of perspective must be maintained:

> there is a limit to the size of thrill you can get out of touching chunks of stone that are 38 million years old. The fact is, that with a few exceptions, such as shiny black obsidian, they feel much like any other chunks of stone you've ever touched. (Middleton, 1996)

The failure to reach those parts which ...

A topic of major concern, which has been given significance and currency by the recent *Portable Antiquities* discussion document (DNH, 1996) and the subsequent establishment on a trial basis of reporting centres for new archaeological finds in England, is the failure, for the most part, of museum archaeologists to cater for the interests of one significant segment of the public interested in the past – the metal detectorists (Gregory, 1983). Ignoring the significant but probably relatively small proportion who are treasure hunters solely motivated by greed, most detectorists have a genuine interest in objects. This may not be too rose-tinted a view. Palmer's recent book (1995: 8) identifies 'antiquity hunting' as 'the most popular and interesting branch of the hobby' and castigates as criminals the 'night-hawks' who despoil scheduled sites (cf. Jones, 1996).

For various reasons, the museum profession has in the main been unable to service this sector – Norfolk Museums Service has been the outstanding exception (Carrington, 1995: 35) – and the detectorists' curiosity about the identification and interpretation of the objects they find has been satisfied through other channels. It has been the detectorist magazines – such as *Treasure Hunting* and *The Searcher* – that have risen to the challenge and provided articles on object types, with various spin-off monographs and catalogues. Companies such as Anglia Publishing and Greenlight Publishing have specialized in this field, and Anglia has also reprinted classic archaeological texts such as the 1940 *London Museum Medieval Catalogue*. This reprint is now on sale in some museum bookshops and rightly so, but why did an archaeological publisher not see any potential here?

It can be argued that a whole constituency of people interested in approaching the past through objects has been let down by museum

archaeologists. There are many issues here, of course, not least that of social class hurdles, since detectorists tend to be dominated by socio-economic groups C2–E and the self-/unemployed, whereas adult museum visitors (like curators) tend to be dominated by salaried groups A–C1 (Merriman, 1991). But there is a tremendous irony in seeing curators using the catalogues compiled for detectorists (Bailey, 1992; Mills, 1995; Whitehead, 1996) to identify objects in museum collections. Clearly a way must be found to bridge the gap so that museum archaeologists can reclaim this area of publishing and satisfy a wider market than their current clientele (Pearce, 1993: 236).

The archaeological establishment appears to be wary of publishing in this field. There seems on the one hand to be a suspicion, almost a distaste, of any association with objects which have been recovered by metal-detecting, as though the method of recovery has somehow tainted an object's intrinsic significance. On the other, there is clearly an element of post-normative antagonism to publications which are 'just' catalogues of objects. For the same reason, students are discouraged from tackling corpora as post-graduate research; artefact research in itself is not thought academically respectable (cf. the stamp-collecting critique and Shanks and Tilley's (1987a: 31) 'index card archaeology'). Many academic archaeologists simply cannot conceive that there are some archaeological circles in which the late D.L. Clarke is best remembered and most consulted for Volume 2 of his work on Beaker pottery (Clarke, 1970), or Professor Rowlands cherished for his Bronze Age metalworking corpus (Rowlands, 1976)! The role of data collection is entirely undervalued and misunderstood (Shanks and Tilley, 1987a: 18–19). As Ian Kinnes (1992: 3) succinctly expressed the situation: 'British archaeology suffers from synthesis without documentation.'

Just as some university-based archaeologists have overreacted against the study of objects *per se* and the notion of corpora, so has the museum community failed to maintain production of catalogues. This is surely another manifestation of the crisis of confidence in the traditional role of museums, in which catalogues were central: 'catalogues are the keys to the treasure vaults of a museum' (Goode, 1897: 229). The internal, professional value of catalogues for the museum archaeologist as the *sine qua non* of basic museum identification and documentation has not been sufficiently trumpeted, let alone their value for the interested public, including detectorists. To its great credit as the national museum institution, the British Museum has continued to publish scholarly catalogues as a fundamental plank of its public service, both in the case of special exhibitions (e.g. Walker and Bierbrier, 1997; Webster and Brown, 1997) and the permanent collections (e.g. Cook and Martingell, 1994; Sieveking, 1987).

It is encouraging that catalogue publications of high standard and

attractive design are still occasionally being produced for aspects of non-national museum collections (e.g. Allason-Jones, 1996; Bishop, 1996). Of course, for museums to produce such works in-house, they not only require a generally favourable climate towards scholarship, they need the scholars who can produce them and the provision of time and space to allow them to do so. The argument that there is no demand for such publications has been neatly turned on its head by the successful activity of publishers such as Anglia and Greenlight. It is claimed that Brian Read's book *History Beneath Our Feet* (1988) has sold over 5000 copies and is advertised by Anglia with such come-ons as 'photographs or archaeological illustrations of 1467 coins and artefacts' and 'each object is described in detail and accurately dated'. What more can the harassed curator ask?

Keeping in touch with our roots

The primacy of the artefact in terms of museum archaeology and the importance of continued championing of artefact research in the face of challenge cannot be too often stressed (Saville, 1994: 155, 165). Lévi-Strauss wrote in support of the importance of direct engagement with artefacts:

> The museographer enters into close contact with the objects: a spirit of humility is inculcated in him by all the small tasks (unpacking, ... etc.) he has to perform. He develops a keen sense of the concrete through the classification, identification, and analysis of the objects ... Texture, form, ... repeatedly experienced, make him instinctively familiar with distant forms of life and activities. Finally, he acquires for the various externalizations of human genius that respect which cannot fail to be inspired in him by the constant appeals to his taste, intellect, and knowledge made by apparently insignificant objects (Lévi-Strauss, 1993: 375; originally published 1954).

There are very practical difficulties which can prevent contact of this kind in the small museum, where the archaeological collections may become a burden because of restricted resources (Wood, 1997). Of more concern, however, are the cultural shifts within archaeology already alluded to, whereby, with the continued prevalence of what may be broadly categorized as theoretical archaeology, material culture studies fly off into a domain in which objects themselves are less or little regarded.

The remarks of Lévi-Strauss quoted above are of course related principally to the museum ethnographer, and there is an interesting archaeological parallel with developments in anthropology, where mainstream academic practitioners turned their backs on the documentation of material culture many years ago, in part because of the association with superseded evolutionary and diffusionist approaches (Miller, 1983). In a seminal article

(1987), repeated in the first chapter of his wonderful book *Made in Niugini*, Sillitoe (1988) showed why the study of artefacts ought to remain a central activity for anthropology. Sillitoe's comments are so relevant to the current situation regarding material culture in archaeology that they merit quotation in full, but a couple of extracts will give an impression:

> The study of material culture relates significantly to the problems of veracity exercising anthropological minds: bearing on tangible things 'out there' it offers a sure observable base line from which to gauge any attempt to understand an alien culture and lifestyle. It would caution those who aspire to achieve meaningful understanding of knotty and abstruse intellectual matters, sow healthy doubt and promote modest circumspection of the epistemological foundations of their theory castles, to realize how difficult it is to learn about the straightforward visible objects of every day life and that in some senses some things about them are apparently unknowable. (Sillitoe, 1988: 5; and cf. 1987: 1–2)

> Regardless of approach, any interpretation should derive from ethnography. It is not possible ... to present ethnographic data relating to material culture ... too thoroughly, to give others too much evidence ... against which to assess, revise and improve our explanations. The raw material of our subject is ethnography; to treat it almost as if it is irrelevant, is analogous to asserting that scientific observation and painstaking recording of experiments ... is inconsequential and pointless. No theoretical scientist would suggest this of the work of his experimental colleagues. Yet anthropologists who ponder theoretical issues cast such aspersions on the work of mere ethnographers. (Sillitoe, 1987: 4; and cf. 1988: 7)

Writing in the 1980s, Sillitoe wondered if the developing interest in anthropology by British ethnoarchaeologists might bring useful new resources to the field documentation of material culture.[3] Despite some promise at the start (Hodder, 1981, 1982; Miller, 1985), it now seems inevitable that this approach would have come to focus not on objects but entirely on sociological aspects, such as funerary custom or spatial function (e.g. Lane, 1994). Outside Britain, however, ethnoarchaeological studies of material culture are continuing to develop contextualized analyses of particular object categories in sufficient detail for them to be of real value to the museum archaeologist (e.g. Clark, 1991; Petrequin and Jeunesse, 1995).

My recent (unscientific) survey of the bookshelves in the anthropology sections of the three largest academic bookshops in Britain showed they were entirely free of works concerned with the documentation of material culture *per se* (Native North American beadwork and Eskimo carving excepted). How long before the archaeology sections fail to contain any excavation reports or books concerned with artefacts?

Final remarks

Nick Wickenden (1996) used the term 'angst-ridden' with regard to archaeological curators having lost confidence in displaying their collections. This curatorial angst, which it is not too fanciful to connect with general post-1960s cultural and political developments in Britain, has been smouldering for some time, as neatly summarized by Pearce (1990). It is probably inevitable that the post-war critical tradition would affect museum display in general, but perhaps not so inevitable that postmodernist relativism should affect the 'permanent' displays in archaeological galleries (Durrans, 1993: 50).

Decisions by curators to adopt relativist positions when preparing new 'permanent' displays could be seen as a response to the precepts of Shanks and Tilley (1987b: 97–9), who, in their attack on museum culture and practice, advocated for exhibitions a mix of ancient and modern artefacts, emphasis on authorship, the use of humour, introduction of political content, and the presentation of pasts as perceived by non-professionals. Such a direct response in terms of a 'permanent' display is arguably unwise because, while the display may be expected to have a life in excess of twenty years, Shanks and Tilley are engaged in a fashionable, and probably ephemeral, polemic, and one which may prove to have more to do with positioning within a small and exclusive sector of the world of academia than with the reality of a museum archaeologist's dialogue with the public. As the inconsistencies and contradictions of the anti-science stance of the post-processualists are increasingly exposed (Kuznar, 1997: 166–72), museum archaeologists, through their focus on objects, may come to be seen to have played a significant part in anchoring the discipline to common sense.

While part of the responsibility of a museum archaeologist may be to communicate to the public new developments and new interpretations within archaeology, very cautious evaluation of theoretical positions should surely precede new 'permanent' displays. Clutching at straws, such as those scattered by Shanks and Tilley, does show a lack of curatorial confidence in display linked with too great a concern with certain critical constituencies.

It is unfortunate for the profession that the role of exhibiting collections to the public has been complicated by this loss of confidence. On the one hand there is the pressure to mix it with the heritage centres; on the other there is the quest for postmodernist 'street-cred'. The former is always going to be a forlorn attempt because of the limitations imposed by responsible curatorship (and lack of funding); the latter, as ever, is a case of the emperor's new clothes.

There must be room for experimentation and alternatives in museum display, following Saumarez Smith (1989: 20) rather than Shanks and

Tilley (1987b), but it is not necessarily appropriate to reject tried-and-tested methods of presenting object-based/dominated displays simply because of a degree of antagonism expressed by a few academic critics.

It could even be maintained that museums may have lost much of the initiative precisely because they have stopped putting more of their collections on 'permanent' display. Rather than developing larger (hidden) archives and smaller (accessible) displays, perhaps the trend should be reversed? As with shopping, the public might like bulk, more choice and upfront display. Why not archaeological superstores where the public (and students and archaeologists for that matter) can see exactly what wares museums have to offer? I see no reason why much or even all of a museum's collection of Samian pottery, its stone axeheads, its pilgrim badges, etc., should not be on display. These need not (should not) be housed in expensive high-security cases nor in fussy over-designed architectural environments, but, like the superstore, can be in economical and efficient warehouse-type buildings. Even the most unprepossessing of bulk finds – the waste flint, the animal bones, the slag – can be housed in storage systems in a form not completely hidden from the visiting public, as I have seen in innovative instances in some of the burgeoning archaeological resource centres in Japan. In this case it is not a question of the public ever wanting to see every piece of animal bone, but that public curiosity (and prerogative) can be satisfied by being able to know (by seeing) just what is going on (cf. Merriman, 1993: 16).

The democratization of museum storage, mirroring the democratization of museums themselves in terms of public access (Bennett, 1995: 70-3), is an inevitable process which archaeologists would do well to lead rather than follow. By all means also have features such as finds work, replication, and hands-on participation (cf. the Archaeological Resource Centre in York) taking place in public view in association with storage and display, but the fundamental selling point of the archaeological museum/resource centre should be that this is where to see the material culture of the past. That is, this is where the public can see the *things* which archaeologists find and keep; the *things* which interest and excite archaeologists; the *things* which archaeologists use to research the past for the benefit of all.

Notes

1. Many of the articles published in this volume were first presented at the extremely successful 1995 SMA conference 'Representing Archaeology in Museums'. Those of us in the audience at this event had our perceptions challenged and were exposed to a variety of new developments and ideas; there was plenty of intellectual stimulus for everyone to reformulate his or

her own position or retrench as appropriate. My own professional interests centre on artefacts (or objects or things), and I was in turn intrigued and annoyed by some of the attitudes towards the display of archaeological artefacts and towards the curation of museum objects in general. The stimulation was sufficient, however, to organize my reactions into a response to accompany the conference proceedings (Saville, 1997). My response was not so much to the individual contributions to the conference, but to some of the wider issues raised about material culture and its interpretation. The present chapter is a revised version of my previous response.

2. Objects do not 'speak for themselves' unless, it may be argued, one specializes in their language. This is clearly true at one level, in terms say of the terminology specialist curators worldwide might use about Polynesian adzes (Gathercole, 1989: 76), though there may be an element of curatorial conceit about this in any wider sense, which could be dismissed as simple idealism (Shanks and Tilley, 1992: 251). The whole question is of course clouded, in the case of archaeological objects, by the degree to which it is required to attempt to use objects in the emic terms of their contemporary cultural context (Hayden, 1984). The difficulties of dealing with some categories of prehistoric artefacts at even the most basic functional level are well known (e.g. Edmonds, 1992) and there need be no hesitancy about the use of etic typological classification in museum display. That the language of the objects is a foreign one should present only a small barrier to the person seeking to know more.

3. As an anthropologist concerned with living peoples, Sillitoe was critical of museum staff studying artefacts in isolation from the cultures in which they were produced and used, though he recognized that, with continuing acculturation and extinction, the development of purely museological studies would become an increasingly important focus for research into 'primitive' cultures (Sillitoe, 1987: 4; 1988: 6).

Bibliography

Allason-Jones, L. (1996) *Roman Jet in the Yorkshire Museum*. York: Yorkshire Museum.

Appadurai, A. (ed.) (1986) *The Social Life of Things*. Cambridge: Cambridge University Press.

Bailey, G. (1992) *Detector Finds*. Chelmsford: Greenlight Publishing.

Batey, C. (1995) 'In touch with the past at Glasgow Museums', in Denford, G. T. (ed.), *Museum Archaeology: What's New? The Museum Archaeologist* 21. Winchester: Society of Museum Archaeologists, 19–23.

Bender, B. (1997) 'Multivocalism in practice: alternative views of Stonehenge', in Denford, G.T. (ed.), *Representing Archaeology in Museums. The Museum Archaeologist* 22. Winchester: Society of Museum Archaeologists, 55–8.

Bennett, T. (1995) *The Birth of the Museum: History, Theory, Politics.* London: Routledge.

Bishop, M.C. (1996) *Finds from Roman Aldborough.* Oxbow Monograph 65. Oxford: Oxbow Books.

Bonham, M. (1997) 'Artefacts in school history', in Denford, G.T. (ed.), *Representing Archaeology in Museums. The Museum Archaeologist* 22. Winchester: Society of Museum Archaeologists, 86–93.

Bourdieu, P. and Darbel, A. (1991) *The Love of Art: European Art Museums and Their Public.* Cambridge: Polity Press. (French original 1969)

Bradley, R. (1993) 'Archaeology: the loss of nerve', in Yoffee, N. and Sherratt, A. (eds), *Archaeological Theory: Who Sets the Agenda?* Cambridge: Cambridge University Press, 131–3.

Campbell, A. (1996) 'Tricky tropes: styles of the popular and the pompous', in MacClancy, J. and McDonaugh, C. (eds), *Popularizing Anthropology.* London: Routledge, 58–82.

Carrington, L. (1995) 'Buried treasure', *Museums Journal,* 95 (9), 33–5.

Chippindale, C. (1993) 'Ambition, deference, discrepancy, consumption: the intellectual background to a post-processual archaeology', in Yoffee, N. and Sherratt, A. (eds), *Archaeological Theory: Who Sets the Agenda?* Cambridge: Cambridge University Press, 27–36.

Clark, J.E. (1991) 'Modern Lacandon lithic technology and blade workshops', in Hester, T.R. and Shafer, H.J. (eds), *Maya Stone Tools: Selected Papers from the Second Maya Lithic Conference.* Monographs in World Archaeology 1. Madison, WI: Prehistory Press, 251–65.

Clark, J.G.D. (1972) 'The archaeology of Stone Age settlement', *Ulster Journal of Archaeology,* 35, 3–16.

Clarke, D.L. (1970) *Beaker Pottery of Great Britain and Ireland,* vols. 1, 2. Cambridge: Cambridge University Press.

Cook, J. and Martingell, H.E. (1994) *The Carlyle Collection of Stone Age Artefacts from Central India.* British Museum Occasional Paper 95. London: The British Museum.

Cotton, J. and Wood, B. (1996) 'Retrieving prehistories at the Museum of London: a gallery case-study', in McManus, P.M. (ed.), *Archaeological Displays and the Public: Museology and Interpretation.* London: Institute of Archaeology, University College, 53–71.

Courbin, P. (1988) *What Is Archaeology? An Essay on the Nature of Archaeological Research.* Chicago: University of Chicago Press.

Diamond, J. (1997) 'Something for the weekend?' *The Times Magazine,* Saturday 8 March.

DNH (Department of National Heritage) (1996) *Portable Antiquities: A Discussion Document.* London: DNH.

Durbin, G., Morris, S. and Wilkinson, S. (1990) *A Teacher's Guide to Learning from Objects.* London: English Heritage.

Durrans, B. (1993) 'Cultural identity and museums', in Southworth, E. (ed.), *'Picking up the Pieces': Adapting to Change in Museums and Archaeology. The Museum Archaeologist* 18. Liverpool: Society of Museum Archaeologists, 42–55.

Edmonds, M. (1992) 'Their use is wholly unknown', in Sharples, N. and Sheridan, A. (eds), *Vessels for the Ancestors: Essays on the Neolithic of Britain and Ireland in Honour of Audrey Henshall*. Edinburgh: Edinburgh University Press, 179–93.

Fleming, D. (1997) 'The regeneration game', *Museums Journal*, 97 (4): 32–3.

Gathercole, P. (1989) 'The fetishism of artefacts', in Pearce, S.M. (ed.), *Museum Studies in Material Culture*. Leicester: Leicester University Press, 73–81.

Goode, G.B. (1897) 'The principles of museum administration', *Annual Report of the Board of Regents of the Smithsonian Institution: Report of the U.S. National Museum*, Part 2: 193–240.

Gosden, C. (1992) 'Endemic doubt: is what we write right?' *Antiquity*, 66, 803–8.

Gregory, T. (1983) 'The impact of metal detecting on archaeology and the public', *Archaeological Review from Cambridge*, 2 (1), 5–8.

Harrold, F.B. and Eve, R.A. (1995) *Cult Archaeology and Creationism: Understanding Pseudoscientific Beliefs about the Past*. Iowa City: University of Iowa Press.

Hayden, B. (1984) 'Are emic types relevant to archaeology?' *Ethnohistory*, 31 (2), 79–92.

Hetherington, K. (1997) 'Museum topology and the will to connect', *Journal of Material Culture*, 2 (2), 199–218.

Hodder, I. (1981) 'Society, economy and culture: an ethnographic case study amongst the Lozi', in Hodder, I., Isaac, G. and Hammond, N. (eds), *Pattern of the Past: Studies in Honour of David Clarke*. Cambridge: Cambridge University Press, 67–95.

Hodder, I. (1982) *The Present Past: An Introduction to Anthropology for Archaeologists* London: Batsford.

Hodder, I. (1992) *Theory and Practice in Archaeology*. London: Routledge.

Hooper-Greenhill, E. (1994) *Museums and Their Visitors*. London: Routledge.

Hull, K. (1997) 'The 'wow' factor', *Museums Journal*, 97 (7), 30–1.

Kinnes, I.A. (1992) *Non-megalithic Long Barrows and Allied Structures in the British Neolithic. British Museum Occasional Paper 52. London: British Museum*.

Kuznar, L.A. (1997) *Reclaiming a Scientific Anthropology*. Walnut Creek: Altamira Press.

James, S. (1993) 'How was it for you? Personal psychology and the perception of the past', *Archaeological Review from Cambridge*, 12 (2), 85–100.

Jones, A. (1996) 'This detectorist has the right idea', *British Archaeology*, 12, 13.

Lane, P.J. (1994) 'The temporal structuring of settlement space among the Dogon of Mali: an ethnoarchaeological study', in Parker Pearson, M. and Richards, C. (eds), *Architecture and Order: Approaches to Social Space*. London: Routledge, 196–216.

Lévi-Strauss, C. (1993) *Structural Anthropology*, vol. 1. Harmondsworth: Penguin Books. (Originally published 1954).

Lubar, S. and Kingery, W.D. (eds) (1993) *History from Things: Essays on Material Culture*. Washington, DC: Smithsonian Institution Press.

Merriman, N. (1989) 'Museum visiting as a cultural phenomenon', in Vergo, P. (ed.), *The New Museology*. London: Reaktion Books, 149–71.

Merriman, N. (1991) *Beyond the Glass Case: The Past, the Heritage and the Public in Britain*. Leicester: Leicester University Press.

Merriman, N. (1993) 'The use of collections: the need for a positive approach', in Southworth, E. (ed.), *'Picking up the Pieces': Adapting to Change in Museums and Archaeology. The Museum Archaeologist* 18. Liverpool: Society of Museum Archaeologists, 10–17.

Middleton, C. (1996) 'Museums', *Observer*, Sunday 21 July.

Miller, D. (1983) 'Things ain't what they used to be: introduction', *Rain (Royal Anthropological Institute News)*, 59, 5–7.

Miller, D. (1985) *Artefacts as Categories: A Study of Ceramic Variability in Central India*. Cambridge: Cambridge University Press.

Mills, N. (1995) *Roman Artefacts Found in Britain*. Chelmsford: Greenlight Publishing.

Palmer, A. (1995) *The Metal Detector Book*. London: Seaby.

Pearce, S.M. (1989a) 'Museum studies in material culture', in Pearce, S.M. (ed.), *Museum Studies in Material Culture*. Leicester: Leicester University Press, 1–10.

Pearce, S.M. (1989b) 'Objects in structures', in Pearce, S.M. (ed.), *Museum Studies in Material Culture*. Leicester: Leicester University Press, 47–59.

Pearce, S.M. (1990) 'Editorial introduction', in Pearce, S.M. (ed.), *Objects of Knowledge*. New Research in Museum Studies 1. London: Athlone Press, 1–5.

Pearce, S.M. (1992) *Museum Objects and Collections: A Cultural Study*. Leicester: Leicester University Press.

Pearce, S.M. (1993) 'Museum archaeology', in Hunter, J. and Ralston, I. (eds), *Archaeological Resource Management in the UK: An Introduction*. Far Thrupp: Alan Sutton/Institute of Field Archaeologists, 232–42.

Pearce, S.M. (1995) *On Collecting: An Investigation into Collecting in the European Tradition*. London: Routledge.

Petrequin, P. and Jeunesse, C. (1995) *La Hache de pierre*. Paris: Editions Errance.

Pitts, M. and Roberts, M. (1997) *Fairweather Eden: Life in Britain Half a Million Years Ago as Revealed by the Excavations at Boxgrove*. London: Century.

Price, J. (1996) 'A live interpretation of the Early Bronze Age in Yorkshire', in McManus, P.M. (ed.), *Archaeological Displays and the Public: Museology and Interpretation*. London: Institute of Archaeology, University College, 138–41.

Read, B.A. (1988) *History Beneath Our Feet*. Devon: Braunston.

Renfrew, C. (1994) 'Towards a cognitive archaeology', in Renfrew, C. and Zubrow, E.B.W. (eds), *The Ancient Mind: Elements of Cognitive Archaeology*. Cambridge: Cambridge University Press, 3–12.

Roland, C. (1995) *History Through Objects: The Sarcophagus: Life and Death on the Nile.* Harmondsworth: Puffin Books.

Rowlands, M. J. (1976) *The Organization of Middle Bronze Age Metalworking. Part 2: Catalogue and Plates.* Oxford: British Archaeological Reports (British Series 31).

Saumarez Smith, C. (1989) 'Museums, artefacts, and meanings', in Vergo, P. (ed.), *The New Museology.* London: Reaktion Books, 6–21.

Saville, A. (1994) 'Artefact research in the National Museums of Scotland', in Gaimster, D. (ed.), *Museum Archaeology in Europe. The Museum Archaeologist* 19/ Oxbow Monograph 39. Oxford: Oxbow Books/Society of Museum Archaeologists, 155–66.

Saville, A. (1997) 'Thinking *things* over after the 1995 SMA Conference', in Denford, G.T. (ed.), *Representing Archaeology in Museums. The Museum Archaeologist* 22. Winchester: Society of Museum Archaeologists, 101–10.

Schultz, F. (1993) *Power Tools: The Stone Age and Bronze Age in North Europe.* New York: Frederick Schultz Ancient Art.

Shanks, M. and Tilley, C. (1987a) *Social Theory and Archaeology.* Cambridge: Polity Press.

Shanks, M. and Tilley, C. (1987b) *Re-constructing Archaeology: Theory and Practice.* Cambridge: Cambridge University Press.

Shanks, M. and Tilley, C. (1992) *Re-constructing Archaeology: Theory and Practice* (2nd edn.). London: Routledge.

Sieveking, A. (1987) *A Catalogue of Palaeolithic Art in the British Museum.* London: British Museum Publications.

Sillitoe, P. (1987) 'Why should anthropologists study material culture?' *Dyn (Journal of the Durham University Anthropological Society)*, 9, 1–17.

Sillitoe, P. (1988) *Made in Niugini: Technology in the Highlands of Papua New Guinea.* London: British Museum Publications.

SMA (Society of Museum Archaeologists) (1993) *Selection, Retention and Dispersal of Archaeological Collections: Guidelines for Use in England, Wales and Northern Ireland.* London: Society of Museum Archaeologists.

Stocking, G.W. (ed.) (1985) *Objects and Others: Essays on Museums and Material Culture.* Madison: University of Wisconsin Press.

Vogel, S. (1991) 'Always true to the object, in our fashion', in Karp, I. and Lavine, S.D. (eds), *Exhibiting Cultures: The Poetics and Politics of Museum Display.* Washington, DC: Smithsonian Institution Press, 191–204.

Walker, S. and Bierbrier, M. (1997) *Ancient Faces: Mummy Portraits from Roman Egypt.* London: British Museum Press.

Webster, L. and Brown, M. (1997) *The Transformation of the Roman World AD 400–900.* London: British Museum Press.

Whitehead, R. (1996) *Buckles 1250–1800.* Chelmsford: Greenlight Publishing.

Wickenden, N. (1996) 'Representing archaeology in museums: the SMA annual conference, Museum of London 9–11 November 1995', *Museum Archaeologists News*, 21, 1–2.

Wood, B. (1996) 'Wot! no dinosaurs? Interpretation of prehistory and a new gallery at the Museum of London', in Devonshire, A. and Wood, B. (eds), *Women in Industry and Technology: Current Research and the Museum Experience.* London: Museum of London/WHAM, 53–63.

Wood, B. (1997) 'Does size matter? Effective presentation of archaeology in small museums', in Denford, G.T. (ed.), *Representing Archaeology in Museums. The Museum Archaeologist* 22. Winchester: Society of Museum Archaeologists, 59–64.

Index

ethnicity 76, 86, 120
evaluation 7, 34–6, 81–2, 129–30,
 175–6, 179, 181

feminist critique 122–3, 136, 138–42
Field Museum of Natural History,
 Chicago, Stone Age
 dioramas 103–5

gender 16, 136–50
 roles 105, 123, 131
Glasgow Museums 37, 180
 'In Touch with the Past'
 exhibition 37, 180, 183
Glen Parva burial 79, 84, 119

Hampshire Museums Service 177
hands-on activities 7–8, 37, 83,
 173–89
 definition of 174
Hawkins, Benjamin Waterhouse
 97–8
heterotopia 161, 163–4
history of archaeology 12–13
history of museums 13
'Hottentot Venus' 101
Tolson Memorial Museum,
 Huddersfield 33
human remains, display of 20–1
humour 83, 96, 151

Ice Man 30, 110
illustrations 117–33, 143
 perception of 121–1
 see also reconstructions
information technology 85–6, 131–2,
 182, 186, 195, 197
interaction
 computer 175, 182, 186
 definition of 174
interpretation, showing processes
 of 130–1

Jorvik Viking Centre, York 112

labels 19–20, 78
Lang, Nikolaus 22–3

Lawn Archaeology Centre,
 Lincoln 178
Leicester
 Jewry Wall Museum 78, 83, 85, 87,
 119
 New Walk Museum 181–2
live interpretation 65–9, 197
Liverpool Museum 8, 77, 79, 84–5
 see also National Museums and
 Galleries on Merseyside
'Lost Magic Kingdoms' exhibition,
 Museum of Mankind 21

Manchester University Museum
 182
material culture 31, 63, 190–209
metal-detecting 198–9
'Mining the Museum' exhibition 22
multiculturalism 46, 61, 65–6,
 68–9
multimedia 131–2, 197
multivocalism 4, 193
museology, criticism of 191–2
Museum of the Iron Age,
 Andover 30, 37
Museum of London 7, 8, 26, 30,
 49–69
 Dark Ages gallery 77, 86
 'Peopling of London'
 exhibition 82
 Prehistoric gallery 34, 37, 51–3,
 118, 120, 180, 194, 198
 Roman gallery 46, 49–69, 180
 'Time Machine' 184, 186
Museum of Welsh Life, St
 Fagans 153–5, 162
museums
 image of 20
 with archaeology collections 29

National Curriculum 35, 50, 82, 132,
 155, 157
national identity 75
National Museums and Galleries on
 Merseyside 177–80
National Museums of Scotland 32
nationalism 75, 86

211

Natural History Centre, Liverpool
 Museum 8
Natural History Museum,
 London 82, 194
Newcastle, Museum of
 Antiquities 78, 132
Norfolk Museums Service 198
Nottingham Museum 83

objects, *see* material culture
older people, absence of 33
origin myth 75
Osborn, Henry Fairfield 98, 103
'Other', past as 120

Paolozzi, Eduardo 21
Peale, Charles Willson 96–7, 100
Peel Heritage Centre, Isle of Man 182
Pitt Rivers Museum, Oxford 22, 25,
 26
Poirier, Anne and Patrick 22, 24
prehistory
 perception of 34–7
 representation of 28–39, 102
progress, idea of 31, 105

reconstructions 64–5, 78, 95–112,
 117–33, 139–40, 143
 definition of 117–18
 open-air 151–72
Red House Museum,
 Christchurch 32
relativism 37, 193–4
relevance 37, 88
representation, definition of 28–9
Roman period
 representation of 44–73
 modern parallels 56–8
Romanization 61–2
room settings 64–5, 78
Royal Ontario Museum, Discovery
 Gallery 176

Saveoc Mill, Cornwall 152–3, 161–2
school visits 68–9, 82, 132, 155, 157

Science Museum, London 82
Scunthorpe Museum 81, 83
SEARCH Hands-on Centre,
 Hampshire 177, 179, 183
slavery 66, 68–9
Smithsonian Institution 101
sociology of archaeology 18
Stavanger Museum, Norway 147–8
stereotypes 102, 105, 109, 140
 challenging 106
Stoke-on-Trent museum 30, 180
Stonehenge 32, 193
stores, access to 203

taxidermy 98–9
Time Team 3, 30, 31
Tolson Memorial Museum,
 Huddersfield 33
treasure-hunting 198

Ulster Museum 177, 180–1

Verulamium Museum, St Albans 30,
 177, 182
videos 83
virtual reality 186
visiting, as performance 164–70
visitor research 7, 34, 74, 81–2, 129

Wasamuseum, Stockholm 145–6
wax figures 101
Web sites 132
Welch, Raquel 67
West Stow Anglo-Saxon village 79,
 84–5, 87
Wilson, Fred 21–2, 24, 26
Winchester City Museums 178
women, under-representation of 33,
 136–50
Women, Heritage and Museums
 (WHAM) 122–3, 139, 141
Women's Museum, Århus 147
world's fairs 100–3
writing 54–5
 and authority 58, 60